Five years earlier, I would have thought it enough to take a picture of a man. No more.

Dorothea Lange

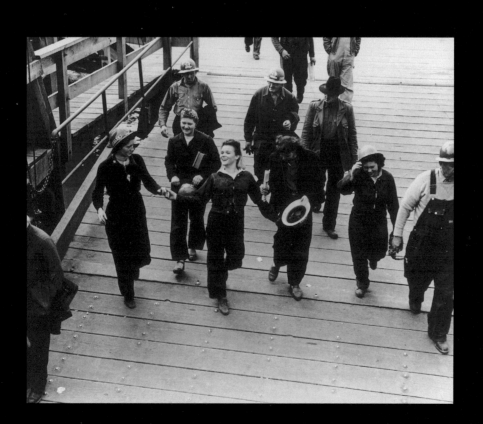

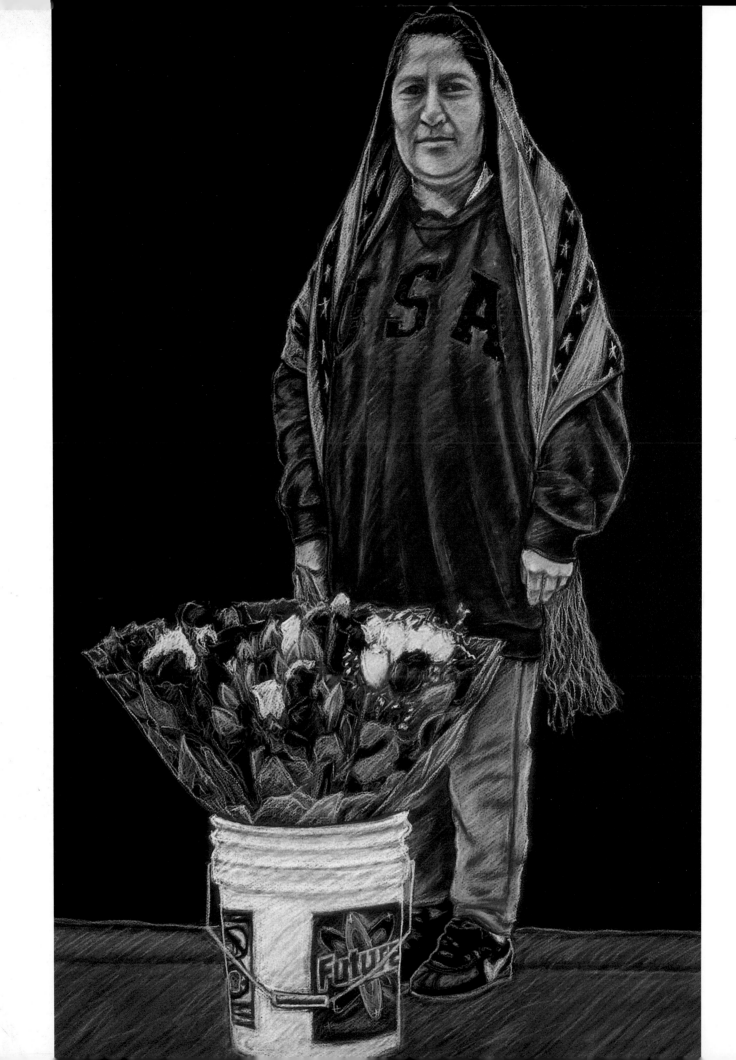

AtWork

The Art of California Labor

Edited by Mark Dean Johnson

Foreword by Gray Brechin · Afterword by Tillie Olsen

California Historical Society Press, *San Francisco, California*

in conjunction with Heyday Books, San Francisco State University,

and the California Labor Federation, AFL-CIO

California Historical Society Press is a collaboration between the California Historical Society and Heyday Books. California Historical Society Press is supported by grants from The William Randolph Hearst Foundation and The Mericos Foundation.

At Work was produced in conjunction with the exhibitions *At Work: The Art of California Labor* at the California Historical Society, San Francisco, and the Fine Arts Gallery at San Francisco State University (opening September 1, 2003). *At Work* is supported by The James Irvine Foundation and the Walter and Elise Haas Fund.

Library of Congress Cataloging-in-Publication Data
At work : the art of California labor / edited by Mark Dean Johnson.
 p. cm.
ISBN 1-890771-67-8 (pbk. : alk. paper)
1. Labor in art. 2. Working class in art. 3. Art, American—California—20th century. I. Johnson, Mark Dean, 1953–
N8219.L2A85 2003
704.9'49331'09794—dc21 2003006809

Front cover: Diego Rivera, *Allegory of California,* 1931, fresco, Pacific Stock Exchange Luncheon Club, San Francisco.

Plate 1. Dorothea Lange, *Shipyards—End of Day Shift at Yard One,* 1943, gelatin silver print, 10" x 8".

Plate 2. Ester Hernández, *La Virgen de las Calles (The Virgin of the Streets),* 2001, pastel on paper, 40" x 30".

Back cover: Emmy Lou Packard, *Half Moon Bay,* ca. 1960, color linocut, 24" x 36".

Cover and book design: David Bullen Design
Printing and Binding: Hatcher Press, San Carlos, CA
Printed in the United States of America

Orders, inquiries, and correspondence should be addressed to:
Heyday Books
P.O. Box 9145, Berkeley, CA 94709
(510) 549-3564, Fax (510) 549-1889
www.heydaybooks.com

10 9 8 7 6 5 4 3 2 1

Contents

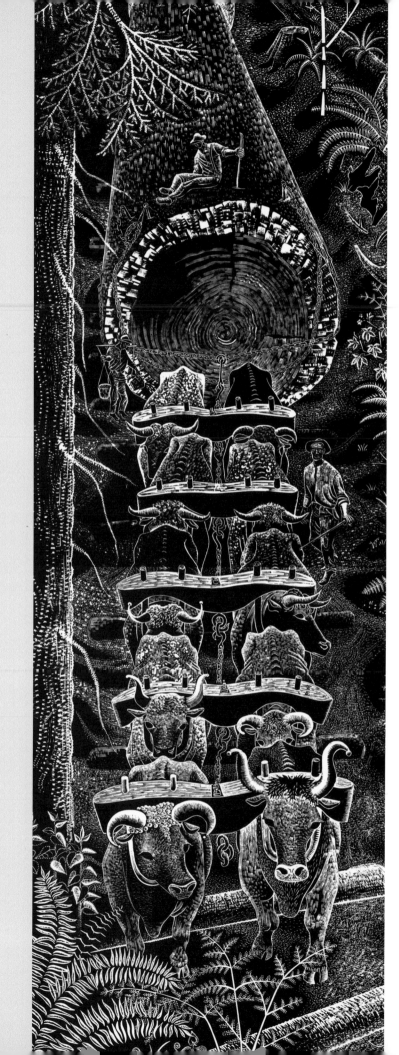

Plate 3. Emmy Lou Packard, *Logging in Mendocino, 1870*, 1969, linocut, 72½" x 15"

Preface

This publication marks a historic collaboration among the California Historical Society; the California Labor Federation, AFL-CIO; San Francisco State University; and Heyday Books. Each of these organizations lent its unique perspective to this project, which consists of this book, as well as exhibitions, a music festival, and related programs. The California Historical Society includes in its mission the importance of integrating art into the study of California history; the California Labor Federation represents the voices of working people and their collective struggle for fair reimbursement; while San Francisco State University encourages and has demonstrated the value of community-relevant interdisciplinary study. For its part, Heyday Books strives to preserve the culture and heritage of Californians through its focused publishing program.

At Work: The Art of California Labor explores a topic that is germane not only to the people of this state but to everyone. Carefully selected artwork and illuminating text combine to offer a compassionate view of both the joy and dignity of work and the conflicts it can engender. *At Work* provides insight into one of the most fundamental components of our daily lives and illustrates how our collective identity as Americans has evolved over the past century. It showcases the work of noted artists while bringing to light those who have until now been neglected but are equally deserving of attention.

We especially want to thank Professor Mark Dean Johnson, whose vision, knowledge, enthusiasm, and persistence inspired this project in the first place and have now brought it to fruition.

We are all proud and honored to have participated in *At Work*, itself a shining example of cooperative labor. We hope that this volume will be a resource and a pleasure for many generations to come.

Stephen Becker, *executive director, California Historical Society*
Tom Rankin, *president, California Labor Federation, AFL-CIO*
Robert Corrigan, *president, San Francisco State University*
Malcolm Margolin, *publisher, Heyday Books*

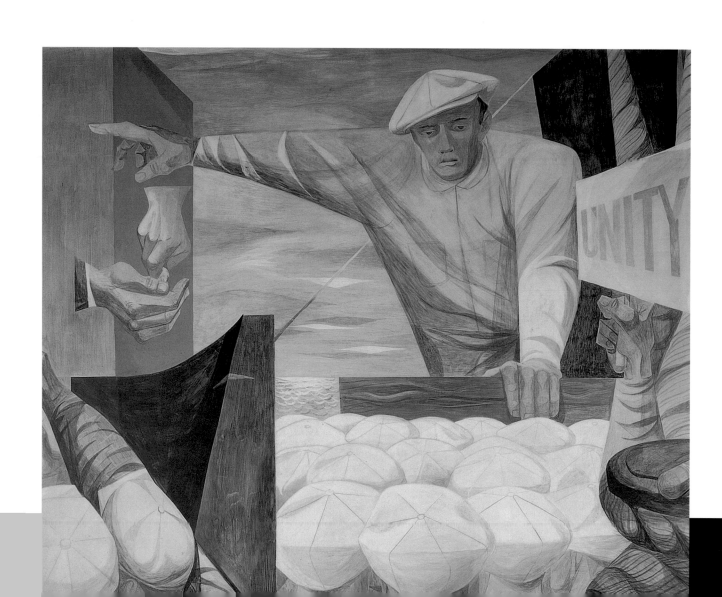

Foreword

GRAY BRECHIN

On the morning of May 1, 1953, a congressional hearing convened in Washington to consider the destruction of murals recently completed by Anton Refregier for San Francisco's Rincon Annex Post Office.[1] The sympathy which "Ref" had shown for workers of all races and the prominence he gave them—even his liberal use of the color red—had so enraged reactionaries accustomed to triumphalist versions of California history that they demanded that the publicly funded cycle of murals be obliterated. *The Nation* noted that the prospective iconoclasm was only the beginning of a wider purge: "The intellectual-moral achievements of the Roosevelt-Truman era are now to be liquidated; its paintings along with its social plans are to be consigned to the rubbish heap. The 'inquisition' of New Deal artists and their works has begun promptly after the conservatives took over in 1953, with Anton Refregier the first defendant."[2]

The murals and the Moderne lobby they adorned survived, but over thirty years later, wreckers razed most of the post office to accommodate a monumental mixed use development called Rincon Center.[3] By the time New York artist Richard Haas installed his own murals in the soaring central food court, the fury over Refregier's murals was long past. A historical curiosity, their figures so vigorously building and contesting the city's terrain were now painstakingly restored to vibrant color. The developers of Rincon Center added explanatory texts so that viewers would not have to guess at the once-famous incidents depicted. As containerization did away with longshoremen, the nearby waterfront morphed into a zone of trendy restaurants, offices, and view condos where history kiosks reminded pedestrians that this had once been the scene of often bloody labor activism.

The transformation of San Francisco's waterfront was emblematic of an epochal change taking place around the world. The economic and social milieu that had conjured such vivid images from Ref's imagination receded in the opening years of the Reagan Revolution. Back in 1947, the artist had wanted a colossal portrait of Franklin Roosevelt to terminate the long lobby, but the Public Buildings Administration ordered him to eliminate it; by 1981, when the new Reagan administration signaled its uncompromising attitude toward unions by firing 11,500 striking air traffic controllers, those who had supported Roosevelt were themselves aging and passing, their ideals in part victims of the very democratized prosperity for which they and Roosevelt had fought.[4] Refregier had painted

San Francisco's past from an unconventional perspective—that of the city's workers and ethnic minorities—but as the years drew on, historical amnesia increasingly vitiated both the meanings he embodied and the progressive vision for a more equitable future free of war, poverty, ignorance, and fear. Forgetfulness of those scourges would make fertile soil for their return.

Haas, I think, scented that change and slyly represented it in a subdued palette of pale blue, tan, and dusty rose that looks blanched after the New Deal murals in the adjacent lobby. The abundant crops in a panel representing California's agribusiness thus resemble tinted styrofoam leached of nutritional value. In a panel representing the city's financial service economy, Haas placed A. W. Clausen, then president of the Bank of America, dead center, standing like a monolith with his arms crossed decisively and his head framed by the half-halo of an arched window, through which an erect Coit Tower can be seen brushing his left ear. White collar workers serve the chief executive while an anomalous female garment worker sews in what appears to be a bank lobby behind him. Across the atrium, in a panel depicting Silicon Valley, workers toil grimly in dust- and union-free office parks to create a brave new future, several of them further dehumanized by bulky moon suits designed to protect the products from organic contamination. A nuclear reactor in the background feeds the requisite juice into that Mecca of high technology.

Decades earlier, critics like Michigan Representative George Dondero had complained that "modern" art like Refregier's was "communistic because it is distorted and ugly, because it does not glorify our beautiful country, our cheerful and smiling people."[5] Dondero's ideal is, no doubt, just the kind of painting that those who commissioned Haas wanted in their lobby to reassure lunching office workers. The artist instead gave them and the workers a vaguely disquieting vision of an *almost* postindustrial world as devoid of enjoyment as it is of conflict. Leached of life, everyone seems turned to stone by what they are doing—*alto-relievo* figures in a frieze from a civilization with little, in fact, to celebrate and less capacity to do so.

What, other than the getting and spending of money, could possibly endow a society of automatons whose unspoken duty is to serve the economy with any meaning? The art critic John Ruskin in 1853 turned from his study of Venetian gothic architecture to ask that question even as the industrial revolution gathered steam. In the central chapter of *The Stones of Venice,* "The Nature of the Gothic," he observed that "we have much studied and much perfected, of late, the great civilized invention of the division of labor; only we give it a false name. It is not, truly speaking, the labor that is divided; but the men."[6] Workers were equally dis-integrated from one another, from themselves, and from the products they made by their assigned and automatic labor: "And the great cry that rises from all our manufacturing cities, louder than their furnace blast, is all in very deed for this—that we manufacture everything there except men; we blanch cotton, and strengthen steel, and refine sugar, and shape pottery; but to brighten, to strengthen, to refine, or to form a single living

spirit never enters into our estimate of advantages." Labor unrest could only be addressed "by a right understanding, on the part of all classes, of what kinds of labor are good for men, raising them, and making them happy; by a determined sacrifice of such convenience, or beauty, or cheapness as is to be got only by the degradation of the workman; and by equally determined demand for the products and results of healthy and ennobling nature."

Ruskin was calling for a revolution not just in the means of production, but of consumption as well, in order to foster human fulfillment and, through that revolution, the reintegration of an ever more divided society. Modern workers must, he insisted, be uplifted by being permitted to exercise their intelligence and artistic faculties, while buyers should be aware of their own responsibilities to the workers when shopping: "Every young lady . . . who buys glass beads is engaged in the slave-trade, and in a much more cruel one than that which we have so long been endeavoring to put down."

It would be easy to dismiss such idealism as the sentiment of a wealthy dilettante who had never done manual labor (and who was, after all, only fitfully sane) if it had not had such profound influence on others. Ruskin's disciple William Morris called "The Nature of the Gothic" "one of the very few necessary and inevitable utterances of the century," and a century on, art historian Kenneth Clark called it "one of the noblest things written in the nineteenth century."[7] Morris attempted to embody Ruskin's advice by creating a much imitated guild of craftsmen, while others founded or worked for settlement houses and workingmen's colleges, public libraries, schools, hospitals, and mechanics' institutes to raise the laborer from the numbed brutality that, for example, poet Edwin Markham depicted in "The Man With the Hoe" and Frank Norris in "The Brute."

During the Great Depression, art once again became critical for educating and uplifting those in the labor movement, as artists such as Dorothea Lange and Maynard Dixon shifted their attention to the dispossessed and distressed. Tillie Olsen [see Afterword] speaks firsthand of the solidarity of labor and art at that time, and of how unions and the California Labor School sought to stimulate the latent potentiality of workers caught in disastrous times.

As remarkable as it seems from the vantage point of 2003, artists and workers then had friends at the very top of the federal government.[8] Inspired by the example of the Mexican muralists, the aristocratic George Biddle suggested a federal arts program to his Harvard classmate Franklin Delano Roosevelt. Biddle wrote of the WPA Federal Art Project that "its credo is that if one creates a cultural background, art will follow. It wasn't Michelangelo who created the fifteenth century but the fifteenth century that created Michelangelo."[9] For a brief and tumultuous period, painters, sculptors, writers, actors, playwrights, and landscape architects had the rare opportunity to create for a *public* audience. Few so daringly pushed that opportunity to educate workers to their own contributions, dignity, and potentiality as Refregier, and he paid dearly for his audacity.

The trial of the Rincon Annex murals, as *The Nation* observed, was just an opening

salvo. In the decades that followed, well-funded reactionary think tanks such as Olin and Scaife, as well as their cousins and proliferating offspring, would plan a "culture war" meant to roll back not only the material gains of the New Deal but the very consciousness that it had helped to foster. In so doing, they would prepare the ground for the ascension of Ronald Reagan together with the consolidation and rightward drift of the mass media that would, in turn, make still further encroachments possible. In this war, what the media *didn't* say was at least as important as what it did.[10]

When César Chávez and his United Farm Workers were gaining strength, the San Francisco *Chronicle*'s labor editor, Dick Meister, ran afoul of conservative publisher Charles de Young Thieriot and his wealthy friends by writing too consistently and sympathetically about the UFW. Meister found his suggestions for stories ignored and labor coverage progressively cut back. When city editor Abe Mellinkoff told him that he would have to adjust his attitude in order to "gain perspective and a sense of journalistic reality," Meister knew that the jig was up and left the paper. He was the *Chronicle*'s last labor editor, a vanishing species across the country.[11]

When *Chronicle* staff went on strike in 1968, public television station KQED filled the void by launching a prime-time nightly news show first called *Newspaper of the Air* but known best as *Newsroom*. *Chronicle* beat reporters decided themselves what stories they would feature and discuss on the air, and they took calls and suggestions from viewers afterward. Initially backed by a grant from the Ford Foundation, *Newsroom* attracted record viewing audiences and public support while spawning imitators at other public stations. Dick Meister joined the lineup, introducing viewers to vital labor issues such as the UFW struggle. *Newsroom* thus earned the enmity of powerful KQED board members who progressively found ways to cripple it; by 1978, that experiment in democratic news coverage was history.

Newsroom and its successor, *A Closer Look,* combined with alternative newspapers and independent radio stations to stimulate unprecedented citizen activism; in the decades that followed, those windows slammed shut as private media consolidated and public stations went commercial. At KQED, corporate underwriting and entertainment gradually replaced the educational mandate until few viewers could remember what they were missing.

Everywhere in the media, labor disappeared as an issue or even as a presence, replaced with an ever more giddy and universal celebration of business itself, of heroic entrepreneurs and CEO titans, of get-rich-quick come-ons in a razzle-dazzle casino economy. The mass media increasingly taught the public that capital rather than labor created wealth; labor, in fact, merely impeded capital's lush self-generation. As in Haas's Financial District mural, workers stepped into the background. The Depression as both event and cautionary tale faded into deep history as pundits and best-selling authors proclaimed that a winning combination of new technology, unfettered trade, bold entrepreneurs, and Federal Reserve chief Alan Greenspan had ended the old market cycle. Union membership withered.

As heavy industry implodes or moves overseas and south of the border, we are led to believe that the visions of technocratic prophets have come true in the United States: tedious manual work has vanished while a cornucopia of steel, appliances, food, and clothes has appeared out of thin air. But because the mass media seldom, if ever, report their causes and concerns, it is the workers themselves who have vanished from public consciousness. Many of those who cannot find work that pays a living wage in the New Economy have *not* disappeared, however, but disturbingly manifest themselves at home in ever growing numbers of street derelicts and crime statistics, and abroad in seething resentment.

By August 2002, according to the men's magazine *Details*, retro working-class chic had become yet another fashion option. Over a photograph of coal-grimed miners, ad text proclaimed, "The current trend of American workwear is the fashion equivalent of a city slicker driving an SUV; it's a look that says you might be on your way to go duck hunting when in fact you've snuck out for a mojito." Subtly acknowledging that the nation was in the midst of a post-9/11 masculinity crisis, the copy continued, "But at a moment when we're surrounded by images of conflict and reconstruction, men want to look ready for action"—just like their president, who responds to emergencies by "rolling up his sleeves at his ranch." One could get that look with the purchase of a pre-distressed $1400 jacket, a $400 shirt, and $575 boots by Louis Vuitton. Information about where those garments were made, who made them, and how much they were paid to do so did not, of course, find its way into the high-consumption pages of *Details* or the minds of its readers.[12] Ruskin's plea for a community of interest between consumers and workers now sounds as alien as Swahili spoken at a meeting of the English-Speaking Union.

Ubiquitous advertising and spectacular entertainment, as well as the ever rightward drift of politics, paved the broad highway to the dis-integrated world of the early twenty-first century; these forces were, in fact, inseparably connected, for they offered the chief career options for making big money. Marin digital animation wizard Spaz Williams walked away from George Lucas's Industrial Light and Magic company when he realized that his work was making a future that he did not want his or anyone else's daughter to inhabit. "Kids believe things are real," he said about special effects. "What we have made here is a weapon. The human race is in trouble if our value system is based on synthetics." Trained to destroy entire solar systems on the screen, he asked "How long will it be before we have the real thing?"[13]

Some California artists foresaw that future. While much of the labor art of the twentieth century focused on individual and collective heroism, suffering, or martyrdom, a few artists depicted the end result for humanity of a system that promises everything—especially freedom—but that delivers the opposite to most and arguably to all. No one conjured such terrifying visions as Irving Norman.

Norman was trained as a barber, but his plans were deflected by his experiences fighting against fascism with the Lincoln Brigade in the Spanish Civil War. That violence

woke him, he later said, to the "realization that . . . the foundation of this society is based on war." Returning to California, he briefly attended art classes at the California School of Fine Arts in order to learn the craft that would allow him to embody the visions that haunted him. He had his first solo exhibition of drawings and paintings in 1940 at the California Labor School in San Francisco, winning high praise from director Giacomo Patri as well as from the director of the California School of Fine Arts, who understood that Norman "draws because of some extraordinary impulsion." In 1946, he traveled to Mexico to see the works of Rivera, Siqueiros, and Orozco, and to "absorb more of their great acknowledgment of suffering: to find an expression of relief for a working society."[14]

Like the paintings of Bosch and Brueghel, Norman's obsessively detailed and immense canvases depict a hell uncannily familiar. Encapsulated commuters attempt to rush in opposing directions in *The Bridge* [see page 41] while trapped in gridlock and suspended by cables under immense strain. In his drawing *The City* [see page 67], workers struggle en masse through the deep canyons of the city to get ahead, like tormented devotees in the cathedrals of finance. Driven on by manufactured illusions of limitless and unfulfillable desire, Norman's naked figures swarm across his paintings and drawings, their mouths agape like those of fish caught in an invisible net or web that draws them in relentlessly.

That was the metaphor that Robinson Jeffers used in his poem "The Purse-Seine" [see page 14]. For Jeffers, the very technology that made the limitless modern city possible made it a target for annihilation as well—an unseen net closing in on the terrified masses, "each person in himself helpless, on all dependent." Jeffers predicted that the government would "take all powers . . . add to kept bodies kept souls—or anarchy, the mass disasters," concluding that "these things are Progress." He did not foresee that "or" would become "and."

Both men retreated from the city into reclusiveness on the California coast—Jeffers to Carmel and Norman to Half Moon Bay—to pursue their uncompromising art. Jeffers fell from high public favor, while Norman never achieved it. Like the Mexican muralists he so admired, Norman wanted his paintings displayed in public places to serve as "an expression of relief for a working society." But during his lifetime, they proved too upsetting for all but a few collectors and museums.[15] As *Chronicle* art critic Alfred Frankenstein correctly noted, "He scares people."[16]

Norman's paintings may yet achieve the renown that escaped their creator, for they offer an external critique of the fate of *all* workers caught in nebulous nouns like "Progress" and "Globalization." Those workers now find themselves suspended together, like Norman's commuters, over the black abyss. Since the Battle of Seattle and before, laborers, students, professionals, and all those who care about the fate of their earth have been forging unprecedented alliances. Artists such as Juana Alicia, Ester Hernández, and Patricia Rodríguez aid that understanding by depicting the inseparability of work, the environment, and health.

Ironically, the very extremism of the second Bush regime aids such a union of formerly disparate interests. No other U.S. administration has shown itself to be so openly inimical to organized labor, environmental values, constitutional rights, and social needs—and so friendly to the claims of a few. As the happy face falls from what political scientist Bertram Gross in 1980 defined as "friendly fascism," the nightmare visions of Irving Norman and others striving to realize a more equitable world seem ever less outlandish. As Ruskin understood, it is art's mission to wake us to our common predicament and peril, and to our responsibilities toward one another and our home. It is to those ends the artists of *At Work* labor.

notes

1. I tell the story in "Politics and Modernism: The Trial of the Rincon Annex Murals," *On the Edge of America: California Modernist Art, 1900–1950,* edited by Paul Karlstrom (Berkeley, Los Angeles, and London: University of California Press, 1996).

2. Matthew Josephson, "The Vandals Are Here: Art Is Not For Burning," *The Nation* 177, no. 13 (26 September 1953): 247.

3. Douglas Frantz, *From the Ground Up: The Business of Building in the Age of Money* (Berkeley, Los Angeles, and London: University of California Press, 1991)—a detailed study of Rincon Center's creation.

4. Refregier substituted a depiction of Roosevelt's Four Freedoms for his portrait as a reminder of what Roosevelt, at his best, stood for.

5. Karlstrom, *On the Edge of America,* 78.

6. John Ruskin, *The Stones of Venice* (New York: John Wiley, 1860), 182-184.

7. John Ruskin, *The Stones of Venice,* edited and introduced by Jan Morris (Boston and Toronto: Little, Brown and Company, 1981), 25-26.

8. An elderly veteran of the Civilian Conservation Corps once told me, "We felt that someone in Washington cared for the little guy."

9. George Biddle, "Art Under Five Years of Federal Patronage," *American Scholar* 9, no. 3 (summer 1940), 333.

10. Mark Dowie, *American Foundations: An Investigative History* (Cambridge, Mass. and London: The MIT Press, 2001), 214-218.

11. Dick Meister, "The Last Labor Editor," *San Francisco Bay Guardian,* March 8, 2000.

12. The cover story of that issue asked if the three male leads of the sitcom *Friends* were worth their $72 million contract with NBC Entertainment.

13. Michael McCarthy, "Virtual Wizard," *Pacific Sun,* February 21-27, 11-14.

14. Patricia Junker, *The Measure of All Things: Paintings by Irving Norman* (San Francisco: Fine Arts Museums of San Francisco, 1996).

15. William Blake wanted his visions painted on the walls of Parliament, and he too died in poverty.

16. Junker, *The Measure of All Things,* 11.

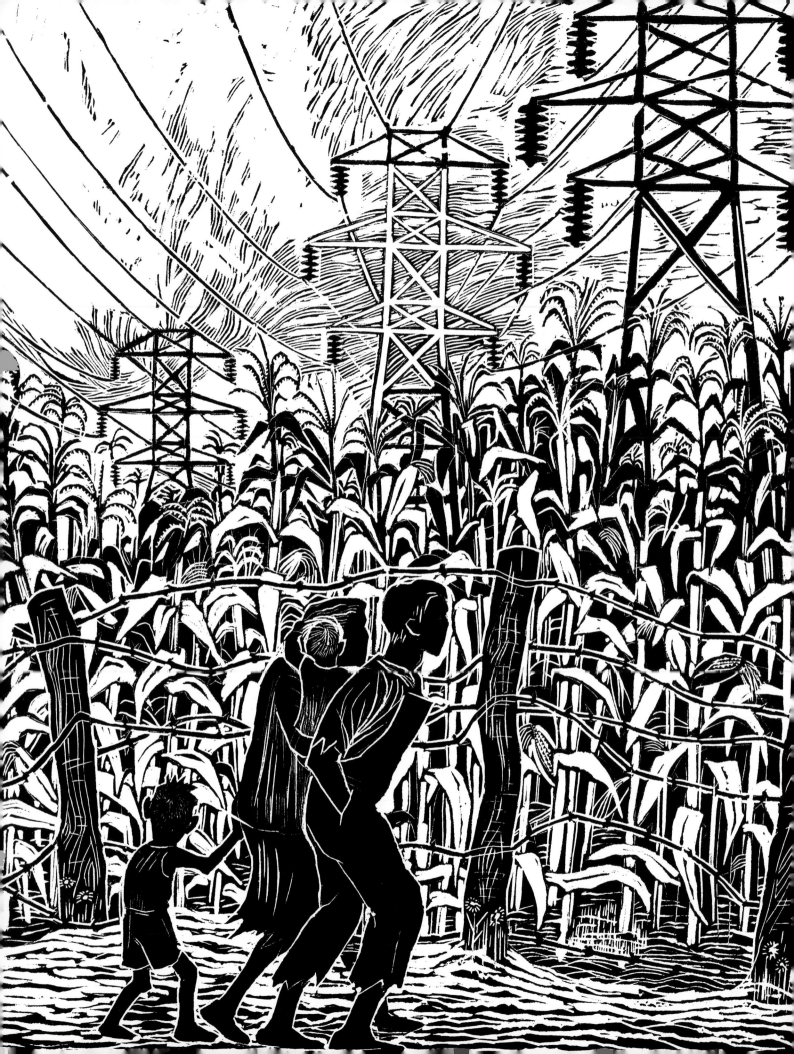

An Illustrated Introduction

MARK DEAN JOHNSON

In Lucienne Bloch's 1930s woodcut *Land of Plenty,* monstrous power lines loom overhead as a silhouetted family of migrant workers in tattered clothes walks past a fenced-off cornfield. Evoking Bethlehem's lack of space for the holy family, the image and Bloch's bitterly ironic title underscore the family's disconnection from the American dream. To see this work is to grasp in an instant the ways in which the barrier of economic inequality blocks any escape from hunger and poverty.

Although Lucienne Bloch was raised in a privileged environment, she understood the powerful potential of art. In the same period when she created *Land of Plenty,* she wondered to what extent "art had in the past been severed from the people and placed upon a pedestal for the privilege of museum students, art patrons, and art dealers."[1] Her goal of creating more relevant, less elitist imagery drew her to make images exploring labor.

Bloch was a close friend of Mexican artists Frida Kahlo and Diego Rivera, and her ideas in some ways parallel those of Rivera, who said, in a May 1931 address to artists and students in San Francisco, "It is of little good for young students to sit before easels and paint things which mean little to them and less to others in the hope that the great spark will come to them to make something really great."[2] Rivera instead promoted a socially conscious focus in art, making an emotional connection with people's daily lives and promoting art as a means of imbuing everyday experience—including the need to work and to survive—with meaning.

Survival, with its constant companion work, is among the most basic of human concerns. The word "work" alone evokes primordial anxieties about sustenance and shelter. Beyond that are issues of personal success, our tendency to define ourselves by our occupations, the fulfillment and frustration that inform our days, the social life built around people we meet on the job. Work, for individuals and for society as a whole, carries great symbolic weight, akin in gravity to love and loss, life and death. Recognizing this, the artists in this volume evidence a humanistic interest in everyday experience and a determination to create art in accessible forms. This commitment to an aesthetic based on the hope of inspiring transformation often comes at a cost. In particular, an affinity for Marxist and communist ideology, feared in the past and now often dismissed with the failed

Plate 5. Lucienne Bloch,
Land of Plenty, ca. 1936,
woodcut, 10½" x 9"

governments it inspired, has been a cause for persecution. More generally, many of these artists sacrificed reputations and financial security for the sake of their populist beliefs. As Woody Guthrie said, "I ain't a communist necessarily, but I been in the red all my life."[3]

Considering the amount of time, thought, and effort we expend at work, the significance of art about labor is self-evident. And so, in *At Work: The Art of California Labor*, we have assembled art from one of California's most important traditions: the struggle, through work, to survive.

Antecedents for California visual art about labor can be found in nineteenth-century Europe, where Honoré Daumier's paintings and prints of peasants, and later the work of realist painters including Gustave Courbet and Jean-François Millet, depicted menial labor. California artists like Douglas Tilden and Armin Hansen studied in Europe and absorbed some of this spirit. By the turn of the twentieth century, the work of New York photographers including Lewis Hine and Jacob Riis presented shocking images of labor and poverty, and the work of the Ashcan School, appearing first in 1908, also looked to social issues and themes. California popular literature from this period, including the novels of Frank Norris, Jack London and Upton Sinclair, reflected related concerns.

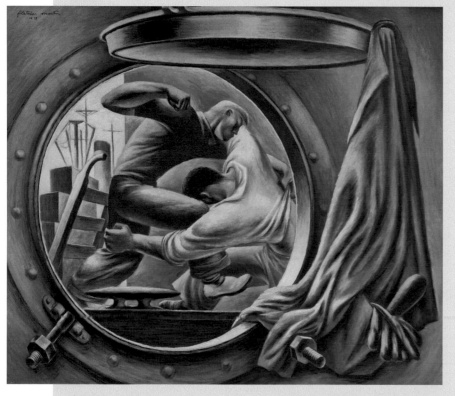

Plate 6. Fletcher Martin, *Trouble in Frisco*, 1938, oil on canvas, 30" x 36"

Yet it was Mexican art that most strongly led the movement toward socially engaged imagery in California. Momentum grew as artists traveled back and forth between Mexico and California. José Guadalupe Posada's prints promoting the cause of the working class transformed Mexican art, and Mexican artists came to the attention of California benefactors such as the noted philanthropist Phoebe Hearst, who funded Alfredo Ramos Martínez's study in France from 1902 to 1906. José Clemente Orozco first visited Southern California from 1917 to 1919, and Francisco Cornejo founded the Aztec Gallery in San Francisco in the early 1920s. Important museum exhibitions of Mexican art were held throughout Northern and Southern California during the 1920s, and Orozco, Ramos Martínez, and David Alfaro Siqueiros all painted murals in Southern California in the years that followed. Diego Rivera was highly influential in California even during the 1920s, before his celebrated Northern California visits and mural commissions. Many of the artists in *At Work* also lived in Mexico or visited there to see the

work of Rivera and the Mexican muralists; several managed to work with them personally. In addition to Lucienne Bloch, examples in this book include Victor Arnautoff, Pele de Lappe, Fletcher Martin, Tina Modotti, Irving Norman, Mine Okubo, Emmy Lou Packard, Henrietta Shore, Ralph Stackpole, Domingo Ulloa, Charles White, and Bernard Zakheim.

Fletcher Martin's 1938 painting *Trouble in Frisco* exemplifies the best of these artistic influences. The painting's fistfight is based on an event that Martin witnessed, but it more generally suggests the waterfront's dramatic history, including 1938 jurisdictional disputes between the American Federation of Labor and the Congress of Industrial Organizations. Martin had worked as an assistant to Siqueiros on a mural project in Southern California, and this painting's staccato modeling immediately recalls the dry paint handling of fresco. At the same time, its porthole composition is like the round, or tondo, format common in the Renaissance. This reference to Italian Renaissance religious art in the depiction of modern working people attempts to elevate a mundane scene of struggle to a more archetypal level.

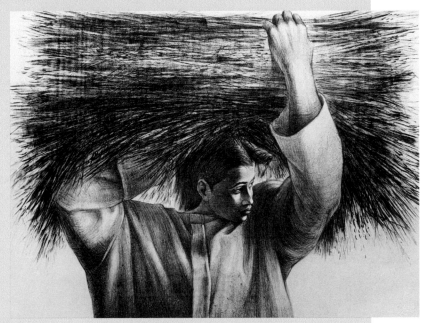

Plate 7. Charles White, *Harvest*, 1963, lithograph, 22¼" x 30"

California artists of the 1930s were not alone in their ambition to glorify the quotidian,[4] but California artists seem in retrospect to have been particularly passionate about the relationship of the individual to labor struggle.[5] In the decades and stylistic periods that followed the Depression, humanist themes were advanced in different ways. During World War II, the depiction of work often reflected a nationalist agenda. After the war, manual work was sometimes seen as an antidote to the rapacious consumerism embraced by white collar society. During the civil rights movement, solidarity with nonwhite workers came to the political and artistic forefront. For example, Charles White's 1963 lithograph *Harvest* was created in the same period as the Watts Uprising and the passage of the American Voting Rights Act. The subject's balance, grace, and upright posture convey a sense of dignity that can be immediately related to the social imperatives of the era. The fact that the nationality of White's subject is not identified delineates a new transnational consciousness that would contribute to America's growing sense of multicultural identity. White's work typifies the potential of art to transform the way in which we see ourselves and our communities.

In the conflicted, contemporary, postmodern epoch, we find yet another image of the worker. It is hard to trace the idealism of the civil rights era in Dan McCleary's intimate 1989 portrait, *Carl's Junior Worker*, yet neither does its subject, a young, uniformed Asian American, show signs of feeling trapped by a minimum-wage, stultifying job at the front

counter of our contemporary service economy. Rather, the bathroom-tile pinks and greens of McCleary's painting give its subject a beatific aura, revealing beauty even in our fast-food culture.

Seeing these works together, one has an opportunity to meditate on the subject of art and labor, and a chance to consider an underrecognized and underappreciated body of work. California art about labor has never really been hidden—indeed, works by Dorothea Lange and John Steinbeck are among the most widely known artistic milestones ever produced—but neither has the extent of this lineage been fully explored. As a collection, these works demand that we recognize the depth of their aesthetic and compassionate power, and that we appreciate the issues of struggle and collective organizing that they envision.

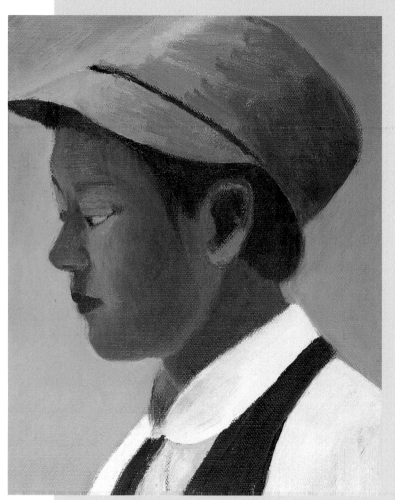

Plate 8. Dan McCleary, *Carl's Junior Worker #2*, 1989, oil on canvas, 10" x 8"

At Work: The Art of California Labor surveys a century of such depictions in five chapters organized thematically as well as chronologically. Chapter 1, "Romantic Foundations," explores the great romantic spirit that pervaded the cultural landscape of California at the turn of the twentieth century, set against the contentious, often vicious labor relations of the Progressive Era. Chapter 2, "The Great California Labor Art Movement," focuses on the ascendance of unionizing, forged from the conflicts of the Great Depression, and then considers the ways in which World War II turned around not only the economy of California but its mind-set. The synergy of labor and art proved catalytic for several communitarian-minded experiments in the arts during these same years, subsequently suppressed during the McCarthy era, and these are the topic of Chapter 3, "California's Collective Art Culture." The resurfacing of organizing issues and artistic responses during the farm workers' movement and related Chicano Arts Movement of the 1960s and 1970s is discussed in Chapter 4, "El Valle Central: A Chicano Art Perspective." And finally, Chapter 5, "Contemporary Expressions," looks at the complexity of today's global economy and the ways in which artists continue to mine these topics in sometimes familiar but often surprising ways.

These five chapters trace the central stories of *At Work*. One is the mutually sustaining relationship between political activism, organized labor, and art. The variety of art produced on the subject of work is another: different regions of the state, different eras, and

different political realities all contribute. We also see that certain media—printmaking and murals in particular—have been favored for their populist potential. Photography too enables broad access through reproduction and publication. And while some of the artists in *At Work* are well known, the majority remain obscure. Some works have suffered from their creators' romantic approach to or misunderstanding of the trades they depict. Far more important is the fact that women, communists, artists of color, Jews, activists, idealists, printmakers, muralists, and "content artists"—those who emphasize content over form—have all at one time or another been seen in a pejorative light, whether for political, economic, or academic reasons. Seeing these works now, we have the opportunity to reclaim this heritage, exploring the links that exist across generations and remembering the constant that runs through this body of art: an awareness of the forces in our society that limit—or enhance—the individual's ability to succeed and prosper.

notes

1. Lucienne Bloch, "Murals for Use," *Art for the Millions: Essays from the 1930s by Artists and Administrators of the WPA Federal Art Project,* edited by Frances V. O'Connor (Greenwich, Conn.: New York Graphic Society, 1973).

2. Sylvia Moore, *Yesterday and Tomorrow: California Women Artists* (New York: Midmarch Arts Press, 1989).

3. Pete Seeger, quoting Woody Guthrie in the film *Roll on Columbia: Woody Guthrie and the Bonneville Power Administration* (University of Oregon, Knight Library Media Services and School of Journalism and Communication, 2000).

4. In the New York region, for example, artists including Raphael Soyer, Philip Evergood, and John Sloan created important works about the economic hardships of the 1930s.

5. For other perspectives on this topic, see Anthony W. Lee's *Painting on the Left: Diego Rivera, Radical Politics, and San Francisco's Public Murals* (Berkeley: University of California, 1999); Anne Loftis's *Witnesses to the Struggle: Imaging the 1930s California Labor Movement* (Reno: University of Nevada, 1998); and the groundbreaking survey edited by Philip S. Foner and Reinhard Schultz, *The Other America: Art and the Labour Movement in the United States* (London and West Nyack, N.Y.: Journeyman Press, 1985).

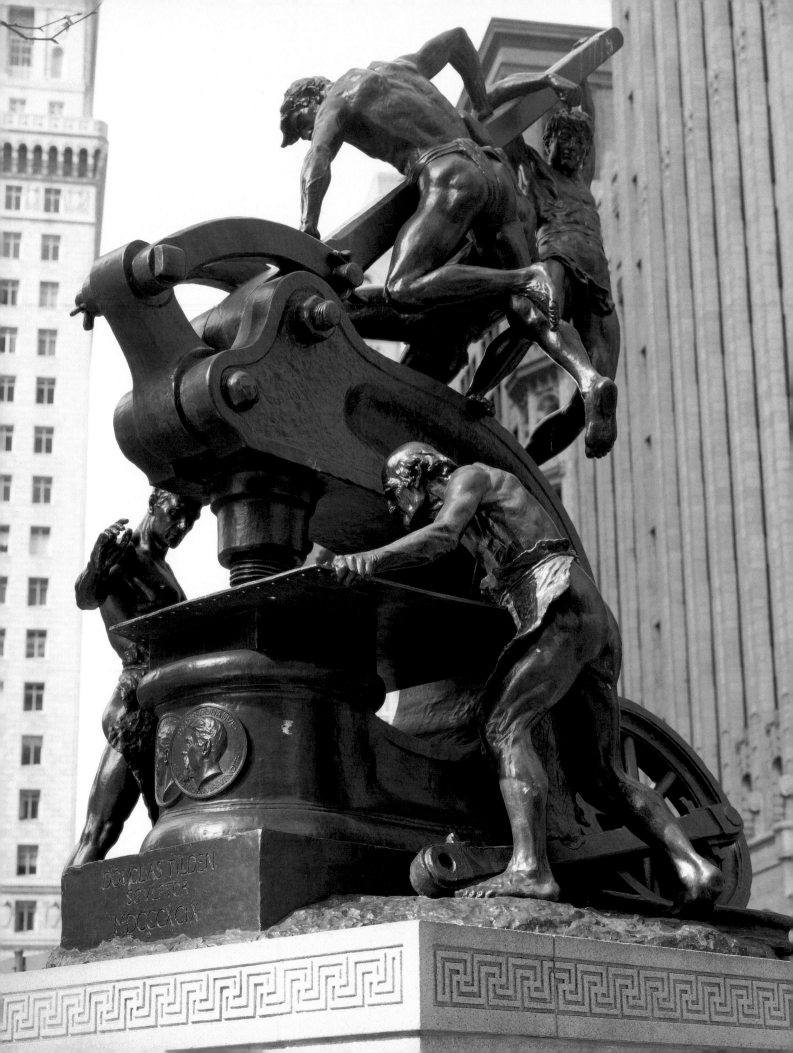

DOUGLAS TILDEN
SCULPTOR
MDCCCXCIX

Romantic Foundations

Joshua Paddison

On May 15, 1901, sculptor Douglas Tilden unveiled his majestic *Mechanics Memorial* before a crowd of ten thousand in downtown San Francisco. Part of Mayor James D. Phelan's attempt to "harmonize" the city by promoting urban beauty, Tilden's monument ostensibly commemorated nineteenth-century industrialist Peter Donahue's contributions to California's ironworks, shipbuilding, and railways. But Tilden, who later referred to his *Memorial* as "the greatest apotheosis to Labor in the world," chose to emphasize not Donahue, who owned the factories, but the skilled workmen who toiled inside them. The sculpture portrays five men operating a colossal punch press. Well-muscled and nearly nude, the men range in age from adolescence to late middle age, symbolizing the stages of a man's working life. The pedestal bears the inscription LABOR OMNIA VINCIT, "labor conquers all." Despite vociferous controversy over the nakedness of its figures (one contemporary headline blared, "Shall the Statuary Be Made to Wear Trousers?"), the *Mechanics Memorial* won acclaim for celebrating California labor and industry in a proudly Greco-Roman tradition.[1]

Douglas Tilden's *Memorial* epitomizes California artists' romantic, gendered portrayals of labor during the Progressive Era. Ralph Stackpole, hired to create twin statues outside the Pacific Stock Exchange in 1928, cast brawny men with proud faces as Industry and a voluptuous woman surrounded by her daughters as Agriculture. Inside the Stock Exchange, two years later, visiting muralist Diego Rivera painted his *Allegory of California,* dominated by a fleshy, doe-eyed earth goddess. These and other stylized works could not be further removed from the day-to-day experiences of working Californians. In their way, they were as fantastical as the lush and uninhabited landscape paintings prodigiously commissioned by California railroad companies, tourist hotels, private collectors, and magazines such as *Out West* and *Sunset* during this period. Masterful in technique and stirring in theme, early California labor art presented an idealized, symbolic vision of work focused upon the strength of workers' bodies.

These romanticized visual depictions of workers were paralleled by literary portrayals. In Oakland-born Jack London's 1909 short story "South of the Slot," nebbish Berkeley sociologist Freddie Drummonds adopts the persona of Big Bill Totts, a hypermasculine labor leader, to research working class life in San Francisco:

Plate 9. Douglas Tilden,
Mechanics Memorial,
1901, cast bronze, San Francisco

When he emerged in Bill Totts' clothes he was another creature. Bill Totts did not slouch, but somehow his whole form limbered up and became graceful. The very sound of the voice was changed, and the laugh was loud and hearty, while loose speech and an occasional oath were as a matter of course on his lips.

By the story's end, Drummonds has disappeared entirely into the personality of Totts, whose easygoing vulgarity and unbridled sexuality offer an escape from the constraints of the white collar world. Oakland poet Edwin Markham's "The Man with the Hoe," first published in the *San Francisco Examiner* in 1899 and reprinted in hundreds of newspapers, portrayed the working man as a noble savage. "Stolid and stunned, a brother to the ox," Markham's laborer bears "on his back the burden of the world." San Francisco writer Frank Norris's 1896 vignette "The Brute" offers a similarly hulking drudge who, upon encountering the beauty of a flower, can respond only by eating it. These writers' heavy-handed political messages, while intended to be pro-labor, reinforced prevailing negative views of the working class. In these depictions, work has strengthened laborers' bodies but stultified their minds.[3]

The Brute

He had been working, all day in a squalid neighbourhood by the gas works and coal yards, surrounded by lifting cranes, pile drivers, dredging machines, engines of colossal strength, where all about him were immense blocks of granite, tons of pig iron; everything had been enormous, crude, had been huge in weight, tremendous in power, gigantic in size.

By long association with such things he had become like them, huge hard, brutal, strung with a crude blind strength, stupid, unreasoning. He was on his way home now, his immense hands dangling half open at his sides; his head empty of thought. He only desired to be fed and to sleep. At a street crossing he picked up a white violet, very fresh, not yet trampled into the mud. It was a beautiful thing, redolent with the scent of the woods, suggestive of everything pretty and delicate. It was almost like a smile-made flower. It lay very light in the hollow of his immense calloused palm. In some strange way it appealed to him, and blindly he tried to acknowledge his appreciation. He looked at it stupidly, perplexed, not knowing what to do; then instinctively his hand carried it to his mouth; he ground it between his huge teeth and slowly ate it. It was the only way he knew. *Frank Norris*

The actual experiences of millions of laborers in California during the Progressive Era were harsh and embittered, a far cry from these semi-respectful representations. The state's economic growth was fueled by the emergence for the first time of a large-scale, wage-earning working class. Wages varied according to skill, industry, gender, and race. White, skilled, male workers earned the most and protected their wages by banding together in craft unions typically affiliated with the American Federation of Labor (AFL), founded in 1886. But the AFL excluded industrial and agricultural laborers, many of them women and workers of color. (The Industrial Workers of the World, IWW, began organizing in these areas after 1905.) Because few laws governed labor relations, employers could impose oppressive working conditions, encouraging anarchic and often destructive responses from frustrated workers.

Despising labor strife, Progressive reformers in California attempted to enact minimum protections, especially for women and children. In 1911, California became the first state to adopt an eight-hour workday for women; the legislature passed a minimum wage for women and children two years later. But the vast majority of workers were adult men who usually had only one weapon—the strike—to improve their lot.

Labor relations played out differently in each of the state's three major regions—Southern California, Northern California, and the Central Valley—shaped by the aftermaths of three violent turning points: two bombings and a "riot."

In the predawn hours of October 1, 1910, a suitcase of dynamite exploded in an alley alongside the *Los Angeles Times* building, causing the first and second floors to collapse into the basement, killing twenty employees. The devastation interrupted a bitter, four-month-old strike by metal trades unions determined to win an eight-hour workday. The strike had been repeatedly denounced by the *Times* and its powerful publisher, Harry Chandler Otis, who had battled union activity in Los Angeles since the 1880s with a passion that verged on obsession. He condemned organized labor in the pages of his newspaper and led an employers' association devoted to stamping it out. Thanks in large part to Otis's efforts, Los Angeles had by 1910 gained a reputation as an open shop town, hostile to unions. As a result, wages in Los Angeles were 20 to 40 percent less than in San Francisco, but Southern California's burgeoning citrus industry, temperate climate, and Edenic reputation continued to attract a steady flow of immigrants. In fact, the 1920 census would reveal that Los Angeles had surpassed San Francisco as the largest city in the West.[4]

Convinced that strikers were responsible for the explosion, Otis seized upon it as a means to discredit organized labor and protect the open shop. "Unionist Bombs Wreck the *Times*," proclaimed his October 1 edition. A private detective hired by the mayor's office indeed traced the crime to two unionists, John J. McNamara, secretary-treasurer of the International Association of Bridge and Structural Iron Workers, and his brother James B. McNamara. The AFL and its president, Samuel Gompers, sprung to the brothers' defense. Staking their reputations on the brothers' innocence, Gompers and labor leaders throughout the country insisted that the brothers had been framed by Otis's agents. The *Times* countered with its usual vitriol, dubbing them "Unionite murderers" who had perpetrated "The Crime of the Century." Observers sympathetic to the prosecution pointed out that John McNamara's Iron Workers had dynamited (with no fatalities) some eighty-seven structures built by nonunion labor between 1906 and 1910.[5]

After proclaiming their innocence for months, the McNamara brothers shocked progressives around the country on December 1, 1911, when they confessed to the bombing in order to avoid the death penalty. A heartbroken Gompers then had to endure a lengthy investigation by the U.S. Department of Justice as to the AFL's involvement in the crime. Organized labor in Los Angeles was especially embarrassed and demoralized. With public sentiment safely on their side, employers redoubled their efforts to obliterate unions. Los Angeles would remain an open shop town for another thirty years.

The McNamara debacle was still vivid in the minds of Californians six years later when another bombing—this one in downtown San Francisco—was linked to unionists. San Francisco boasted a tradition of labor radicalism that dated back to fights for an eight-hour

workday in the 1860s and the anti-capitalist (and anti-Chinese) agitation of the Working-men's Party in the late 1870s. Organized labor in San Francisco had enjoyed considerable power since 1901, when striking teamsters, sailors, and longshoremen had shut down the waterfront for nine weeks. Police brutality against the strikers had raised public indignation and helped spawn the Union Labor Party, which went on to win several city elections. The city's laborers had received further wage increases and improved working conditions during the rush to rebuild following the earthquake and fire of 1906.[6]

In the months prior to the bombing, San Francisco had swirled with controversy. The closing of the Panama Pacific International Exposition in December 1915 had ended a period of cooperation between employers and workers. In June and July 1916, longshoremen struck twice for higher wages. The Chamber of Commerce responded by forming a Law and Order Committee to break the waterfront strikes and to challenge San Francisco's reputation as a stronghold of unionism. Disputes over U.S. involvement in the Great War in Europe, which had begun in August 1914, intensified the labor conflict. Most San Francisco business leaders supported U.S. entry into the war, a position known as Preparedness. Following the lead of the national AFL, most union members opposed U.S. intervention. When local businessmen announced a giant Preparedness Day parade to be held on July 22, unionists declared a boycott and joined with pacifists and socialists to stage a demonstration of their own two days earlier.[7]

A little after two o'clock in the afternoon on July 22, with the Preparedness parade underway, a bomb exploded on the corner of Market and Steuart Streets, killing ten people. San Francisco anarchist Alexander Berkman, publisher of the unfortunately titled *Blast* magazine, was lunching with Emma Goldman when he heard the news. "I hope they aren't going to hold the anarchists responsible for it," Goldman cried out. "How could they not?" Berkman replied; "they always have." In fact, the police—without evidence or warrants—quickly arrested five suspects, all radical unionists. Iron molder and labor agitator Thomas J. Mooney and his friend Warren K. Billings were convicted in hasty trials. Before the third defendant's trial, however, clues surfaced indicating that the district attorney had encouraged perjury to secure the convictions. The remaining three suspects went free, but Mooney and Billings went to prison.[8]

Over the next two decades, Tom Mooney became famous, despite being confined to San Quentin prison. Unionists, leftists, and intellectuals around the world called for his emancipation. The McNamara case had disillusioned and diminished organized labor in Los Angeles, but the "Free Tom Mooney" movement gave San Francisco unionists a martyr, a symbol, and a rallying cry that would aid them in future conflicts. The movement culminated in 1939 when Democratic Governor Culbert Olson fulfilled a campaign promise by freeing both prisoners.[9]

The names McNamara, Mooney, and Billings meant little to workers in California's

third region—the great agricultural landscapes of the Sacramento, San Joaquin, Imperial, and other valleys. Agriculture in California was not based upon year-round family farms, as it was in the Midwest, but upon large-scale seasonal farms that demanded a steady supply of cheap, migratory labor. A succession of nonwhite groups had been providing this labor, beginning with Native Americans and Chinese in the nineteenth century and continuing through Japanese, Hindustanis, Filipinos, and Mexicans in the early twentieth. Excluded from the AFL due to their race and "unskilled" status, agricultural workers were unorganized and exploited, lacking union representation and even the right to vote. They commonly worked sixteen-hour days in the blazing sun for extremely low wages while living in execrable temporary camps. In the estimation of historian Cletus Daniel, migratory farm workers possessed "the most disadvantaged and degraded occupational status in California."[10]

Agricultural workers occasionally did manage to band together long enough to win temporary pay raises or to attract a measure of attention to their plight. In 1903, in Oxnard, on the coast north of Los Angeles, fifteen hundred Japanese and Mexican sugar beet harvesters staged California's first recorded agricultural strike. It lasted two months and won the workers a pay hike, but the new union dissolved after the AFL refused to grant it a charter.[11]

The most important incident occurred on August 3, 1913, near Wheatland, in the Sacramento Valley. Needing fifteen hundred pickers for his hop harvest, grower Ralph Durst had lured twenty-eight hundred workers to his ranch in the hopes of keeping competition high and wages low. Feeling betrayed by Durst and facing intolerable conditions in his work camp, a group of pickers supported by IWW activists threatened to strike. Dubbed "Wobblies" by Otis's *Los Angeles Times*, members of the IWW were making the first serious attempt to organize California farm workers, part of their bid to form "one big union" from the world's working classes. A fight broke out between the Wheatland workers and a posse of Yuba County deputies, and four men—a district attorney, a deputy sheriff, and two pickers—were killed. The Wheatland hop riot, as the incident became known, sparked an investigation by the state Commission of Immigration and Housing, which determined that the true causes of the bloodshed were the camp's

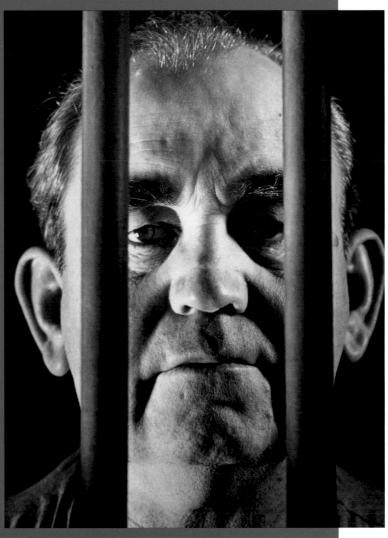

Plate 10. Otto Hagel, *Tom Mooney*, 1936, gelatin silver print, 14" x 11"

inadequate housing and unsanitary conditions. Progressive reformers led by Carleton H. Parker attempted to ensure a minimum standard of hygiene in agricultural labor camps, but their short-lived efforts never addressed or alleviated the powerlessness of the workers themselves.[12]

The Wheatland hop riot of 1913 triggered a backlash against the IWW that intensified in the 1920s, a difficult decade for leftists, socialists, and unionists across the state and nation. U.S. Attorney General A. Mitchell Palmer ordered raids on "subversives" in seventy cities in 1920, part of an anti-radical campaign carried out at the federal and state level. California and thirty-one other states passed criminal syndicalism acts making it a felony to belong to any organization that promoted violence as a means of effecting political change. Transparently aimed at the IWW, California's Criminal Syndicalism Act facilitated the harassment and imprisonment of hundreds of Wobblies from Eureka to San Diego.

Despite the general prosperity and high employment of the 1920s, organized labor suffered major setbacks. Labor activists were discouraged not only by the conservative political climate but by employers' adoption of efficient but dehumanizing "scientific management" techniques and "yellow dog" contracts forbidding union membership. In California, the Better America Federation in Los Angeles and the Industrial Association in San Francisco led successful drives to brand organized labor as unpatriotic and dangerous. Union membership plummeted and would remain anemic until the changes wrought by the economic straits of the 1930s.[13]

These three violent incidents—two acts of terrorism and a riot—cast long shadows over the labor history of California in the Progressive Era. All three had far-reaching repercussions, affecting the lives of working people in California as well as the course of national labor campaigns. The desperation that triggered these events was shared by thousands of ordinary Californians in cities, towns, and labor camps who struggled for security and—in the case of many farm workers—survival. This fundamental, often brutal struggle between labor and capital in California is belied by artists' romantic depictions of workers during this period. But Tilden, Stackpole, Rivera, and others provided a beginning, an acknowledgment of the centrality of work in Californians' lives that would blossom into the great labor art movement of the 1930s.

notes

1. Mildred Albronda, *Douglas Tilden: The Man and His Legacy* (Seattle: Emerald Point Press, 1994).
2. Claire Perry, *Pacific Arcadia: Images of California, 1600–1915* (New York: Oxford University Press, 1999).
3. Jack London, "South of the Slot," *Saturday Evening Post* 181 (May 1909), reprinted in Jack London, *The Strength of the Strong* (New York: Macmillan, 1914); Edwin Markham, "The Man with the Hoe,"

San Francisco Examiner, 15 January 1899, reprinted in Edwin Markham, *The Man with the Hoe and Other Poems* (New York: Doubleday & McClure Company, 1899); Frank Norris, "The Brute,"originally published in *The Wave,* 13 March 1899, later in Norris's *Collected Writings* (New York: Doubleday, Doran & Co., Inc., 1928).

4. David F. Selvin, *Sky Full of Storm: A Brief History of California Labor* (Berkeley: Institute of Industrial Relations, University of California, 1966), 27-31; James J. Rawls and Walton Bean, *California: An Interpretive History,* 7th ed. (New York: McGraw Hill, 1998), 240-43; Robert Gottlieb and Irene Wolt, *Thinking Big: The Story of the Los Angeles Times, Its Publishers, and Their Influence on Southern California* (New York: Putnam, 1977).

5. Selvin, *Sky Full of Storm,* 27; Justin Kaplan, *Lincoln Steffens: A Biography* (New York: Simon & Schuster, 1974), 186-87; Herbert Shapiro, "The McNamara Case: A Window on Class Antagonism in the Progressive Era," *Southern California Quarterly* 70 (1988), 64-95; Philip S. Foner, "*A Martyr to His Cause:* The Scenario of the First Labor Film in the United States," *Labor History* 24 (1983), 103-11; Priscilla Murolo and A. B. Chitty, *From the Folks Who Brought You the Weekend: A Short, Illustrated History of Labor in the United States* (New York: The New Press, 2001), 145-50.

6. Selvin, *Sky Full of Storm,* 7-26; William Issel and Robert W. Cherny, *San Francisco, 1865–1932: Politics, Power, and Urban Development* (Berkeley: University of California Press, 1986), 80-94; Kevin Starr, *Endangered Dreams: The Great Depression in California* (New York: Oxford University Press, 1996), 3-27.

7. Selvin, *Sky Full of Storm,* 37; Issel and Cherny, *San Francisco,* 177-78; Murolo and Chitty, *From the Folks Who Brought You the Weekend,* 161.

8. Emma Goldman, *Living My Life* (New York: New American Library, 1977), 577; Curt Gentry, *Frame-Up: The Incredible Case of Tom Mooney and Warren Billings* (New York: W. W. Norton, 1967).

9. Starr, *Endangered Dreams,* 216-20.

10. Cletus E. Daniel, *Bitter Harvest: A History of California Farmworkers, 1870–1941* (Ithaca: Cornell University Press, 1981), 71.

11. Kevin Starr, *Inventing the Dream: California Through the Progressive Era* (New York: Oxford University Press, 1985), 172-75; Tomás Almaguer, "Racial Domination and Class Conflict in Capitalist Agriculture: The Oxnard Sugar Beet Workers' Strike of 1903," in Daniel Cornford, ed., *Working People of California* (Berkeley: University of California Press, 1995), 183-207.

12. Starr, *Endangered Dreams,* 28-48, 61-63; Daniel, *Bitter Harvest,* 88-99; Rawls and Bean, *California,* 243-47.

13. Starr, *Endangered Dreams,* 48-57; Murolo and Chitty, *From the Folks Who Brought You the Weekend,* 167-86; Issel and Cherny, *San Francisco,* 95-99; Rawls and Bean, *California,* 281-83.

ONE OF SAN FRANCISCO'S greatest works of public sculpture, Tilden's *Mechanics Memorial* reflects the pervasive influence of French realism at the turn of the twentieth century. Tilden himself was able to study in Paris through the California School for the Deaf, where most of his education took place. (He had become deaf at age four after contracting scarlet fever.) Since his boyhood, Tilden had felt that his ideal life was that of a mechanic, and he worked in this trade later in life, when his style of art had fallen out of favor. His romantic model of muscled male figures survived the 1906 earthquake and fire, and standing alone in a wasteland of destruction, it became a symbol of hope and endurance during the subsequent rebuilding of the city.

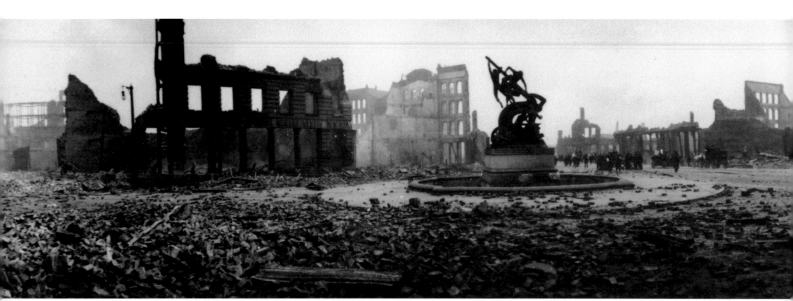

THE FRONT PAGE of the 1927 *Labor Clarion,* the official journal of the San Francisco Labor Council, is another example of French influence on California art. The illustration appears to recycle Perham Nahl's famous poster for the 1915 Panama Pacific International Exposition. Nahl's image, a giant who opens a fissure in the earth with his brute strength, was itself based on a sculpture that the French government had presented to San Francisco in conjunction with the 1894 California Midwinter Exposition: a bronze figure operating a wine press. The popularity of the image persisted into the next decade; here it was used, as the text below it explains, to represent the "irresistible" nature of labor.

In the editorial to this Labor Day issue, J. B. Dale summarized the status of the labor movement: "As Labor Day of 1927 peeps over the hilltops, labor—organized labor, as that is the only kind of labor which counts—has much to be thankful for. Especially is it thankful for opposition, with which it is always confronted, as it was opposition that brought forth the labor movement, which has resulted in the eight-hour workday and the Saturday half-holiday, better wages, better conditions, the Union label, humane legislation in behalf of children and women, and universal recognition of the right of labor to bargain collectively."

ABOVE: Plate 11. Anonymous photographer, *Douglas Tilden Mechanics Memorial after 1906 Earthquake,* photograph

OPPOSITE: Plate 12. Anonymous artist (after Perham Nahl), *Labor Clarion,* Labor Day 1927, cover illustration, 13½" x 10¼"

LABOR CLARION
Issued every Friday

LABOR CLARION
Issued every Friday

Labor Day

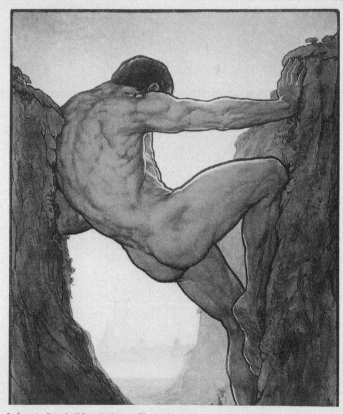

Labor is Irresistible. It Bores Through, Splits and Moves Mountains, Promotes Civilization and Demands Justice for the Humblest of Humankind. It Protects the Weak, Administers to the Afflicted and Strives Always for the Brotherhood of Man With an Energy That Never Tires. In the End Its Policies Will Prevail.

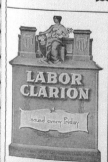

LABOR CLARION
Issued every Friday

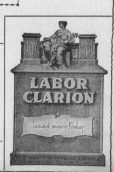

LABOR CLARION
Issued every Friday

1927

These two illustrations are examples of popular graphic art from the early decades of the twentieth century in California. Henry Kiyama's *manga* chronicles the plight of Japanese-born artists who came to San Francisco to study art and found their employment opportunities limited to being houseboys and migrant workers. Kiyama experienced much of this firsthand, and his insights are both funny and horrific. The page that is reproduced here documents the 1922 "Turlock Incident," in which Japanese pumpkin harvest workers were rounded up at gunpoint and shipped out of town. It provides an insider's perspective on the racist treatment that nonwhite agricultural workers encountered in California.

Kiyama himself sailed to San Francisco to study art in 1904 and became part of a community of Japanese student workers and other immigrants. He attended the California School of Fine Arts and eventually opened his own studio in Japantown. Intending to visit Japan temporarily in 1937, Kiyama could not return to San Francisco once war broke out with the United States.

Plate 13. Henry Yoshitaka Kiyama, "Turlock Incident, 1922," from *The Four Immigrants Manga*, 1931, illustrated book

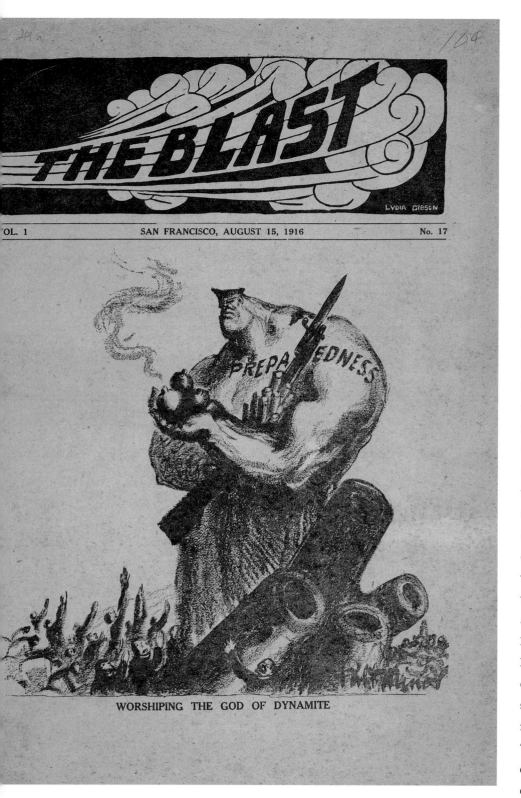

WORSHIPING THE GOD OF DYNAMITE

THE COVER ILLUSTRATION for the August 15, 1916, issue of *The Blast,* published as the United States prepared to enter World War I, features a giant god of dynamite, with huge biceps and neck, sporting a military cap atop his tiny head. Clutching a bomb with lit fuse and a rifle with bayonet, this square-jawed ogre stands alongside raised cannon barrels, attracting the adulation of a crowd of sycophants who reach up with worshipping hands. The giant resembles the subject of Goya's famous 1810 painting *The Colossus,* another war god who straddles the death and destruction wreaked throughout the countryside. This open criticism of U.S. war efforts was published only three weeks after the July 22 San Francisco Preparedness Parade bombing in which ten people were killed, and despite the word "preparedness" emblazoned on the giant's chest, some construed it as a pro-terrorist image. An editorial inside placed the blame for the bombing on "the advocates of militarism" and their "murder psychology." In the aftermath of its publication, both the editor, Alexander Berkman, and his life partner—renowned anarchist intellectual Emma Goldman—fled San Francisco. Labor activists Tom Mooney and Warren Billings were arrested for the bombing and imprisoned for twenty years before their pardon.

11

Plate 14. Lydia Gibson and Robert Minor, *The Blast* (August 15, 1916), cover illustration, 12¾" x 9¾"

IMAGES OF THE WATERFRONT like Consuelo Kanaga's *Nets* and Armin Hansen's *Nino* evidence the way in which ocean fishermen captured the romantic imaginations of artists during the first decades of the twentieth century. This early photograph by Kanaga dates from the period when she worked as a photojournalist for the *San Francisco Chronicle;* her tenure there began in 1915, when she was twenty-one. She later became an important supporter and influential friend of both Tina Modotti and Dorothea Lange. Like Lange, she is known for her portraits of the poor and her involvement with the highly influential Group f/64, which advocated and produced straightforward, sharply focused photography. Like Modotti, Kanaga was committed to progressive politics, and her photographs were sometimes featured in radical publications, including the *Daily Worker* and *New Masses*.

This photograph shows nets at San Francisco's Fisherman's Wharf being set out to dry. One man handles the densely laid nets, while a group of well-dressed individuals carry on a conversation behind him, seemingly oblivious to the worker. Kanaga's photograph is marked by clarity of focus, as well as extremes of light and darkness. In this portrait of labor, the contrasts are as much a function of content as aesthetics.

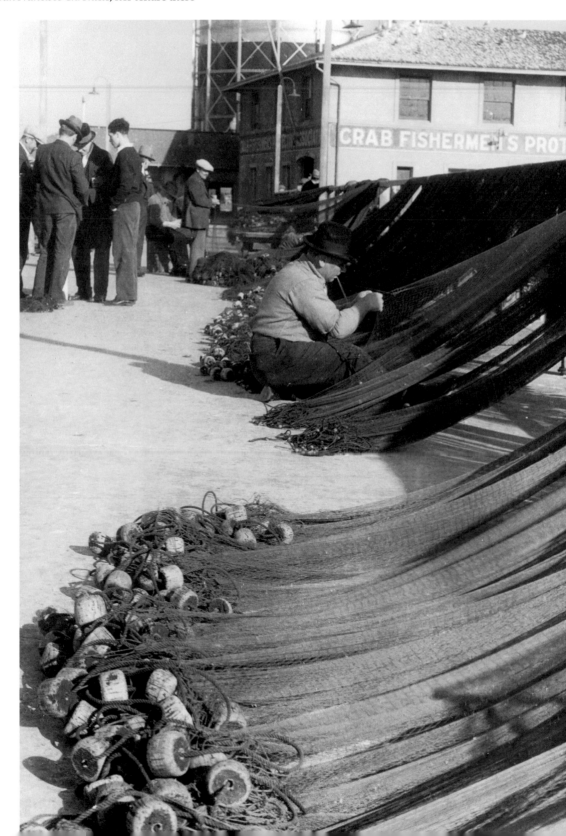

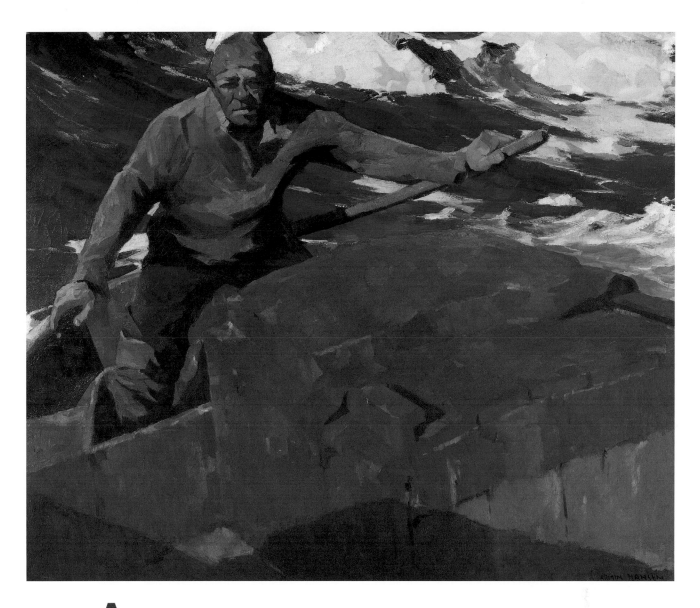

ARMIN HANSEN'S PORTRAITS of the community of Portuguese and Italian fishermen along Monterey's Cannery Row are among the most widely appreciated paintings from this region's famous artist colony. Born in San Francisco, Hansen traveled to Europe in his twenties and worked on a Norwegian trawler, gaining firsthand experience that informed his subsequent painting. He returned to California and moved to Monterey in 1913. One of California's most successful artists in the 1920s, Hansen won recognition in New York for works of this period from the National Academy of Design.

This painting combines impressionist paint handling with gritty subject matter. The sardine fisherman's expression of determination, his solidly planted stance, firm grip on the tiller, and the high surf in the background indicate that he is navigating heavy winds and seas. Hansen has selected an angle that brings the viewer right on board the boat to experience the thrill of this moment firsthand. The artist is quoted as having said, "Every move I have made and everything that I have done has always been to go back to the water and to the men who gave it romance. I love them all."

OPPOSITE: Plate 15. Consuelo Kanaga, *Untitled (Nets)*, ca. late 1910s, gelatin silver print, 7" x 5"
ABOVE: Plate 16. Armin Hansen, *Nino*, ca. 1922, oil on canvas, 50½" x 60³⁄₈"

The Purse-Seine

Our sardine fishermen work at night in the dark of the moon; daylight or moonlight

They could not tell where to spread the net, unable to see the phosphorescence of the shoals of fish.

They work northward from Monterey, coasting Santa Cruz; off New York's Point or off Pigeon Point

The look-out man will see some lakes of milk-color light on the sea's night-purple; he points, and the
 helmsman

Turns the dark prow, the motor-boat circles the gleaming shoal and drifts out her seine-net. They
 close the circle

And purse the bottom of the net, then with great labor haul it in.

 I cannot tell you

How beautiful the scene is, and a little terrible, then, when the crowded fish

Know they are caught, and wildly beat from one wall to the other of their closing destiny the
 phosphorescent

Water to a pool of flame, each beautiful slender body sheeted with flame, like a life rocket

A comet's tail wake of clear yellow flame; while outside the narrowing

Floats and cordage of the net great sea-lions come up to watch, sighing in the dark; the vast
 walls of night

Stand erect to the stars.

 Lately I was looking from a night mountain-top

On a wide city, the colored splendor, galaxies of light; how could I help but recall the seine-net

Gathering the luminous fish? I cannot tell you how beautiful the city appeared, and a little terrible.

I thought, We have geared the machines and locked all together into interdependence; we have
 built the great cities; now

There is no escape. We have gathered vast populations incapable of free survival, insulated

From the strong earth, each person in himself helpless, on all dependent. The circle is closed,
 and the net

Is being hauled in. They hardly feel the cords drawing, yet they shine already. The inevitable
 mass-disasters

Will not come in our time nor in our children's, but we and our children

Must watch the net draw narrower, government take all powers—or revolution, and the new
 government

Take more than all, add to kept bodies kept souls—or anarchy, the mass disasters.

 These things are Progress;

Do you marvel our verse in troubled or frowning, while it keeps its reason? Or lets go, lets the
 mood flow

In the manner of the recent young men into mere hysteria, splintered gleams, cracked laughter.
 But they are quite wrong.

There is no reason for amazement: surely one always knew that cultures decay, and life's end
 is death.

Robinson Jeffers

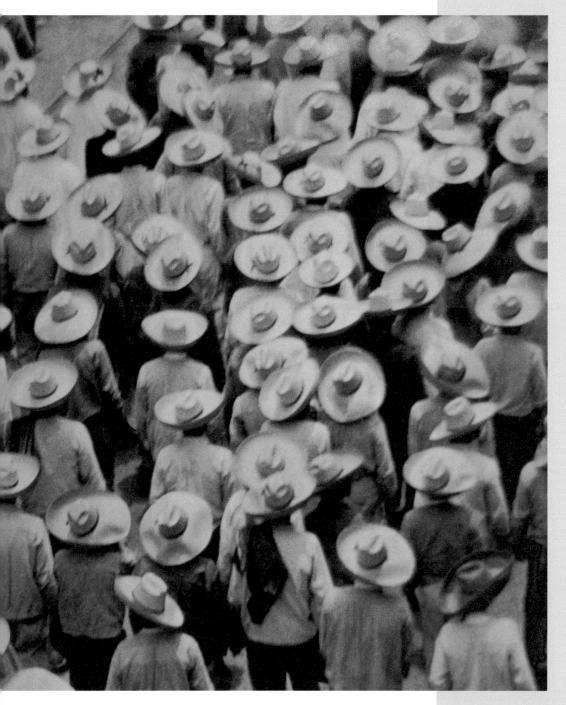

T ina Modotti's beautiful photographs were often loaded with political implications. Her *Campesinos (Workers Parade)* was photographed on May Day, 1926, from her friend Pablo O'Higgins's rooftop in Mexico City. The photograph appeared later that summer in the bilingual magazine *Mexican Folkways,* published in Mexico by a friend of Modotti's from Berkeley, Francis Toor. Displaying Modotti's abstract formalism while celebrating the spirit of workers in Mexico, the photograph has become one of her most famous images.

Italian-born Tina Modotti came to San Francisco in 1913 as a girl and later described the city as her hometown, even though her aesthetics and politics drew her to make photographs in Mexico. Friend to Diego Rivera and Frida Kahlo, Modotti was exemplary of the cultural exchange between Mexico and California that engaged so many artists during the 1920s.

Plate 17. Tina Modotti, *Campesinos (Workers Parade),* 1926, gelatin silver print, 8³/₈" x 7³/₈"

DIEGO RIVERA'S MASTERPIECE *The Tortilla Maker* depicts two women, likely mother and daughter, with their simple stove and stone for grinding corn. The central figure makes the tortillas while the younger waits behind her with a basket on her lap to keep the tortillas warm, possibly before going out to sell them. The deep earth tones and neoclassical yet stocky forms are characteristic of Rivera's celebration of indigenous people and culture in his art.

Rivera made several visits to California and left behind an important body of mural work. The complexity of Rivera's compositions, his style of rendering, and his attachment to common people all made a powerful impression on California artists. Active in all levels of Mexican society and politics, Rivera often turned to the subject of labor in his work and was himself a founding member of the Revolutionary Union of Technical Workers, Painters, and Sculptors in Mexico. This painting now hangs in the lobby of San Francisco General Hospital, a gift of Dr. Leo Eloesser, trusted friend and physician of Rivera and Kahlo.

Plate 18. Diego Rivera, *La Tortillera (The Tortilla Maker)*,
1926, oil on canvas, 43" x 36"

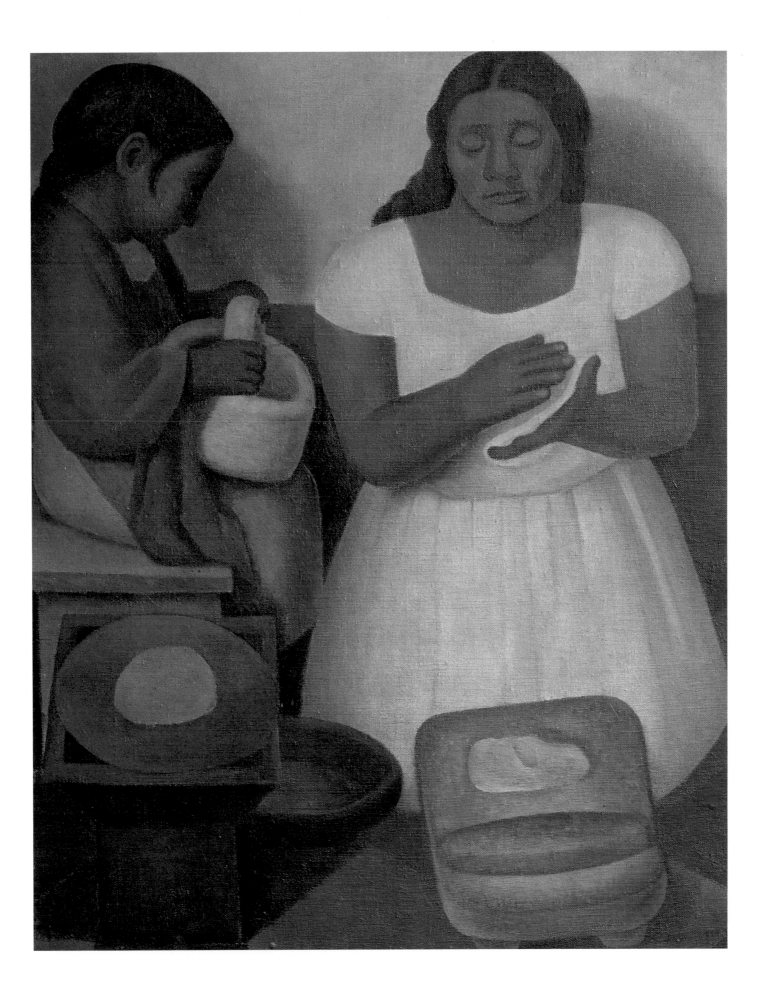

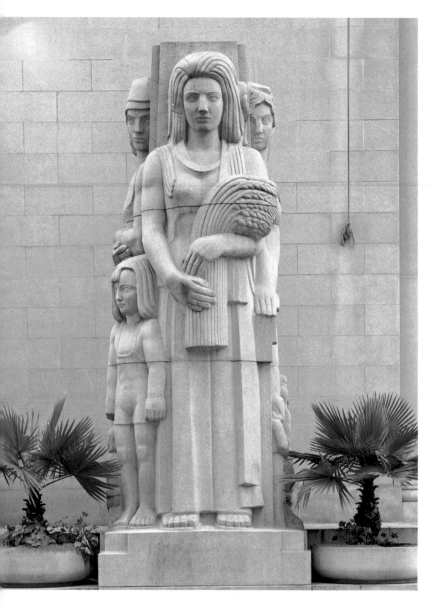

RIGHT: Plate 19. Diego Rivera, *Allegory of California*,
1931, fresco, Pacific Stock Exchange Luncheon Club, San Francisco
ABOVE: Plate 20. Ralph Stackpole, *Bountiful Earth*,
1929–1932, granite, Pacific Stock Exchange, San Francisco

THESE POWERFUL WORKS reflect the
artistic dialogue between Diego Rivera and California artists.
Ralph Stackpole had worked with Rivera in Mexico during
the 1920s and subsequently played a critical role in the invi-
tation that brought Rivera to San Francisco in 1930. Repre-
senting California's labor force, with agriculture on one side
(pictured here) and industry on the other, Stackpole's two
monumental carvings frame the grand stairs of the Pacific
Stock Exchange, on Pine Street in San Francisco. These
totemic monuments to labor recall Rivera's neoclassical fig-
ures, and in fact Rivera gave a nod to Stackpole's pillars the
next year in the Pacific Stock Exchange Luncheon Club mural,
Allegory of California. This brilliant fresco not only recycled
Stackpole's iconographic polarity of agriculture and industry
(here again, a female giant holds the bounty of the state in
her arms) but it also features a portrait of Stackpole's adoles-
cent son Peter near its heart.

Stackpole moved to San Francisco from Oregon after the
turn of the century and established a reputation as one of the
most important sculptors in Northern California. He worked
as a teacher at both the California School of Fine Arts and the
California Labor School. A friend to many artists, he appears
in five Coit Tower murals.

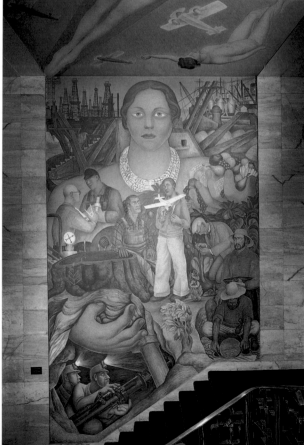

JAPANESE

AMERICAN **ARTIST** Mine Okubo painted with Diego Rivera at the Golden Gate International Exposition on Treasure Island in 1940, demonstrating fresco techniques while Rivera executed his *Pan-American Unity* mural. Like Ralph Stackpole's sculptures, Okubo's *Men Working* shows the influence of Rivera, in the rounded figurative forms and in the focus on work. The portrayal of men laying heavy pipe into a trough conveys both physical strength and personal dignity.

Okubo's best-known work in this style was created when she was interned at Topaz, Utah, during World War II. She was one of the most influential teachers at the art school there, and her illustrations for the camp magazine, *Trek,* ultimately brought her work to the attention of New York magazine publishers who arranged for her early release. Okubo returned to the Bay Area in the early 1950s to teach at the University of California but found her figurative focus out of step with the prevailing abstract expressionist emphasis of that period. She subsequently decided to live out the remainder of her life in New York City.

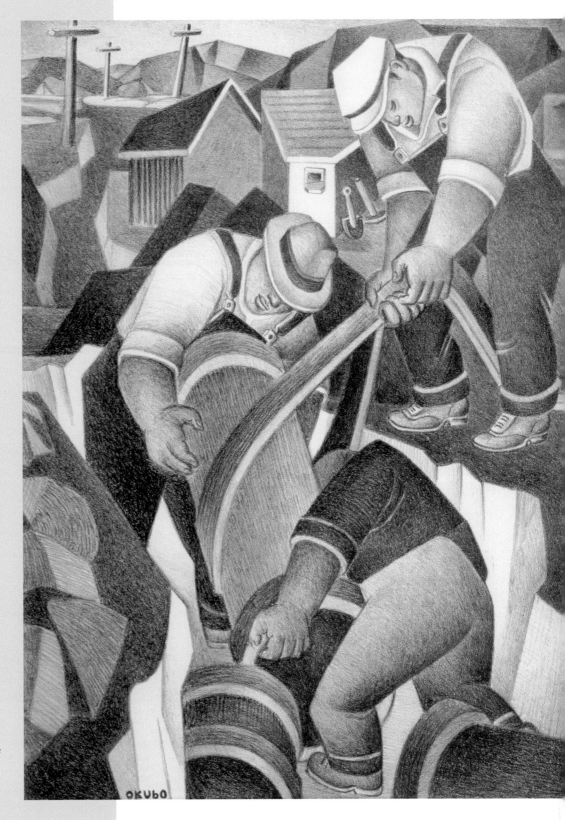

Plate 21. Mine Okubo, *Men Working (The Pipe Layers),* ca. 1939, lithograph, 16" x 11½"

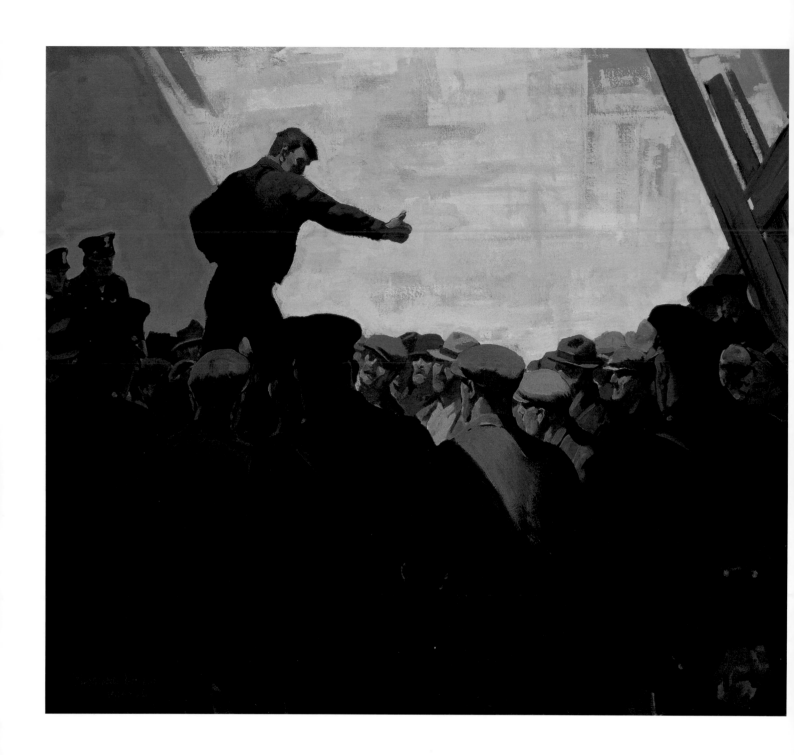

Plate 22. Maynard Dixon, *Free Speech*,
1934–36, oil on canvas, 40" x 48"

The Great California Labor Art Movement

Joshua Paddison

Labor activism and artistic expression intertwined in California during the 1930s as a generation of photographers, painters, and printmakers rejected romanticism for social realism. Surrounded by homelessness, unemployment, and unprecedented levels of labor strife, artists strove to chronicle the experiences of ordinary men and women whose lives —in the words of Dorothea Lange—had begun to "crumble on the edges." California painter Ray Strong explained that the decade's turbulent labor conflicts demanded a response: "Any artist worth his salt or mental equipment became a recorder or an interpreter." The resulting works were impassioned and politically charged, imbued with the artists' outrage or hope. The movement dominated California art into the 1940s and produced some of the state's most enduring and powerful images.[1]

The stock market crash of October 1929 signaled the onset of a depression shocking in its depth and longevity. The impotence of organized labor during the 1920s had exacerbated the nation's unbalanced economy by allowing wages to lag behind production, creating an unequal distribution of income and fueling underconsumption. Between 1929 and 1933, the gross national product plummeted 29 percent while unemployment soared to a third of the labor force. Immigrant and minority workers suffered the most, as they were typically the last hired and first fired; Mexican Americans and Filipino Americans additionally faced xenophobia and the threat of deportation.

California benefited from its film and defense industries, which were not hit as hard as other enterprises, but nonetheless about a fifth of the state's workers were dependent on public relief by 1934. As unemployment mounted, the state and federal governments put hundreds of thousands of Californians to work in a spate of public projects, most visibly the completion of the Hetch Hetchy Aqueduct and the Colorado River Project and the construction of the San Francisco Bay Bridge and the Golden Gate Bridge. These massive projects emerged as testaments to the grit and resilience of California workers.[2]

The 1930s saw a revitalization of organized labor throughout the United States as hard times galvanized workers' militancy. Grassroots strikes by food employees and coal miners, autoworkers and textile workers found community support and won impressive victories. Union membership swelled, invigorated by Section 7(a) of President Roosevelt's National

Industrial Recovery Act of 1933, which affirmed workers' right to bargain collectively, "free from the interference, restraint or coercion of employers." Roosevelt followed Section 7(a)—which lacked enforcement power—with the Wagner Act in 1935, which actively promoted collective bargaining, eviscerated employer-controlled "company unions," and created a permanent National Labor Relations Board to compel obedience. This unprecedented and never-to-be-repeated governmental support for organized labor especially heartened unionists in mass production industries (mining, oil, textiles, garment work, steelwork), who continued to feel ignored by the more traditional AFL. In November 1935, several of these industrial unions—led by John L. Lewis, president of the enormous United Mine Workers—formed the Committee for Industrial Organization (CIO), later renamed the Congress of Industrial Organizations. By embracing industrial workers, African Americans, Latinos, and immigrants, the CIO quickly rivaled the AFL. Successful grass-roots organizing, support from the federal government, and greater union democracy together helped American workers persevere through the depths of the Depression.[3]

Strike after strike erupted in California's fields, factories, and docks. When the Depression cut farm workers' already meager wages in half, they responded with an aggressive series of more than one hundred and fifty work stoppages—half of all agricultural strikes in the nation. In the early 1930s, the Cannery and Agricultural Workers Industrial Union (CAWIU) provided leadership, led by Mexican American activists and Anglo communists. Before its demise in 1935, the CAWIU led twenty-four strikes, losing only three. The most active year was 1933, when fifty thousand agricultural workers across the state went out on strike—pea pickers in the Bay Area, lettuce workers in the Salinas and Pajaro Valleys, cherry pickers in the northern Santa Clara Valley, cotton workers throughout the Central Valley. The surprising successes of the CAWIU garnered a swift response from agribusiness and utility companies, which not only employed posses of armed goons to break picket lines but enlisted the aid of the courts to imprison CAWIU leaders under the Criminal Syndicalism Act of 1919.

The second half of the 1930s brought more strikes but fewer victories. The CIO attempted to organize cannery workers and fruit packers under the auspices of the United Cannery, Agricultural, Packing, and Allied Workers of America (UCAPAWA) but made little headway and gave up after two years. The publication in 1939 of John Steinbeck's *The Grapes of Wrath* and Carey McWilliams's *Factories in the Fields*—both exposés of the exploitative conditions California's agricultural workers endured—increased public sympathy for farm workers, especially Anglo "Okie" migrants from the Midwest, but that sympathy brought few lasting changes. Overall, wages and conditions for California farm workers did improve in the 1930s, but not enough to alter their status as the most impoverished segment of the state's workforce.[4]

Working women likewise struggled for workplace improvements, facing prejudice

from governmental agencies as well as unions. The great work relief programs of the New Deal—the Civilian Conservation Corps, the Civil Works Administration, the Works Progress Administration—employed millions of workers, but less than 10 percent were women. Because the Wagner Act did not extend its protections to domestic, hospital, and cannery workers, the AFL and CIO had little incentive to organize those predominantly female industries. Almost one million American women joined unions during the 1930s, but they seldom rose to positions of power. Yet women were essential to grassroots labor organizing; they talked to neighbors and visited churches to mobilize community support, they staffed soup kitchens and food cooperatives, they marched in picket lines.

California unions, somewhat more progressive than those in other states, occasionally promoted women to positions of authority. Half of the officers in the CIO's short-lived UCAPAWA were women, many Latinas. In 1933, the International Ladies Garment Workers Union (ILGWU), led by Rose Pesotta, organized Latina cloakmakers and dressmakers in Los Angeles and successfully struck for a wage increase.[5]

The decade's most famous and violent labor confrontation came in July 1934 during a bitter, protracted strike by San Francisco longshoremen and sailors. A relatively homogenous group (most were Scandinavian), seafaring workers seldom backed down from a fight, especially in blue collar San Francisco, where the waterfront was still at the heart of the city's economy. In the 1920s, employers had controlled the docks with the Blue Book Union, which distributed work through a "shape-up" system that was rife with corruption—men stood on the docks like cattle as hiring bosses handed out assignments to whomever they preferred. Section 7(a) of the National Industrial Recovery Act of 1933 emboldened organizers to form a new local of the International Longshoremen's Association (ILA), led by Australian Harry Bridges. After months of rancorous negotiations with the Waterfront Employers Union, the San Francisco ILA struck on May 9, 1934, joined by ILA locals in San Diego, San Pedro, Portland, Seattle, and Tacoma. The walkout, supported by teamsters and other waterfront workers, dragged on until July 5, when the San Francisco business community attempted to reopen the port. One thousand police officers clashed with five thousand picketers, resulting in widespread gunplay, sixty-four injuries, two deaths, and the calling in of the National Guard. The violence of "Bloody Thursday" triggered a sweeping general strike as virtually every union in San Francisco and Alameda County refused for four days to go to

Ballad of Harry Bridges

I'll sing you the tale of Harry Bridges
Left his parents and his home
He sailed acrost that rollin' ocean,
And into Frisco he did roam.
 Now Harry Bridges saw starvation
 Was a creepin' along that ocean shore,
 'Gonna get good wages for th' Longshoremen!
 That's what Harry Bridges swore.

He went to the seamen 'long the ocean,
He organized them day and night
Most of the seamen follered Harry,
Because they figured that he was right.
 Hard times was bad along the ocean,
 And there was a many an idle hand,
 And there was a many of wives and children,
 Going hungry in a Rich Man's land.

Now the big ship owners they shook their timbers,
They moaned and groaned and hung their head,
They flapped their fins, and swore they'd get him,
Because they figured that he was Red.
 They carried him away to the Angels Island
 It was there they had his trial
 They sighed, and spied, and lied, and cried;
 But Harry Bridges laughed and smiled.

Old Harper Knowles and Captain Keegan
Will some day sleep in a restless grave
And old Red Hynes, and R. P. Bonham,
Of men like these—no songs are made.
 What a bloody old day was Bloody Thursday
 What a bloody case of low disgrace
 For every man that the police killed there,
 Ten thousand rise to take their place.

I've sung you the tale of Harry Bridges,
Of Howard Speery, and Nick Bordoise
Of Helland, Daffron, Parker, Knudson,
And all of those other Union Boys.
 They fought and died to save the Union,
 They fought and died for what is Right
 The Union Way is the American Way,
 By God, I figure I'm just 'bout Right!

Song lyrics by Woody Guthrie

work, a remarkable display of solidarity never repeated on such a scale in the United States. On October 12, a federal arbitrator finally ended the longshoremen's strike, empowering the ILA with union-run hiring halls and the right to bargain collectively. In subsequent years, the conflict would grow to take on symbolic power for Californians; employers would remember it as radicalism run amok, while unionists and leftists would celebrate it as labor's finest hour. More than anything else, the four-day general strike revealed workers' potential to effect change through cooperation. That revelation would help keep organized labor strong in California for two decades.[6]

Labor's strength in the 1940s came as a result of the war mobilization effort, when working suddenly became an act of patriotism, especially in strategically important California. The federal government spent a staggering $35 billion in the state between the years 1940 and 1946, almost 10 percent of total domestic expenditures. This influx of federal dollars spurred new defense industries, most importantly shipbuilding and aircraft manufacturing that together employed nearly six hundred thousand Californians in 1945. Virtually every sector of the economy expanded, from restaurants and nightclubs to farms and steel factories. Unemployment plunged even as the state's workforce increased by 40 percent, mostly due to immigration from other states. All told, the personal incomes of Californians tripled during the war. Organized labor made the most of this growth, supported by the National War Labor Board, which arbitrated disputes between employers and workers. Total union membership in the United States more than doubled during the war, to 15 million.[7]

World War II brought significant numbers of African Americans to California for the first time. African Americans had comprised only 1.8 percent of the state's population in 1940; that number rose to 4.3 in 1950 and would continue to grow. Many black immigrants during the 1940s were former tenant farmers or farm workers from the South drawn west for lucrative jobs in California's shipyards and aircraft factories. Most settled in segregated neighborhoods in the San Francisco Bay Area and Los Angeles. The U.S. armed forces were also segregated during World War II, with African American soldiers and sailors often assigned to the most dangerous tasks. This situation received national attention following an explosion at Port Chicago, east of San Francisco, on July 17, 1944. The blast—the worst home-front disaster of World War II—killed 320 military personnel and injured 300 more. Two-thirds of the dead were African American stevedores who had been loading ammunition onto Liberty ships, a duty assigned only to black units. When the surviving sailors refused to return to work, the Navy imprisoned 50 African Americans for mutiny and dishonorably discharged another 208. During the trial, the stevedores' lawyer,

Plate 23. Frank A. Rowe,
Port Chicago Incident,
1980, woodcut, 25" x 25"

Thurgood Marshall, denounced the military for its racist policies: "This is not fifty men on trial for mutiny. This is the Navy on trial for its vicious policy towards Negroes....Negroes in the Navy don't mind loading ammunition. They just want to know why they are the only ones doing the loading!" The Navy eventually released the convicted stevedores in 1946, and the entire armed forces were desegregated the following year.[8]

Exhorted by politicians, business leaders, and the propaganda icon Rosie the Riveter to join the war effort by taking jobs, more than eighteen million American women worked as electricians, welders, assemblers, secretaries, and a host of other occupations. American women had never before worked alongside men in such numbers. In California, about half of the wartime women workers had already held jobs; for them, the mobilization effort meant higher wages and a chance to learn new skills. With these opportunities came discrimination and sexual harassment, however. Some employers refused to promote women to supervisory positions, and finding child care was a constant worry. African American women faced particularly intense prejudice from both employers and white female coworkers. After the war's end in 1945, the majority of working women in California wanted to keep their jobs, but industry after industry laid them off to make room for returning soldiers. Most women returned home, ushering in the postwar baby boom and the rise of the suburbs, but the competence they demonstrated would pave the way for increasingly open and equitable workplaces in subsequent years.[9]

Writers "capable of using their eyes and ears, capable of feeling the beat of the time, are frantic with material," wrote John Steinbeck in 1936, a year in which he spent several months in the Central Valley investigating living conditions in migratory labor camps for what would become *The Grapes of Wrath*. Steinbeck was not the only California artist "frantic with material" during the 1930s and 1940s. The period's dramatic labor struggles acted as an inspiration for a diverse but remarkably likeminded group of California visual artists. Committed leftists, these artists turned the course of California art away from the postimpressionist landscapes of the early twentieth century toward social realism. Heavily influenced by the Mexican muralists who visited the state during the late 1920s and 1930s, California artists strove to capture the often violent labor struggles they read about on the front page and witnessed with their own eyes. Many of these artists found support from the various public art projects of the New Deal, joining the hundreds of thousands of Californians who needed the help of the federal government to survive the Depression.[10]

The California labor art movement included artists both famous and obscure. In 1934, painter Maynard Dixon turned away from the romantic portraits of American Indians that had made his reputation and toward gritty urban scenes of strikes and unemployed laborers. Dixon's wife, Dorothea Lange, had abandoned genteel portraiture for documentary street photography the year before, after watching unemployed men wandering past her San Francisco studio. "I was compelled to photograph as a direct response to what was

around me," she said later. Her *Migrant Mother* (1936), a photograph of a "hungry and desperate" pea picker and her children in San Luis Obispo County, would become one of the most celebrated American images. Northern Californian social realist painters Victor Arnautoff, Anton Refregier, John Langley Howard, and Paul Sample had counterparts in Southern California, including Edward Biberman, Boris Deutsch, Millard Sheets, Phil Dike, and Phil Paradise.[11]

The times influenced the art and the art influenced the times. Lange's photographs of migrant workers, published in 1939 in *An American Exodus: A Record of Human Erosion*, helped convince Wisconsin Senator Robert La Follette to launch an extensive investigation into agricultural working conditions in California. His committee's monumental report, *Violations of Free Speech and Rights of Labor* (1942–1944), rivaled *The Grapes of Wrath* in its indictment of California agribusiness. On the other hand, the imagery of the labor-focused murals of Coit Tower (1934) and Rincon Annex (1941) in San Francisco—both funded by federal art projects—was called "inconsistent with American ideals and principles." Artists and unionists formed picket lines to protect both of these murals from vandalism.[12]

The massive changes wrought by World War II would permanently transform California art. Previously revolutionary, labor art became patriotic, celebratory of mobilization. The WPA's Southern California Art Project now hired muralists to produce "fighting art to inspire fighting soldiers." The ravages of the war and the arrival of so many immigrants directed California artists' attention away from the local and toward national and international events and trends. Social realism would be supplanted by modernism, with its splintering into increasingly abstract subgenres. Mainstream California art swerved away from the naturalistic labor images of the 1930s, but those works would serve as touchstones for later artists and endure as testaments to an era when art and labor militancy invigorated each other.[13]

notes:

1. Richard K. Doud, "Interview with Dorothea Lange," 22 May 1964, Archives of American Art, Smithsonian Institution; "Oral History Interview with Ray Strong," 14 September 1993, Archives of American Art, Smithsonian Institution.

2. Gerald D. Nash, *The Crucial Era: The Great Depression and World War II, 1929–1945*, 2nd ed. (New York: St. Martin's Press, 1992), 14-22; Priscilla Murolo and A. B. Chitty, *From the Folks Who Brought You the Weekend: A Short, Illustrated History of Labor in the United States* (New York: The New Press, 2001), 186-91; Nelson Lichtenstein, *State of the Union: A Century of American Labor* (Princeton: Princeton University Press, 2002), 21-25; James J. Rawls and Walton Bean, *California: An Interpretive History*, 7th ed. (New York: McGraw Hill, 1998), 318-21; Kevin Starr, *Endangered Dreams: The Great Depression in California* (New York: Oxford University Press, 1996), vii, 121, 275-339.

3. Murolo and Chitty, *From the Folks Who Brought You the Weekend,* 189-215; Lichtenstein, *State of the*

Union, 30-53; Daniel Nelson, *Shifting Fortunes: The Rise and Decline of American Labor, from the 1820s to the Present* (Chicago: Ivan R. Dee, 1998), 111-21.

4. Cletus E. Daniel, *Bitter Harvest: A History of California Farmworkers, 1870–1941* (Ithaca: Cornell University Press, 1981), 105-285; Starr, *Endangered Dreams,* 61-83; Devra Weber, "Raiz Fuerte: Oral History and Mexicana Farmworkers," in Daniel Cornford, ed., *Working People of California* (Berkeley: University of California Press, 1995), 208-24.

5. Lichtenstein, *State of the Union,* 88-92; Murolo and Chitty, *From the Folks Who Brought You the Weekend,* 194, 212; Vicki Ruiz, "A Promise Fulfilled: Mexican Cannery Workers in Southern California," in Cornford, ed., *Working People of California,* 265-83; Clementina Durón, "Mexican Women and Labor Conflict in Los Angeles: The ILGWU Dressmakers' Strike of 1933," *Aztlán: International Journal of Chicano Studies Research* 15 (1984): 145-62.

6. David F. Selvin, *A Terrible Anger: The 1934 Waterfront and General Strikes in San Francisco* (Detroit: Wayne State University Press, 1996); Bruce Nelson, "The Big Strike," in Cornford, ed., *Working People of California,* 225-64; Starr, *Endangered Dreams,* 84-120.

7. Roger W. Lotchin, ed., *The Way We Really Were: The Golden State in the Second Great War* (Urbana: University of Illinois, 2002); Marilynn S. Johnson, *The Second Gold Rush: Oakland and the East Bay in World War II* (Berkeley: University of California Press, 1993); Arthur C. Verge, *Paradise Transformed: Los Angeles during the Second World War* (Dubuque, Iowa: Kendall/Hunt, 1993); Gerald D. Nash, *The American West Transformed: The Impact of the Second World War* (Bloomington: University of Illinois Press, 1985); Rawls and Bean, *California,* 345-57; Murolo and Chitty, *From the Folks Who Brought You the Weekend,* 221-31; Nash, *The Crucial Era,* 142-55, 162-66; Sally M. Miller and Daniel A. Cornford, eds., *American Labor in the Era of World War II* (Westport, Conn.: Greenwood Press, 1995).

8 . Nash, *The Crucial Era,* 173-75; Kevin Starr, *Embattled Dreams: California in War and Peace, 1940–1950* (New York: Oxford University Press, 2002), 118-21; Robert L. Allen, *The Port Chicago Mutiny* (New York: Warner Books, 1989).

9. Sherna Berger Gluck, *Rosie the Riveter Revisited: Women, the War, and Social Change* (Boston: Twayne Publishers, 1987); Susan M. Hartmann, *The Home Front and Beyond: American Women in the 1940s* (Boston: Twayne Publishers, 1982); Kevin Starr, *Embattled Dreams,* 123-58; Nash, *The Crucial Era,* 167-72.

10. Anne Loftis, *Witnesses to the Struggle: Imaging the 1930s California Labor Movement* (Reno: University of Nevada Press, 1998), 3; Kevin Starr, *The Dream Endures: California Enters the 1940s* (New York: Oxford University Press, 1997), 233-34; Anthony W. Lee, *Painting on the Left: Diego Rivera, Radical Politics, and San Francisco's Public Murals* (Berkeley: University of California Press, 1999).

11. *Dorothea Lange: The Making of a Documentary Photographer* (Berkeley: University of California Regional Oral History Office, 1968), 145; Sally Stein, "Starting from Pictorialism: Notable Continuities in the Modernization of California Photography," in Drew Heath Johnson, ed., *Capturing Light: Masterpieces of California Photograph, 1850 to the Present* (New York: Oakland Museum of California and W. W. Norton & Company, 2001), 127-28.

12. Starr, *Endangered Dreams,* 265-71; Loftis, *Witnesses to the Struggle,* 177; Gray Brechin, "Politics and Modernism: The Trial of the Rincon Annex Murals," in Paul J. Karlstrom, ed., *On the Edge of America: California Modernist Art, 1900–1950* (Berkeley: University of California Press, 1996), 68-93.

13. Susan Landauer, "Painting Under the Shadow: California Modernism and the Second World War," in Karlstrom, ed., *On the Edge of America,* 40-67.

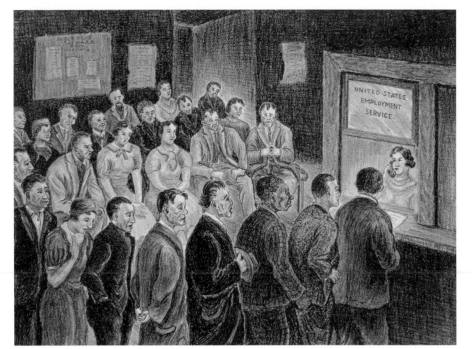

IMAGES OF UNEMPLOYMENT
and desperation give stark evidence of the
dehumanizing personal toll of the Great
Depression. David Chun's lithograph *Waiting
for a Job,* created under the auspices of the
WPA, depicts the multiethnic crowd at the
offices of the United States Employment
Service. An advocate for increased participa-
tion of Chinese Americans in defining San
Francisco's Chinatown, Chun became the first
president of the Chinese Art Association in
1935.

DOROTHEA LANGE's famous photo-
graph *White Angel Bread Line, San Francisco,* was her first
attempt to document life on the street for the Depression's
dispossessed. In making this photograph, Lange experi-
mented with vantage point, shooting the same scene
from ground level. Ultimately she selected an aerial
perspective, accentuating the dirty hat and folded hands
of an anonymous man in a moment of contemplation,
or perhaps prayer, as he waits in the bread line operated
by a local woman known as the white angel.

Lange had moved to San Francisco in 1918 and
opened her own studio the following year. She devoted
the first ten years of her professional career to portraiture
but, compelled by the abject conditions of the Depression,
began in the thirties to do documentary work. Later she
would travel to the rural areas of California to record the
hardships of farm laborers, and these images won her a
permanent position with the Farm Security Admini-
stration (FSA). Lange's highly influential photography
continues to inspire artists to create images with social
content.

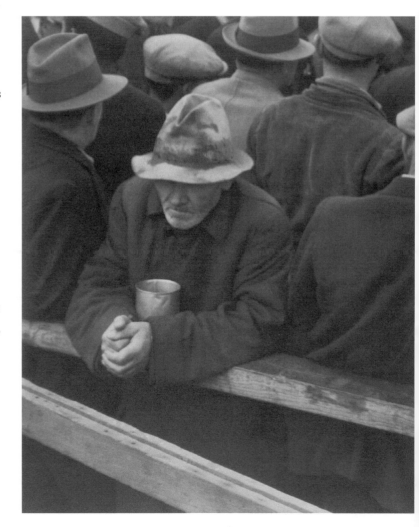

Plate 24. David Chun, *Waiting for a Job,*
ca. 1938, lithograph, 7¾" x 10⅝"
Plate 25. Dorothea Lange, *White Angel Bread Line, San Francisco,*
1933, gelatin silver print, 10" x 8"

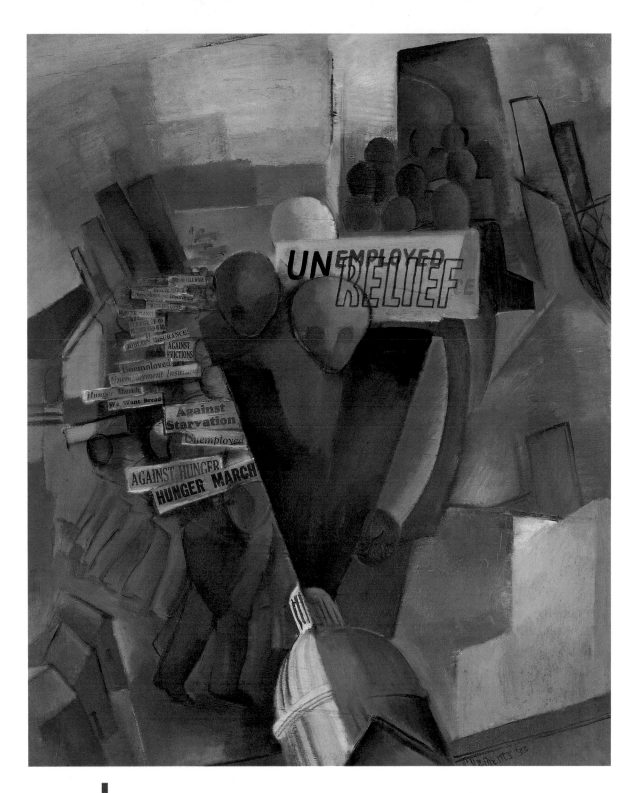

LIKE MANY OTHER artists who worked during the 1930s, Grace Clements is
distinguished by her blending of modernist abstraction with social awareness. She supported
herself as a teacher at the Chouinard Art Institute and as a critic. Her painting *Winter 1932*
pairs actual newspaper headlines about Depression-era unemployment and hunger marches
with images of ghostly marchers. The collage of other images in this work, including the U.S.
Capitol and generic skyscrapers, conflates multiple cities and events, while its perspective
conveys the endless desperation of this period; some of the numerous protests and hunger
marches represented here ended in violence and death.

Plate 26. Grace Clements, *Winter 1932*,
1933, oil on canvas, 42" x 34"

The Big Strike, or General Strike, of 1934 is among the most discussed events in San Francisco history. It also looms large in California art. In different graphic media and artistic styles, the next five images suggest its genesis and consequences.

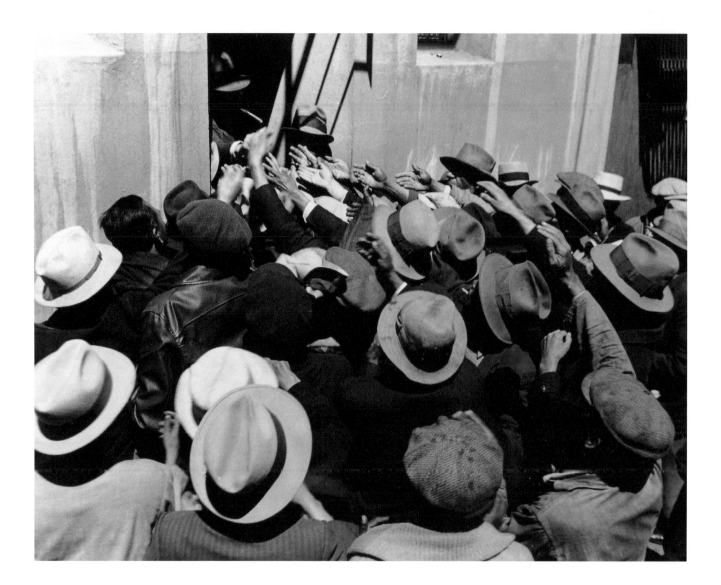

Outstretched Hands shows the "shape up," as it was called—the chaotic and desperate reach for work by longshoremen who knew full well that, for reasons both unfair and corrupt, they would likely not be hired. This famous photograph was taken by husband and wife Otto Hagel and Hansel Mieth.

Plate 27. Otto Hagel (with Hansel Mieth), *Outstretched Hands*, 1934, gelatin silver print, 10" x 13"

In CONTRAST TO the frenetic energy of Mieth and Hagel's photograph, Maynard Dixon's charcoal study for the painting *Keep Moving* illustrates exhaustion and tedium and signals the protracted nature of strikes; these figures appear dark and colorless, as if their individuality has been eroded by the monotony of walking the picket line.

Maynard Dixon was a mostly self-taught artist who became one of the most successful painters in the West, known for his heroic portraits of Native Americans and landscapes of the Southwest. His mid-1930s works are his most socially sensitive.

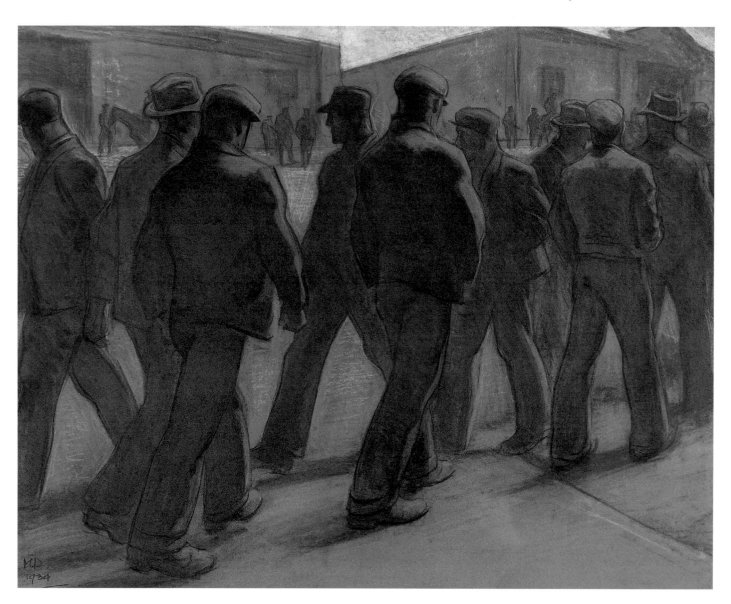

Plate 28. Maynard Dixon, *Keep Moving*, 1934, charcoal on paper, 30" x 44'

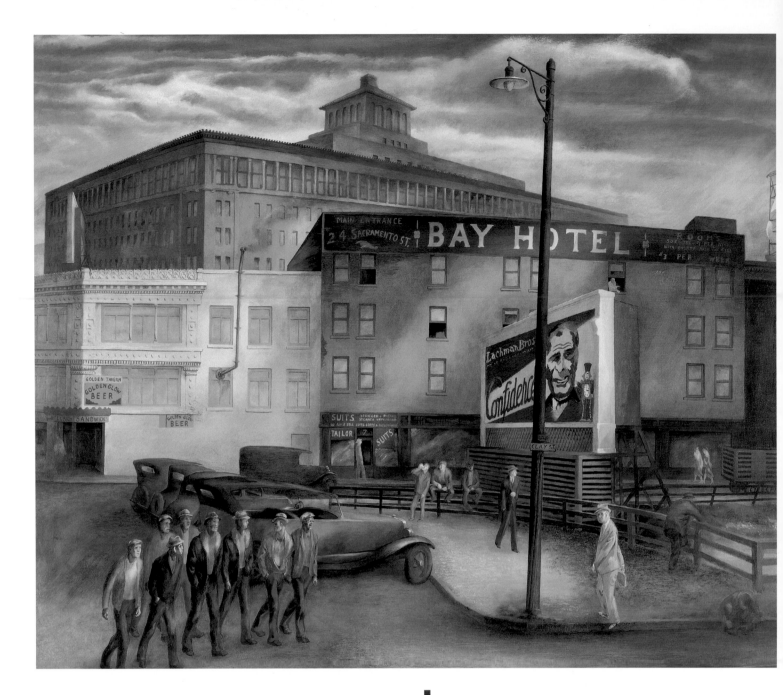

Plate 29. John Langley Howard, *Embarcadero and Clay Streets*,
1935, oil on canvas, 35⅞" x 43½"

JOHN LANGLEY HOWARD was another politically
committed artist of the thirties. His *Embarcadero and Clay Streets*
presents a moment of escalating tension between white collar
employers and blue collar workers along the waterfront. In this
complex image, we see the employer looking over his shoulder
in apprehension as a group of workers approaches. The billboard
looming overhead promises "Confidence," while the imposing
presence of the Southern Pacific Company office building recalls a
history of robber barons and corporate greed. A study in contrasts,
this painting suggests that the confidence one gains from the sup-
port of one's peers is stronger than any confidence money can buy.

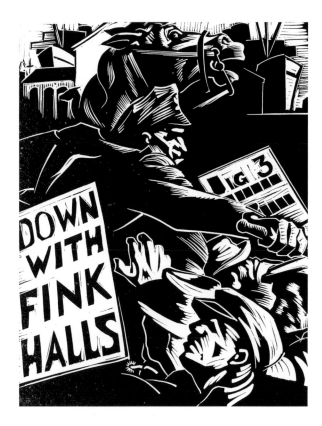

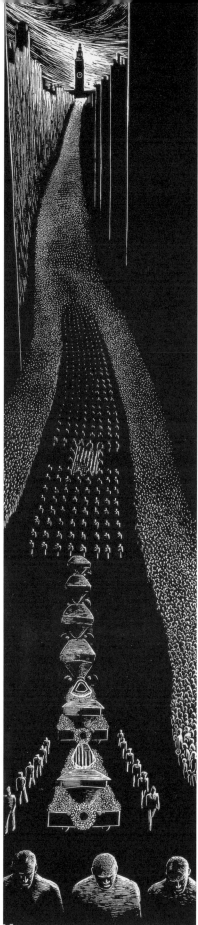

VICTOR ARNAUTOFF'S woodcut in the Mexican style, *Down with Fink Halls*, shows one of the events leading to the Bloody Thursday clash between police and workers over the hiring of scabs—we see the dramatic profile of a striker about to be struck by a police baton. The sense of violence, and of right and wrong, is palpable. The iconic use of contrast and the terrified expression on the horse's face telegraph the injustice of the moment. Arnautoff served in the czarist cavalry and often painted horses.

Arnautoff later worked in Mexico as one of Diego Rivera's principal assistants. One of the most important public muralists in the United States, he taught at several schools, including Stanford and the California Labor School. He relocated to the Soviet Union after his retirement in 1963.

THE EVENTS OF Bloody Thursday culminated in the death of two strikers, followed by a mass funeral march and a four-day general strike. Adelyne Cross Eriksson's rendering of the funeral march captures its somber mood and the enormous crowd, which stretched the full length of Market Street. The people here look like stars in the night sky, streaming from the Ferry Terminal.

Cross Ericksson was an influential teacher at the California Labor School and a founder of the Graphic Arts Workshop. When the United States deported her husband because of his political views, the two returned to his native Sweden, where she continued to work as a teacher and artist.

Plate 30. Victor Arnautoff, *Down with Fink Halls*, 1934, woodcut, 10" x 8"
Plate 31. Adelyne Cross Eriksson, *Funeral March*, ca. 1950, woodcut, 22¼" x 5¼"

When the cauliflower season was over my crew moved to Nipomo to work in the lettuce fields. I went to Lompoc and found the town infested with small-time gangsters and penny racketeers. My brother Amado was still with Alfredo, but they had given up bootlegging. Now they were partners in gambling, cheating the Filipino farm workers of their hard-earned money. I could not live with them.

I found a crew of lettuce workers on J Street and joined them. It was cold in Lompoc, for the winter wind was beginning to invade the valley from Surf. The lettuce heads were heavy with frost. I worked with thick cotton gloves and a short knife. When the lettuce season was over, the winter peas came next. I squatted between the long rows of peas and picked with both hands, putting the pods in a large petroleum can that I dragged with me. When the can was full, I poured the pods into a sack, then returned to my place between the long rows of unpicked peas.

from *America Is in the Heart*, by Carlos Bulosan

ALTHOUGH SHE CONSIDERED her work to be documentary and not art photography, this image by Dorothea Lange shares a great affinity with Jean-François Millet's famous 1857 painting *The Gleaners*. Both works represent backbreaking labor and reflect the artistic tradition of romanticism. In Lange's photograph, the blousy clothing and ground-level perspective connect these Filipino field hands to the earth. The angle suggests that the artist looks up to these workers. Elegantly echoing the textural lines of the lettuce leaves, the photograph's sharp focus correlates the soil, riddled with cracks, to the difficult lives of the people who perform such demanding work. In this way, Lange's work simultaneously demonstrates the aesthetics of modern photography and fulfills her documentary goal.

Lange's image quickly became an icon of the conditions of migrant laborers, among whom Filipinos were often the lowest paid in the twenties and thirties. She took this photograph before her tenure with the FSA but later added it to those files. This record of stoop labor in California agriculture continues to be relevant.

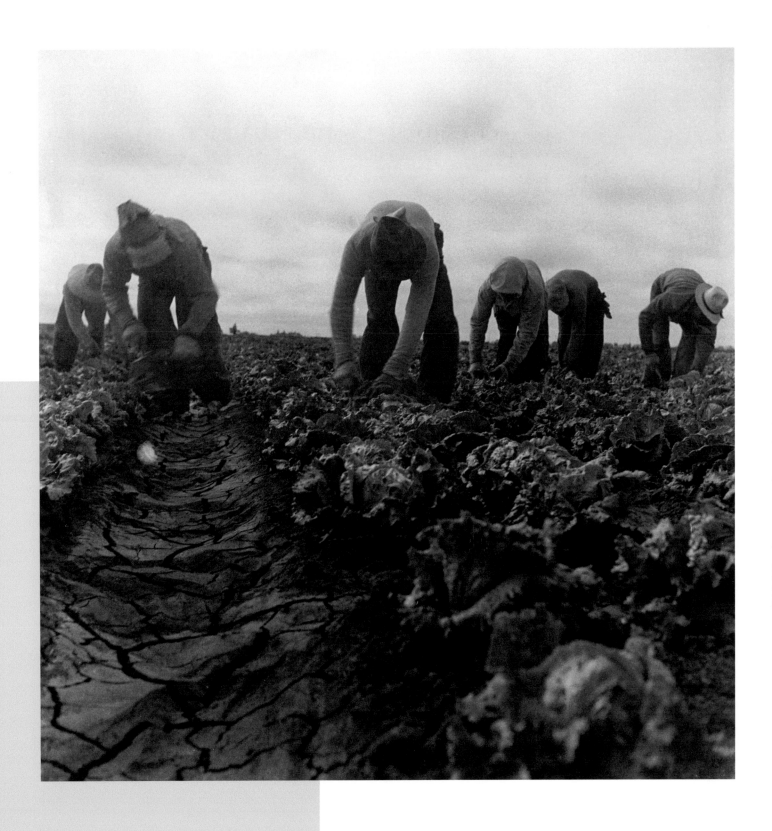

Plate 32. Dorothea Lange, *Filipino Field Hands—Stoop Labor,*
1936, gelatin silver print, 10" x 8"

THIS IMAGE BY Mieth and Hagel captures a secretive gathering of striking lettuce pickers in the San Joaquin Valley. The dramatic illumination—especially the underlit orator in the upper right of the photograph—gives the scene a frightening and theatrical glow.

Otto Hagel and Hansel Mieth met in Germany at the age of fifteen, at the beginning of their lifelong commitment to writing and photography. The rise of fascism in Germany led Hagel to immigrate to the United States in 1928, paying for his passage by working on a freighter. Mieth followed him to San Francisco two years later. During the Depression, the couple supported themselves as migrant workers and continued their photography. It was during this time, while they were living in a tent, that their infant daughter was run over and killed. Mieth suspected that her documentary work was the cause. She refused to touch her camera for a year but eventually picked it up again. Although later blacklisted for her politicized imagery, Mieth became one of the first women to work for *Life* magazine. This remarkable couple often collaborated on photographs until Hagel's death in 1974.

And the migrants streamed in on the highways and their hunger was in their eyes, and their need was in their eyes. They had no argument, no system, nothing but their numbers and their needs. When there was work for a man, ten men fought for it—fought with a low wage.

If that fella'll work for thirty cents, I'll work for twenty-five.

If he'll take twenty-five, I'll do it for twenty.

No, me, I'm hungry. I'll work for fifteen. I'll work for food.

from *The Grapes of Wrath,* by John Steinbeck

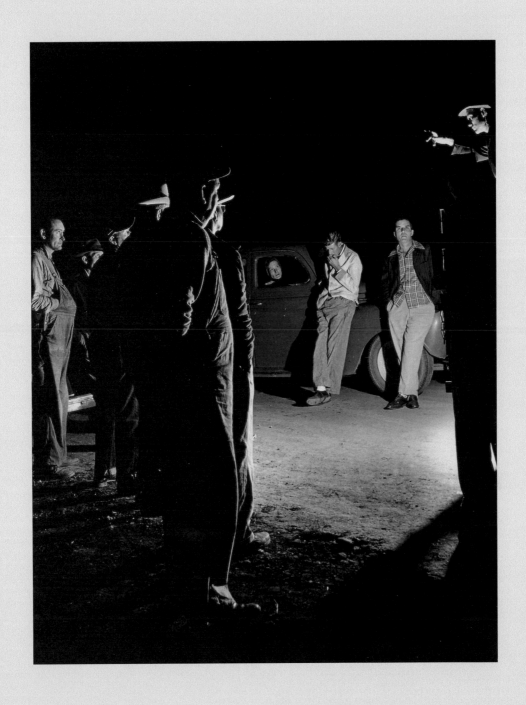

Plate 33. Otto Hagel (with Hansel Mieth), *Salinas Lettuce Strike, Night Meeting*,
1939, gelatin silver print, 13" x 10"

Known as America's most famous muralist, Thomas Hart Benton was a painter of the Regionalist school who chronicled American life for over half of the twentieth century. He began his career in New York, where he taught Jackson Pollock and other artists. In the mid-1920s, he set off across the country on a series of expeditions that led to an expansive body of work portraying the people and history of America. His experience with California's motion picture industry prompted him to describe it as "the combination of a machine and sex that Hollywood is." Indeed, featured at the center of *Hollywood,* his major painting of 1937, is a man kneeling before a nearly nude woman who is surrounded by machinery—cameras, lights, sound equipment—and fragments of movie sets. In this context, the actress is but a cog in the mechanism. The paradoxical nature of Hollywood, glamorous and exploitative at the same time, is suggested by the placement of the actress's feet both on and off a red carpet. The half-open red curtain behind her exposes the burning city from *In Old Chicago,* which Benton had seen filmed, and suggests the damage done behind the scenes. Benton intended to execute this work in the lobby of a movie theater, but not finding financial backing, he made it as an easel painting. To his dismay, *Life* magazine rejected it for publication on the basis that it was too scandalous.

Plate 34. Thomas Hart Benton, *Hollywood,*
1937, tempera with oil on canvas mounted on panel, 53½" x 81"

WILL CONNELL'S close cropping, weird lighting, and obfuscating shadows lend the subject of *Editing* the demonic presence of a mad scientist. Connell's work has been described as surrealist because of its bizarre juxtapositions and photographic manipulations. Active in both commercial and editorial photography, in 1931 Connell helped establish the photography department at the Art Center School in Los Angeles.

ESCAPIST HOLLYWOOD movies grew in popularity as economic hardships worsened. These two photographs from the 1930s demonstrate the vastly different world of the Hollywood workforce from the Depression experiences of mainstream America. Peter Stackpole's portrait of a screenwriter (ironically named Baker) in a Turkish bath is simultaneously a hilarious image of work done in what appears to be the lap of luxury and a comment on the very real constrictions that screenwriters encounter in their creative work.

Plate 35. Will Connell, *Editing*, from the book *In Pictures*, 1937
Plate 36. Peter Stackpole, *Screenwriter Baker*, ca. 1939, gelatin silver print, 7³/₈" x 9¹/₈"

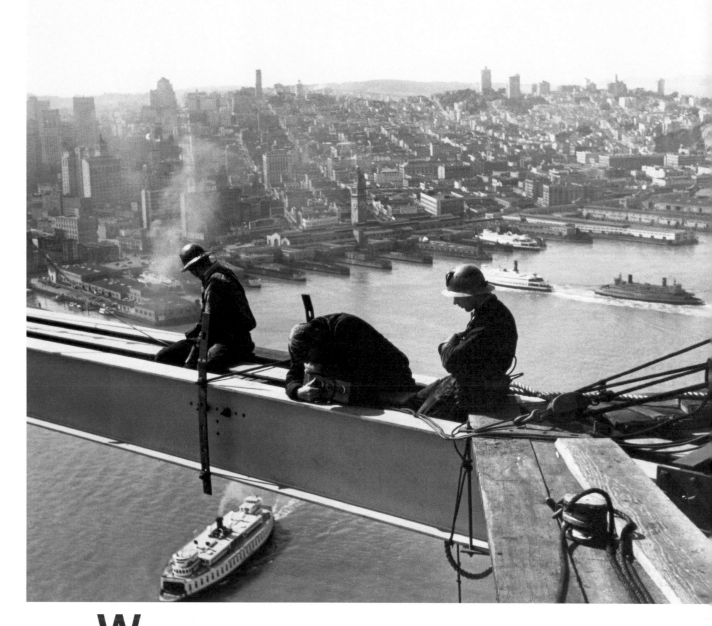

WHEN FRANKLIN D. ROOSEVELT took office in 1933, a host of new programs, often referred to by abbreviations—CCC, CWA, FERA, FSA, PWA, TVA—were initiated as a way to put Americans to work. Some of the most exciting efforts were massive construction projects, including dams, parks, and bridges, that changed the landscape of the nation and the way people related to it.

In California, the construction of bridges captured the attention of artists. The series by Peter Stackpole (son of sculptor Ralph Stackpole) about the construction of the Oakland Bay Bridge and the Golden Gate Bridge, the largest and longest suspension bridges of their time respectively, includes some of his most famous images. The Bay Bridge construction was especially gripping, as a dozen workers fell to their deaths from great heights in high winds. A safety net was installed during the subsequent construction of the Golden Gate Bridge, but eleven men died nonetheless. The nineteen men who were saved by the net were known as the Halfway to Hell Club.

Plate 37. Peter Stackpole, *Building of the Bay Bridge*, ca. 1933, gelatin silver print, 7" x 9¼"

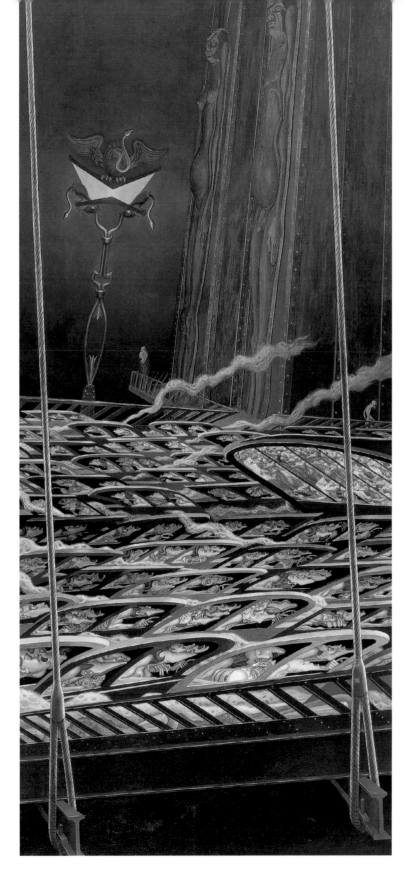

Irving Norman's 1953 painting *The Bridge* is a darker take on this Herculean construction project that, ironically, had been envisioned as a way to reduce Bay Area traffic. In Norman's image, ghastly naked commuters are sardined in buses and cars in a hellacious traffic jam of the type that has become universally familiar to Northern California drivers, while skull shapes appear subtly in the clouds of exhaust. A buzzard stretches its wings atop one of the bridge's distinctive yellow lamps, apparently sensing imminent death. Noose-like cables seem inadequate for the job of suspending the weight of humanity over the black abyss below. Norman lived outside San Francisco, but he often scheduled appointments in the city for 5:00 p.m., the worst of the rush hour, so that he could best experience the inspiration for this modern purgatory.

Plate 38. Irving Norman, *The Bridge*, 1953, oil on canvas, 76" x 34"

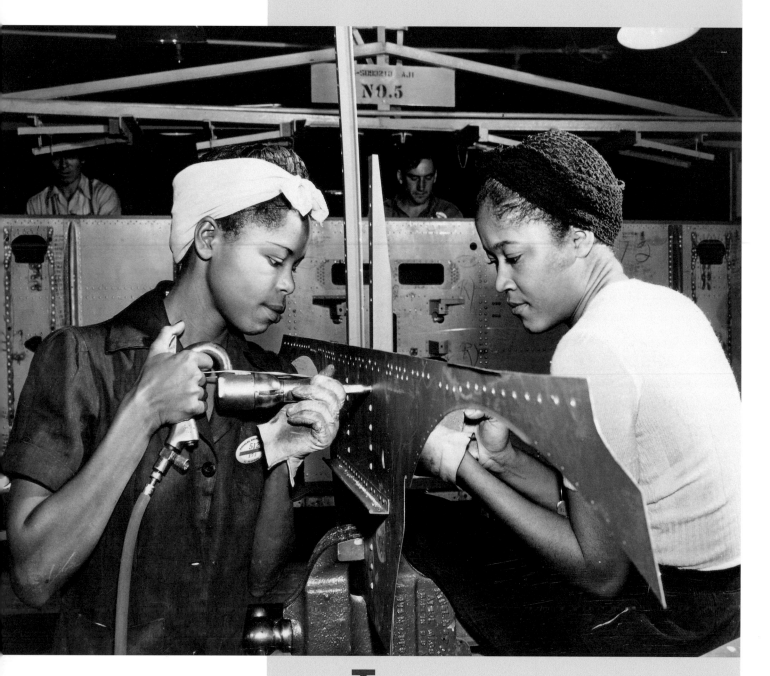

Plate 39. Emmanuel Joseph, *Rosies*,
ca. 1943, gelatin silver print, 8" x 10"

THE ENTRY OF the United States into World War II brought an end to the Depression with the creation of millions of jobs for people who served in the armed forces and for many more who found war-related work. Richmond, California, became known for shipbuilding and steelwork, attracting national attention as the labor of ordinary people became prized for its value to the war effort.

Artists endeavored to create images of Californians at work on behalf of a shared vision. African American photographer Emmanuel Joseph documented the workers in the Kaiser shipyards, where the faces of "Rosie the Riveter" were often black or brown. Joseph was the photographer for the publication *We Also Serve*, which chronicled the broad involvement of African American workers in the shipyards.

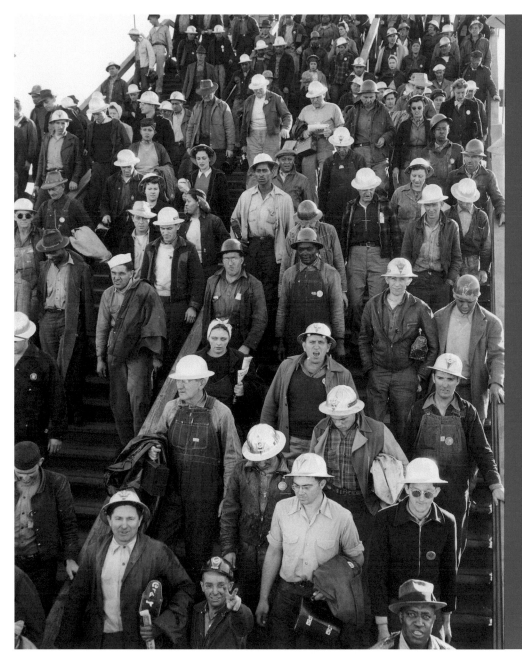

DOROTHEA LANGE created hundreds of images of shipyard workers in Richmond, and this is one of the most famous. Although it is usually attributed to Lange, this photograph may have been taken by someone else: Lange worked on a collaborative assignment for *Fortune* magazine with Ansel Adams in 1944 in the shipyards in Richmond. In the *Fortune* magazine article that appeared in February of 1945, the image is credited to "Ansel Adams and Dorothea Lange," and in a later interview, Adams noted that they worked together on many of the *Fortune* images, saying that "the one with the people coming down, the whole crowd—that was mine." (Ruth Teiser and Catherine Harroun, "Conversations with Ansel Adams," unpublished interview, University of California Regional Oral History Office, 1978)

Plate 40. Dorothea Lange, *Kaiser Shipyard—Shift Change 3:30*, 1942, gelatin silver print, 10" x 8"

PIRKLE JONES's shirtless muscled man with a hammer recalls depictions of labor from fifty year earlier, but this photograph's subject works in home construction. The building of the suburbs was to transform the landscape and mind-set of California. Jones had a long association with Ansel Adams, having been both his student and assistant, and he collaborated on a large project with Dorothea Lange. Later he was himself a famous teacher at the San Francisco Art Institute.

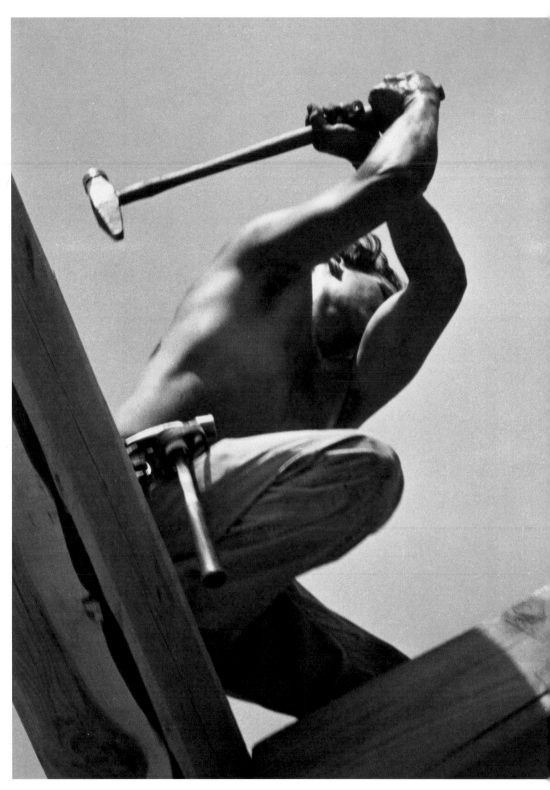

Plate 41. Pirkle Jones, *Worker,* from *Story of a Winery,* Saratoga, 1958, gelatin silver print, 14" x 11"

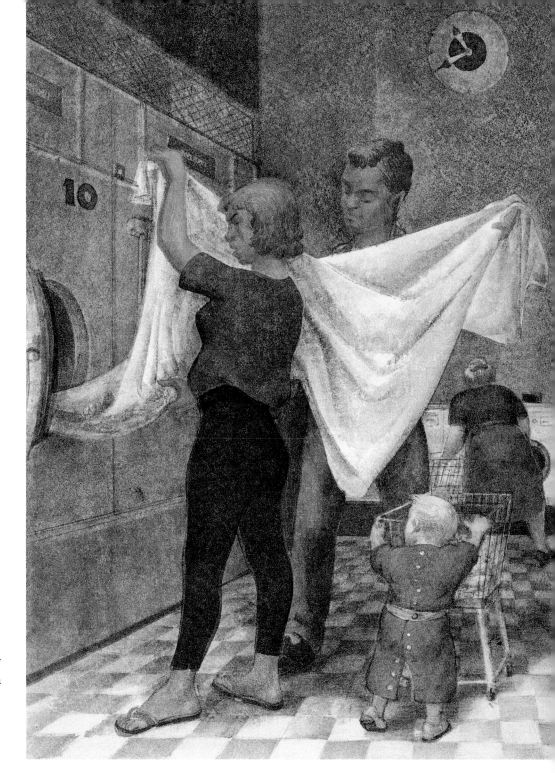

AFTER WORLD
WAR II, GIs came home looking for a
new life, and industrial jobs were no
longer available to women. The result-
ant baby boom attracted the attention
of many of the artists whose earlier
work had portrayed labor.

Instead of focusing on militant
clashes with police as he had during
the 1930s, Victor Arnautoff found a new inspiration in the nuclear family and the
mundane world of *Family Chores*. It is interesting to note that both parents are
involved in folding sheets at the laundromat—the inclusion of the father in this
color lithograph seems progressive for the time.

Plate 42. Victor Arnautoff, *Family Chores*,
ca. 1950, color lithograph, 20" x 16"

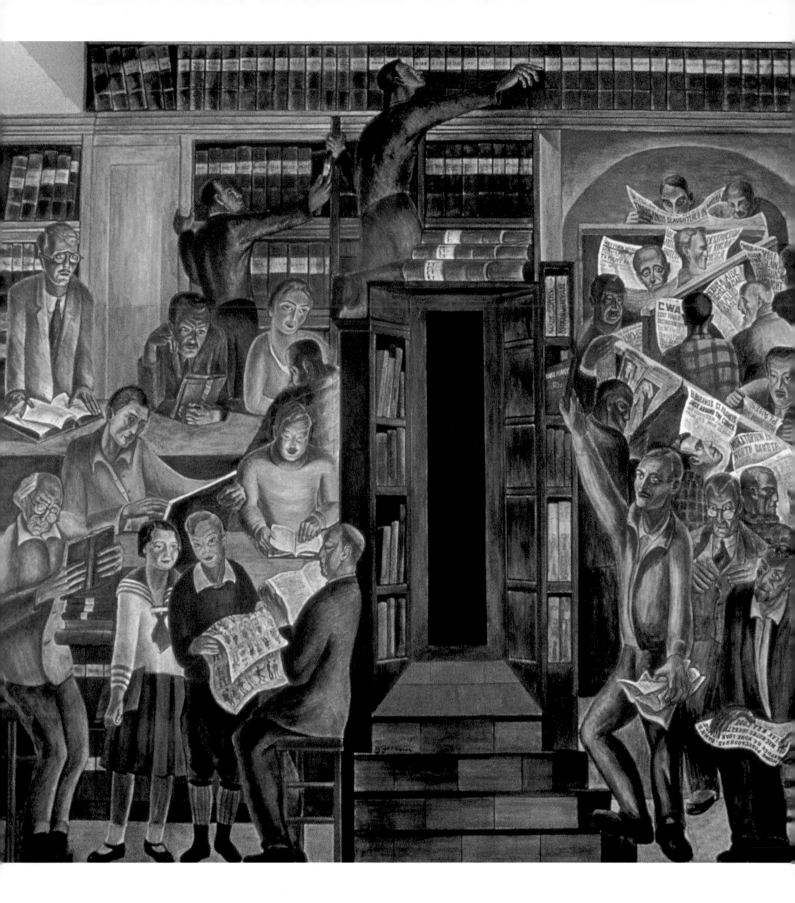

Plate 43. Bernard Zakheim, *Library*,
1934, fresco, Coit Tower, San Francisco

California's Collective Art Culture

Mark Dean Johnson

The founding of the San Francisco Artists and Writers Union in 1933 reflects the spirit of solidarity that was in the air as California artists responded to the upheavals of the Great Depression. First conceived by a painter, a poet, and a political activist, the union, with an illustrious group of inaugural members that included Bernard Zakheim, Kenneth Rexroth, Victor Arnautoff, and Maynard Dixon, ultimately attracted a total membership of about three hundred and fifty. Several of these artists could boast of having had strong political ties before banding together. Rexroth had organized political street theater on the back of a flatbed truck at the edge of San Francisco's Western Addition; Arnautoff, Zakheim, and several others were avowed communists and had studied with Diego Rivera, either in Mexico or at his side in San Francisco.[1]

Artist George Biddle had already lobbied his former classmate and friend Franklin Roosevelt to adopt the public artworks model originated in Mexico in the 1920s by Education Minister José Vasconcelos that had generated so many world-class murals there. This no doubt sped the stunningly prompt reply that the San Francisco artists' union received in response to their first action, petitioning the federal government to support public artwork. Within weeks, a team was setting out to Telegraph Hill to paint murals throughout the interior of Coit Tower, San Francisco's new memorial to firemen.

Leftist artists' unions had also been founded in New York and Chicago in the early 1930s, and these too have their own impressive histories. Nonetheless, looking back, it seems just short of amazing that these dispersed efforts by firebrand artists attracted such important support from Washington. Coit Tower was an important test case in America, and in any other political environment the controversies that surrounded its opening might have precluded further federal support for public artworks.

The artists who painted Coit Tower filled its walls with provocative images of labor. Giant workers painted by Clifford Wight overlook complex depictions of agriculture and food processing by Maxine Albro and Ralph Stackpole, while a bitter allegory of poverty and inequity by John Langley Howard faces a library of radicalism painted by Bernard Zakheim. Coit Tower was painted in tandem with the escalating tension along the waterfront that could be seen from Telegraph Hill, and the Coit Tower artists also contributed leaflets and printed images for that cause.

The Bad Old Days

The summer of nineteen eighteen
I read *The Jungle* and *The
Research Magnificent*. That fall
My father died and my aunt
Took me to Chicago to live.
The first thing I did was to take
A streetcar to the stockyards.
In the winter afternoon,
Gritty and fetid, I walked
Through the filthy snow, through the
Squalid streets, looking shyly
Into the people's faces,
Those who were home in the daytime.
Debauched and exhausted faces,
Starved and looted brains, faces
Like the faces in the senile
And insane wards of charity
Hospitals. Predatory
Faces of little children.
Then as the soiled twilight darkened,
Under the green gas lamps, and the
Sputtering purple arc lamps,
The faces of the men coming
Home from work, some still alive with
The last pulse of hope or courage,
Some sly and bitter, some smart and
Silly, most of them already
Broken and empty, no life,
Only blinding tiredness, worse
Than any tired animal.
The sour smells of a thousand
Suppers of fried potatoes and
Fried cabbage bled into the street.
I was giddy and sick, and out
Of my misery I felt rising
A terrible anger and out
Of the anger, an absolute vow.
Today the evil is clean
And prosperous, but it is
Everywhere, you don't have to
Take a streetcar to find it,
And it is the same evil.
And the misery, and the
Anger, and the vow are the same.

Kenneth Rexroth

Fueled by incendiary newspaper coverage that overemphasized the radical components of the murals, the public found them outrageous. Claiming that it was protecting the tower from vandals, the city park commission closed it for several weeks and silently removed a hammer and sickle from a mural by Clifford Wight. Yet time has proved the tower to be a grand success for which there was no American precedent, and the exuberance of its images continues to impress visitors today. Thirty years after its completion, Kenneth Rexroth wrote:

> No better picture of California in the thirties exists anywhere. True, there are masses of strikers and demonstrators and unemployed brandishing copies of the *Western Worker*, but they are inconspicuous really, alongside the harvest workers and factory hands and longshoremen and just plain people, all suffused with the most extraordinary buoyancy—joy, hope, faith in the future, once again the mood of San Francisco even in the very depths of the Depression.[2]

Roosevelt's evolving federal art projects, which included the WPA, eventually supported public works, printmaking, painting, photography, and other art forms. Remarkably, the artists involved in these programs—many of the best in the country—survived the Depression by creating socially minded art. Huge, colorful frescos were commissioned for post offices and other federal buildings, and government projects generated thousands of extraordinary prints and photographs. The Farm Security Administration's photography program allowed such artists as Walker Evans, Marion Post Wolcott, and Dorothea Lange to produce some of the most magnificent work of their careers. In San Francisco, the Federal Arts Project funded a print workshop. Located at 901 Potrero Avenue, it brought together artists of diverse backgrounds, including Chee Chin S. Cheung Lee, David Chun, Pauline Vinson, and Sargent Johnson.

Coupled with the California State Emergency Relief Administration (which employed Arnautoff, Lange, and others for a time), federal programs provided a spark that ignited California art in exciting ways. Local unions picked up on this energy and commissioned artists to make murals and other major artworks for their public spaces. The architecture and artistic iconography of California were transformed with new images, often of the state's agriculture, industry, and working people.

The largest commission ever granted by the New Deal's Section of Fine Arts, and one of its last, was a series of twenty-seven murals for San Francisco's Rincon Annex post office. Anton Refregier, another communist, received the commission in 1941 and completed the work in 1948. Like Coit Tower, the Rincon Annex

project was flooded with criticism even as it was being painted. Congress held hearings about the imagery's purported anti-American content, and the artist was forced to make some minor alterations while other artists rallied noisily in his support. Denounced by politicians, the murals were popular with the faculty and students at the school where Refregier taught: the California Labor School.

The activities of the Labor School are among the brightest flashes produced by the combined chemistry of labor and art in California. Surprisingly, the school's history is little known outside a small circle of labor historians. Labor schools opened in several American cities during this period, including the Jefferson School in New York, the Samuel Adams School in Boston, and the Abraham Lincoln School in Chicago, but the California school was distinguished by its size, vitality, and arts programming. The ethnic diversity of the school's student body is also significant; it has been estimated that 40 percent of students were African American. The school's special focus on the arts had international precedents, such as the short-lived art school for workers, the Estudio Libre de Pintura y Escultura, that opened in Havana in 1937, but the California Labor School is the most important example in the United States.[3]

The Labor School opened on Van Ness Avenue in 1942 as the Tom Mooney Labor School. The name was changed in 1944 as the school expanded to open satellite campuses in both Oakland and Los Angeles. The main San Francisco campus later moved to 216 Market Street, and it moved again when a building at 240 Golden Gate Avenue was purchased. The Labor School's curriculum included training in various trades and skills appropriate to the wartime economy, along with classes in political philosophy that were generally Marxist in nature. But as the mural-covered social center in the school's basement coffee shop attested, the biggest and most popular classes were always in the arts.

The first permanent director of the school was David Jenkins, a charismatic man with connections to San Francisco society and the Communist Party. Funding for the school came from trade unions, for whose members tuition was waived, as well as other sources. A testament to the special culture that had developed in San Francisco, these sources included some of the city's wealthiest people, including the Crocker, Strauss, Giannini, and Hallinan families, as well as the Communist Party.

The cultural and art departments of the school, mostly directed by Holland Roberts, offered dance, music, theater, and visual arts. Poet Maya Angelou was one of the people who benefited from a scholarship to the Labor School. Studying theater and dance, she was taught mime as an antidote to "melodrama," and she overcame her shyness by learning to "occupy space."[4] A line can be drawn linking the influence of the Labor School's theater department with the famous Actor's Workshop, and later with the San Francisco Mime Troupe and the populist Teatro Campesino.[5]

The jewel of the music department was its chorus, which regularly performed labor

songs in four-part harmony and Bach motets, sometimes singing from the backs of trucks at strikes and other labor events throughout the state. One of their most memorable performances took place in 1950 in Chinatown, where the first anniversary of the Chinese Communist revolution was to be marked with the American premiere of Xian Xinghai's 1939 *Yellow River Cantata,* still considered one of the preeminent vocal works of modern Chinese music. The performance erupted into a confrontation when black-garbed Chinese nationalists pelted the audience with open black ink wells.[6]

The California Labor School's visual art department was particularly strong. After the war, California campuses swelled with veterans studying on the GI Bill, and a legendary period of experimentation in the arts blossomed at schools such as the California School of Fine Arts (later renamed the San Francisco Art Institute). The art department of the California Labor School also flourished during this time, rivaling the California School of Fine Arts in size, and well-known Bay Area bohemian and nonobjective painters such as Jean Varda and Robert McChesney served on the faculty. But the Labor School's principal focus was boldly graphic figurative work, at a time when the California School of Fine Arts had eschewed that tradition, going so far as to cover their famous Diego Rivera mural with a curtain.

Sculptor Ralph Stackpole and painters Victor Arnautoff and Anton Refregier were among the important figurative artists who taught at the Labor School, giving it a strong program in mural and fresco painting. The chairman of the art department during this period was Giacomo Patri, who taught popular courses in life drawing. Many women held positions of leadership, including regular faculty members Louise Gilbert and Pele de Lappe and frequent guest instructor Emmy Lou Packard. All of these artists contributed widely to union newsletters with witty illustrations or comics. The celebrated American/ Mexican muralist and printmaker Pablo O'Higgins taught several influential classes in lithography, first in 1945 and again in 1949, and his students remember lugging heavy litho stones home on the streetcar to work on so they would have something ready to print the next day. The gallery at the school also provided an important forum for exhibitions of figurative art.

Although the California Labor School received accreditation in 1944 and even hosted the delegation from the Soviet Union during the founding meeting of the United Nations held in San Francisco in April 1945, by 1946 the mood that had once supported it had started to shift. Tolerance of communist influence waned within the unions and also within the wealthy community that had provided important funding. Both David Jenkins and Holland Roberts were subpoenaed in September 1946 by the state's Un-American Affairs Committee, and a veterans' group petitioned the Veterans Administration to withhold GI Bill financing. Nevertheless, supported by vibrant rank-and-file fund-raisers, the school reached a peak of activity in 1948 and 1949. An extravagant annual artists'

Halloween ball and costume party initiated a tradition that continues in some fashion to this day. And the school continued to cut a radical profile, evidenced by the 1948 publication of "The Communist Manifesto in Pictures," a twenty-page pamphlet with illustrations by art department faculty.

Even though up to five thousand students were taking classes during this period, the school was placed on the Attorney General's subversive activities list in 1948, and Jenkins left the school in 1949. In 1951, the campus was relocated to a smaller building at 127 Divisadero Street, and many departments, including the art department, shrank dramatically. The Graphic Arts Workshop, which had been founded earlier by instructors Victor Arnautoff and Adelyne Cross Eriksson as well as Irving Fromer and others to provide access to printing presses outside the classroom, relocated to Francisco Street and managed to maintain a strong presence in the years that followed. For example, Arnautoff produced a lithograph at the Graphic Arts Workshop caricaturing the young Vice President Richard Nixon, *Dick McSmear,* which created a storm when it was censored from the city's 1954 Arts Commission exhibition. After the loss of its tax-exempt status in 1953 and a subsequent series of financial troubles, the California Labor School's doors were chained shut permanently in 1957.

The closing of the school was not the only example of political pressure that affected California artists and intellectuals during the McCarthy era. The FBI collected huge files about many of these individuals, and several were investigated by the House Un-American Activities Committee. In retrospect, the list of artists and intellectuals who were investigated and/or blacklisted during this period is truly staggering, including internationally recognized figures like Woody Guthrie, Pete Seeger, and Charlie Chaplin as well as many lesser known artists. Hansel Mieth and Otto Hagel were blacklisted from working for mainstream magazines in 1953 for refusing to testify. Beginning in 1950, the Levering Act was implemented, requiring all teachers and university faculty to sign a loyalty oath. Non-signers lost their jobs. In this atmosphere of suspicion and fear, some even suspected that the government was capable of shocking extremes, up to and including murder.

Perhaps it is because so many of these artists left the city that so little has been remembered about them. Both Victor Arnautoff and Anton Refregier eventually relocated to the Soviet Union, and Ralph Stackpole went to France. Others moved to rural communities in Mendocino County. The rush to build a new culture rooted in a monolithic American idealism left little room for artists whose political ideology was increasingly out of step with the times.

Yet their agenda never died; art about labor and political issues persists. The soul of Coit Tower survives as public art programs commission work for both federal and state construction projects. The spirit of the Artists and Writers Union persists in the anonymous wheat-paste posters that regularly appear on city streets, such as the rugged woodcuts of

the 1970s Poster Brigade. And exuberant agitprop performances have resurfaced in countless demonstrations. Artists' co-ops and collectives continue to take up the cause of labor. The aesthetic of activism is still one of California's strongest suits.

notes

1. The research of two scholars has been immeasurably important to the portion of this essay describing the 1930s; Anthony Lee's fantastic *Painting on the Left* (Berkeley: University of California Press, 1999) and Masha Zakheim Jewett's brilliantly researched *Coit Tower, San Francisco, Its History and Art* (San Francisco: Volcano Press, 1983) are invaluable tools in the study of this period.

2. *San Francisco Examiner*, 23 February 1964.

3. This discussion of the Labor School reflects the original research of several people. Robert Cherny has studied archival materials for many years and conducted a research seminar for which John Skovgaard authored a major paper on the Labor School, and his original scholarship is also important here. San Francisco State University Labor Archives and Research Center (LARC) librarians identified relevant documents and materials.

4. Maya Angelou, *I Know Why the Caged Bird Sings* (New York: Bantam Books, 1969).

5. Bill Shields, telephone interview by author, San Francisco, CA, December 2002.

6. The discussion of the music department's chorus is based on several conversations with Carol Coenod, who performed with the chorus during the early 1950s.

NEW DEAL FUNDING for art helped spawn one of California's strongest and most persistent art forms: muralism. Federally sponsored California mural activity both began and ended with big projects in San Francisco. The first, a complex collective effort that covered the walls of Coit Tower in 1934, was the pilot project of the fledgling San Francisco Artists and Writers Union [see page 46]. The last was the monumental twenty-seven-panel frieze painted by Anton Refregier at Rincon Annex, completed in 1948.

Many WPA murals were painted in true fresco—mineral pigments on wet plaster—while others were painted in oil on canvas, wood, or masonite panel. That so many murals from the 1930s have survived is a testimony to their popularity, but the proliferation since that time of murals, often taking their inspiration from labor, in communities throughout California is perhaps the greatest evidence of the continuing relevance of these earlier works.

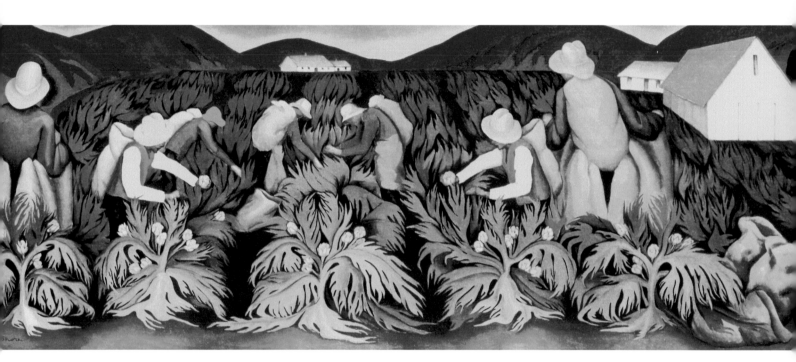

HENRIETTA SHORE's *Artichoke Pickers* is one of the most beautiful of all WPA murals in California. It depicts people working in a field near the Santa Cruz coastline, where the mural was installed. These laborers seem focused on their work and integrated into the warmth of the environment as they wade through knee-high artichokes. Throughout her life, Shore was interested in Eastern religions and endeavored to depict the interconnectedness of things through the harmony of natural forms.

The Canadian-born Shore studied art in New York and London and went on to garner international acclaim for her work. She featured prominently among women modernists in California, and in 1913 she helped found the Society of Modern Artists in Los Angeles. Although Shore traveled extensively in the intellectual circles of the 1920s— she was a friend of Edward Weston's in Los Angeles and painted a portrait of José Clemente Orozco in Mexico—her artistic career seems to have ended early; the Santa Cruz murals she painted after her 1930 move to Carmel are among her final works.

Plate 44. Henrietta Shore, *Artichoke Pickers*, 1936, oil on masonite panel, 21" x 72"

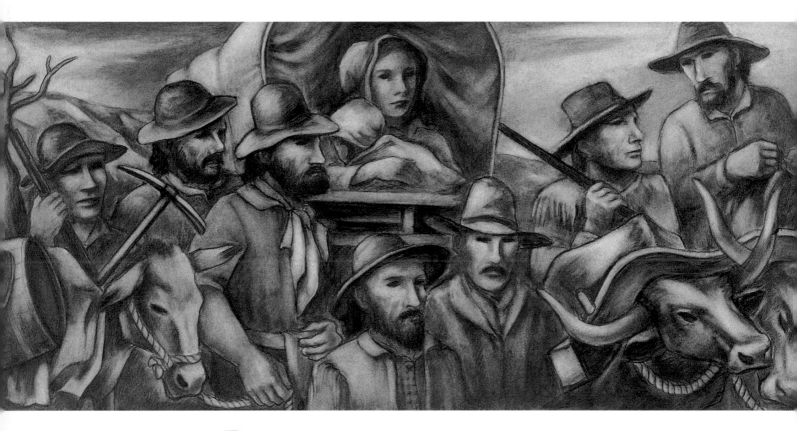

BORIS DEUTSCH's mural for the Terminal Annex post office in Los Angeles presents a historical perspective on California labor history, incorporating scenes from the nineteenth century. In the crowded composition of this study for the mural, gold rush miners face an uncertain future in a bleak landscape with the tools of their trade: mule, pickax, and firearm.

Lithuanian-born Boris Deutsch immigrated to the United States after studying art in Europe. He shared a studio with Jackson Pollock and Ben Shahn before going to work as a federally funded muralist. He later worked as a successful commercial artist in Hollywood and taught at the Otis Art Institute.

Plate 45. Boris Deutsch, *1848 Gold! In 1848 The Great Trek for Gold*,
1946, mural study, detail, watercolor and gouache mounted on cardboard, 24" x 24"

ANTON REFREGIER'S Rincon Annex panel commemorating the 1934 General Strike is a brilliant synthesis of art and political history. The twenty-seven-panel series was the last major commission of the WPA, and it was probably the most controversial; ninety-two changes were made in response to the concerns of special-interest groups. The pointed angularity of Refregier's composition and drawing style conveys an edginess associated with the expressionist style of Orozco, and also with El Greco's work of centuries earlier. The center of the panel depicts an organizer pointing to the left while addressing a group of longshoremen in white hats. Looking in the direction of his gesture, we see a representation of men reaching out for waterfront work—the "shape up," an unfair system for distributing work and a major issue in the strike. This image seems to be drawn from the famous photograph by Hagel and Mieth (see Chapter 2). The disembodied hand dropping coins into the palm of another, white-cuffed and jacketed, borrows imagery used by Fra Angelico in Renaissance Florence but here alludes to the graft that was a bitter point of contention along the waterfront. On the right side, a newspaper headline proclaims the successful outcome of the strike, while a bouquet of calla lilies reminds us of the horrible cost. The standing figures at the right edge are the fallen strikers—now remembered as American heroes.

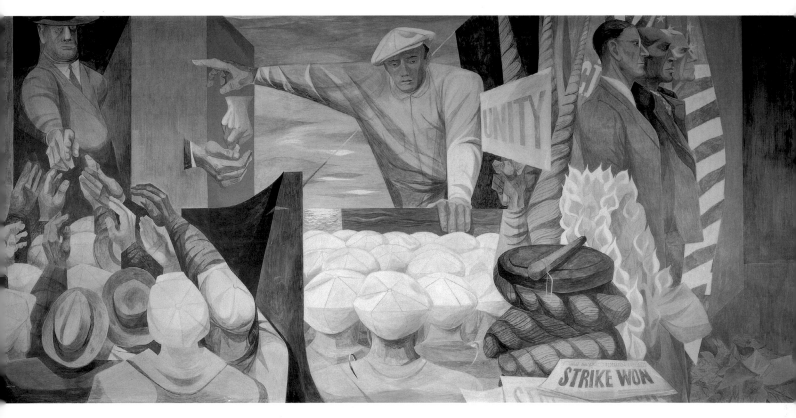

Plate 46. Anton Refregier, *Maritime and General Strike*, 1946–1948, casein-tempera on white gesso over plaster wall, Rincon Center, San Francisco

PELE DELAPPE's caricature of the California Labor School faculty is a snapshot of key teachers at the school during one term in the 1940s. Director David Jenkins leans over a book in the foreground, while Cultural and Art Department Director Holland Roberts sits smiling behind him. A wide range of creative disciplines, including music and dance, are represented by the faculty pictured, mostly clustered at the back of the illustration. Visual arts instructor Leo Nitzberg is seen holding a camera, painter Victor Arnautoff dabs with a brush, and printmaker Adelyne Cross Eriksson appears in profile. The illustration's creator, Pele deLappe, is seen peeking out from behind her drawing pad at the back right corner.

1. Mimi Kagan **2.** Adelyne Cross Eriksson **3.** Herman Griffin **4.** Leo Christiansen **5.** Lily Anne Killen **6.** Victor Arnautoff **7.** Gordon Mosteller **8.** David Sarvis **9.** Winnie Mann Sarvis **10.** Avrum Rubenstein **11.** Pele deLappe **12.** Leo Nitzberg **13.** Gordon Williams **14.** Gilbert Daunic **15.** George Hitchcock **16.** Genevieve Blue Sinel **17.** Ernestine Gatewood **18.** ? **19.** Peggy Sarasohn **20.** Irwin Elber **21.** Julian Hicks **22.** Hazel Grossman **23.** Holland Roberts **24.** Dave Jenkins **25.** Harry Williams **26.** Celeste Strack **27.** Jules Carson

Plate 47. Pele deLappe, *California Labor School Faculty,* ca. 1945, offset, 7½" x 9½"

DURING OTHER TERMS, the art faculty included Ralph Stackpole, the premiere sculptor of his day. In this poster created by Louise Gilbert to advertise his class, a stonecutter's mallet overlays a clay modeling tool, underscoring the importance of the tools of art-making. Gilbert created hundreds of flyers for art and political events, often—as spelled out on some graphics—with labor donated.

Plate 48. Louise Gilbert, *Study Sculpture with Ralph Stackpole*, ca. 1945, original art for poster, 9¼" x 12¼"

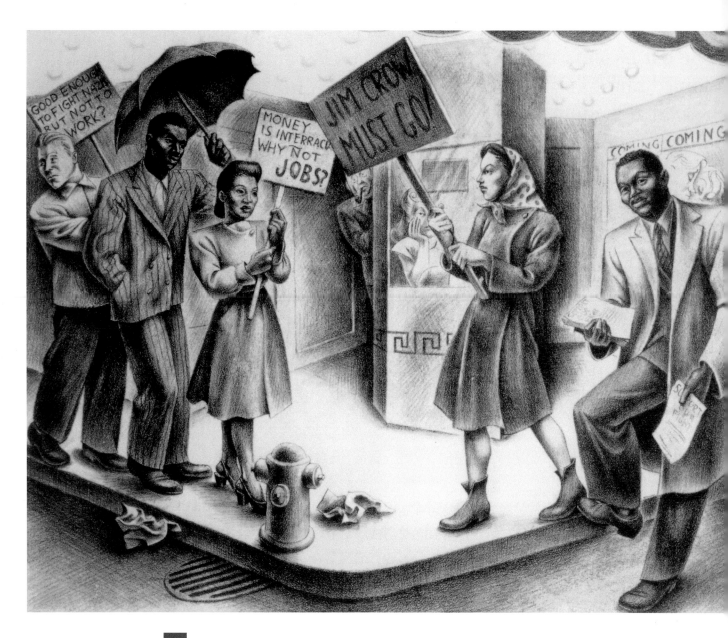

TWO IMPORTANT ARTISTIC themes surface in many of the works created by artists at the California Labor School and the related Graphic Arts Workshop: racism and labor. The struggle for racial equality in California emerges as a central theme in works by artists of varying ethnicity, reflecting the diversity of the school's students as well as its progressive atmosphere. In Pele deLappe's *Uptown Theater Picket Line,* we witness the picketing of a San Francisco movie theater, the Fillmore district's Uptown, where African Americans were welcomed in the audience but not as employees. In this crowded composition, the sidewalk is filled with an interracial group holding placards while a nervous manager peers out from behind the box office.

An expert lithographer, deLappe was also noted for her caricatures, a skill she learned as a child from her father, a well-known illustrator. DeLappe's caricatures appeared in such publications as *The People's World,* the Communist newspaper of the West Coast, to which Woody Guthrie contributed a regular musical column.

Plate 49. Pele deLappe, *Uptown Theater Picket Line,*
ca. 1945, dimensions unavailable, present location unknown

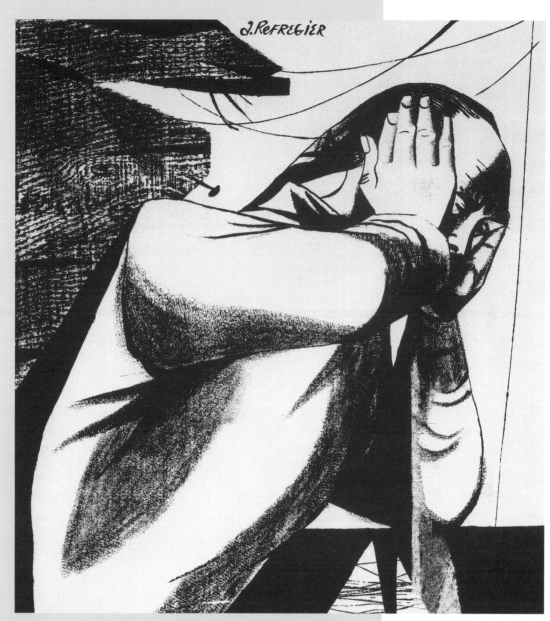

ANTON REFREGIER's *Untitled* woodcut depicts a figure leaning forward in pain. We can assume, from the subject's profile and because his hair is braided in a queue, that he is a Chinese man. The angularity of the composition communicates a sense of anguish, possibly linked to the racist treatment of Chinese by the Workingman's Party in the late nineteenth century. The pose of the figure recalls the famous Renaissance masterpiece by Massacio, *The Expulsion from Paradise*, transforming this portrait of an anonymous Chinese individual in California into a kind of everyman unfairly evicted from the garden of opportunity.

Plate 50. Anton Refregier, *Untitled*, ca. 1949, color lithograph, 14" x 12½"

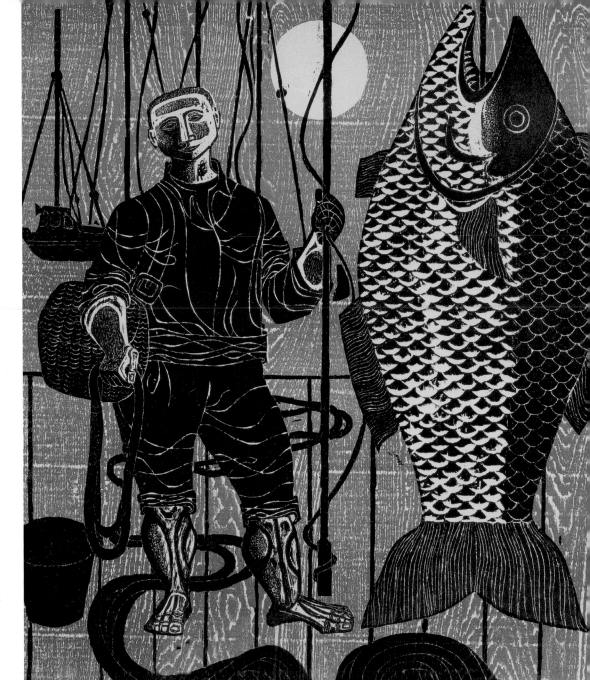

AN EVEN more common theme among the California Labor School artists is work itself. Louise Gilbert's elegant woodcut of a fisherman and his catch plays the lines in the fisherman's clothes against the sinewy shapes of his fishing lines and the rigging behind him. The woven tackle box under his arm repeats the shapes of the scales of his monstrous catch, which are rendered in a way that lends the image the sense of a Japanese print.

Gilbert relocated from Oregon to the Bay Area during the Second World War. She studied at the California Labor School under Refregier and later became his assistant at the Rincon Annex mural project. She supported herself as a drill-press operator in an airplane factory and as a draftswoman for Bethlehem Steel, and she is remembered for her efforts to organize draftspeople into a union. Her postwar refusal to sign the loyalty oath led to her being blacklisted from government employment. Gilbert was an important early member of the Graphic Arts Workshop, and her lifelong commitment to political activism can be seen throughout her art.

Plate 51. Louise Gilbert, *Fisherman,*
ca. 1950, screenprint, 19" x 16¾"

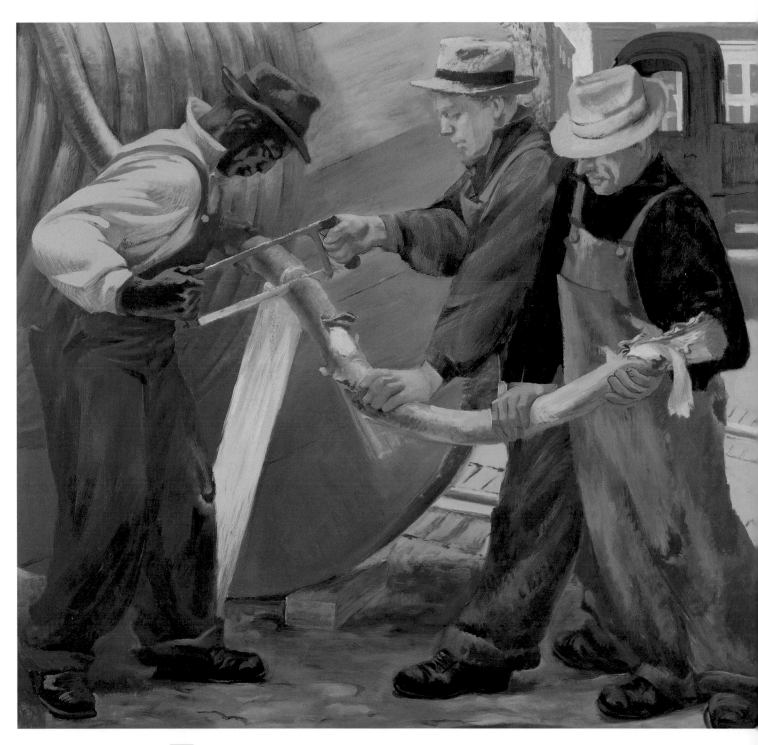

THIS IMAGE by Victor Arnautoff and the next, by Emmy Lou Packard, of men in overalls, the laborer's uniform of the day, evoke the lyrics of Malvina Reynolds's song "Bury Me in My Overalls," which was published in a songbook by the California Labor School in 1954. These works convey subtle but interesting contrasts in mood: the Packard communicates vigor and movement, while the Arnautoff expresses a sense of fatigue.

Plate 52. Victor Arnautoff, *Cable Men*, ca. 1948, oil on canvas, 45" x 49"

Bury Me in My Overalls

Bury me in my overalls, don't use my gabardine,
Bury me in my overalls or in my beat-up jeans,
Give my suit to Uncle Jake,
He can wear it at my wake,
And bury me in my overalls.

The undertaker will get my dough, the grave will get my bones,
And what is left will have to go for one of those granite stones,
But this suit cost me two weeks pay
So let it live another day,
And bury me in my overalls.

The grave it is a quiet place, there is no labor there,
And I will rest more easy in the clothes I always wear.
This suit was made for warmer climes,
Holidays and happy times,
So bury me in my overalls.

And when I get to heaven, where they tally work and sin,
They'll open up those pearly gates and holler, "Come on in!
A working stiff like you, we know,
Has had his share of Hell below
So come to glory in your overalls!"

Song lyrics by Malvina Reynolds

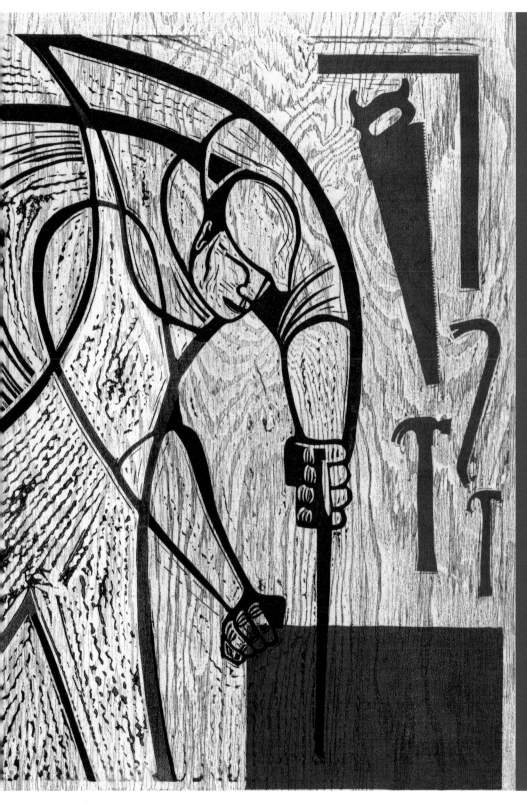

EMMY LOU PACKARD developed a distinctive and influential graphic style during her long career, which spanned half a century. She met Diego Rivera in Mexico when she was only fourteen and they became lifelong friends. She was his principal assistant on *Pan-American Unity*, the mural created in 1940 for the Golden Gate International Exposition on Treasure Island (today installed at San Francisco City College). To quote from a 1998 exhibition catalog of her work at the Natsoulas Gallery in Davis, "Her prints have been said to resemble murals, which is not surprising. An overall sense of monumentality, stylized forms, graphically drawn body parts, and dramatic gesture communicate a heroic essence."

Plate 53. Emmy Lou Packard, *Carpenter*, ca. 1950, woodcut, 16" x 12"

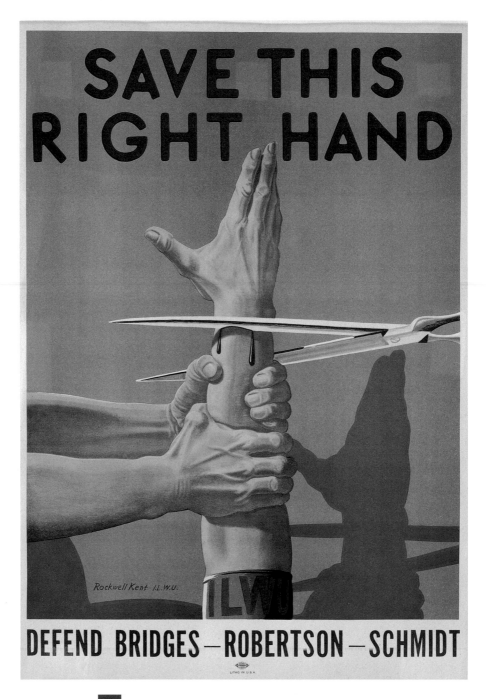

THROUGHOUT THE 1930s and 1940s, California politics and art were attracting national attention. Still in prison, Tom Mooney had become a national symbol, and the works of Steinbeck and Lange were widely read and seen. International artists like Rockwell Kent weighed in by contributing posters supporting Harry Bridges, who was repeatedly arrested, his loyalties continually questioned. This unforgettable image features oversize scissors nightmarishly closing in on a worker's hand that is raised in solidarity.

Kent had lived in Los Angeles and was a close friend of Bridges. A rugged adventurer and socialist sympathizer, Kent was one of the most famous illustrators of his day.

Plate 54. Rockwell Kent, *Save This Right Hand,*
1949, color lithograph, 15½" x 11"

R EFREGIER WAS born in Moscow and had worked as an artist in New York. He maintained a national profile after moving to the Bay Area, promoting the aesthetic vision of labor and the California Labor School through his murals, his teaching, and his widely seen magazine illustrations. In this crowded scene, workers cluster behind the heavy gate of a mine elevator. Their lanterns and eyes are visible, but their mouths are obscured, suggesting that they are voiceless.

Late in his life, Refregier returned to Moscow, where he was a tireless promoter of world peace and other social ideals.

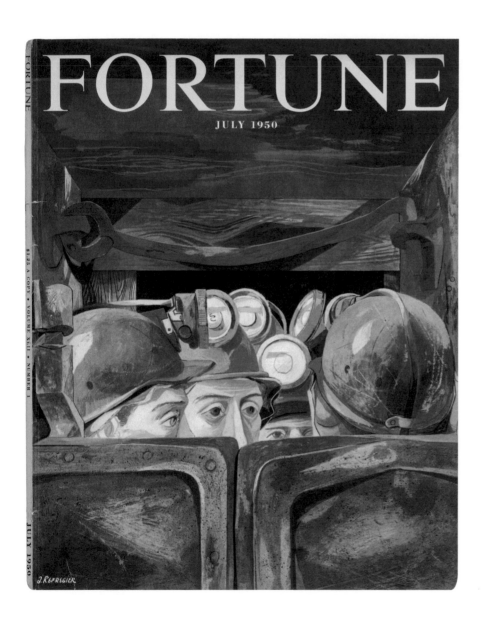

Plate 55. Anton Refregier, *Fortune*,
July 1950, cover illustration

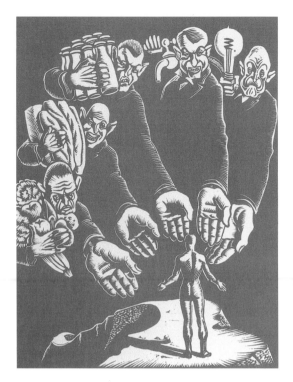

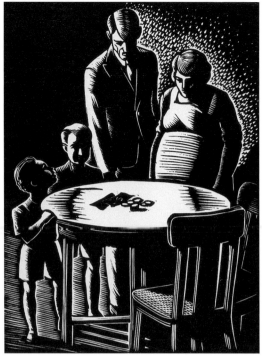

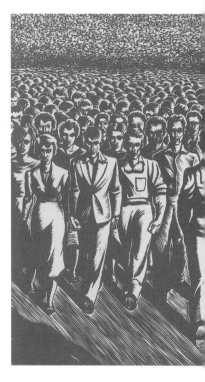

ANOTHER HALLMARK of the artistic community that congregated around the California Labor School was its powerful graphic style. In 1940, art department chairman Giacomo Patri, a former student of Ralph Stackpole's who went on to head his own art school, published an entire novel of linocut imagery. Unfolding in stark, monochromatic pictures with no text, his novel recounts the experiences of an artist in the years after the 1929 stock market crash. Unable to find work with advertising agencies, the novel's protagonist loses his house just as his wife informs him that she is pregnant. He soon learns that he shares much with blue collar workers and, like them, can benefit from union organizing.

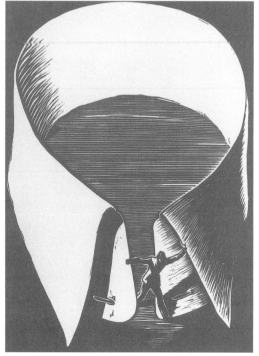

Plate 56. Giacomo Patri, pages from *White Collar*, 1940, novel in linocuts

IRVING NORMAN found himself changed when he returned to California after serving in the Abraham Lincoln Brigade during the Spanish Civil War. He is remembered as having said that there are only two kinds of people, "those who have seen war and those who haven't." The intensity of his vision reflects his membership in the former category. Although Norman found little support in San Francisco's art establishment, Patri helped arrange for the exhibition of his work at the California Labor School's Tom Mooney Gallery and contributed a glowing review.

In Norman's brilliant 1941 drawing, *The City,* San Francisco is seen as if through the lens of Fritz Lang's influential 1927 silent film *Metropolis.* The sculptural ornamental figure on the left, which is drawn from the Masonic Temple of California in San Francisco's Civic Center, looks over the teeming mass of white collar commuters like Dante witnessing the inferno. The streams of workers that crowd the street bury one another in their oblivious hurry. The two figures supporting the columns in front of the neoclassical building on the right, which references San Francisco City Hall, are being crushed by the weight they carry.

Plate 57. Irving Norman, *The City,* 1941, pencil on paper, 30" x 24"

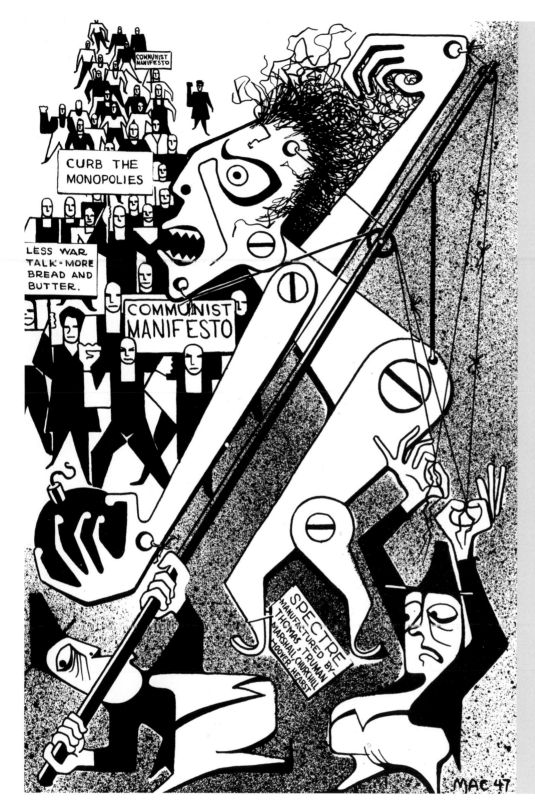

THE POLITICAL idealism of this generation of artists and intellectuals came into sharp conflict with the shift in American ideology that took place after the Second World War. The publication of the *Communist Manifesto* with illustrations by California Labor School art department faculty flew in the face of the increasingly repressive attitude exemplified by Senator Joseph McCarthy. The publication included this illustration by noted Bay Area artist Robert McChesney. Although McChesney is known for his abstract expressionist painting and sculptural works, his early illustrations are typical of the Labor School approach to the graphic depiction of labor.

Plate 58. Robert McChesney, "A Specter Is Haunting Europe," illustration for *The Communist Manifesto in Pictures*, 1948, 10¼" x 7"

HUNDREDS OF CALIFORNIA teachers lost their jobs for refusing to sign the Levering Act oath, which required government employees to certify that they were not members of vaguely defined un-American organizations: "...nor am I a member of any party or organization, political or otherwise, that now advocates the overthrow of the government by force or violence." Several faculty members at San Francisco State University refused to sign the Levering Act oath and were promptly dismissed, including young artist Frank Rowe and noted poet John Beecher. Pictured in this photograph by Hansel Mieth, created in Rowe's living room on Alabama Street in San Francisco, are (from left to right): Dr. Leonard Pockman, Charlotte Howard, Marguerite Rowe, Frank Rowe, John Beecher, Dr. Eason Monroe, Phiz Mozzeson, and Dr. Herb Bisno.

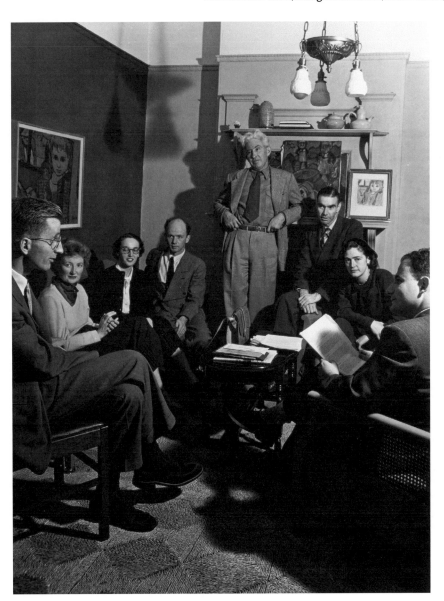

In the poem "Reflections of a Man Who Once Stood Up For Freedom," published in his collection *Report to the Stockholders & Other Poems,* Beecher recollected:

I'd say that gesture cost enough
But who can reckon up these things?
I'll hardly live to see the day
When I'll be justified at last.
And so I got the old heave-ho
From my profession as perhaps
I should have known and after that
I found myself an outcast.

Rowe eventually chronicled his experiences in *The Enemy Among Us: A Story of Witch-Hunting in the McCarthy Era* and continued to create artwork that valorized those who suffer injustice [see page 24]. Through the activism of many people, including Beecher and Rowe, the Levering Act was overturned—but not before irreparably transforming the lives of those who refused to comply because they believed it was unconstitutional.

Plate 59. Hansel Mieth, *Non-Signers of Levering Act of SF State Faculty,* 1950, gelatin silver print, 14" x 11"

INDIVIDUAL SOUTHERN CALIFORNIA artists also portrayed the struggle for solidarity in their work during the 1940s and 1950s. Domingo Ulloa's *Painters on Strike* shows reptilian painters being dumped out of a garbage can by a cigar-smoking boss in an obvious attempt to break a strike— "the company owner bringing in scabs," as Ulloa put it.

Ulloa was born in California but studied art in Mexico. A house painter and member of the painters' union, he said this image was inspired by a seven-week strike in which he participated.

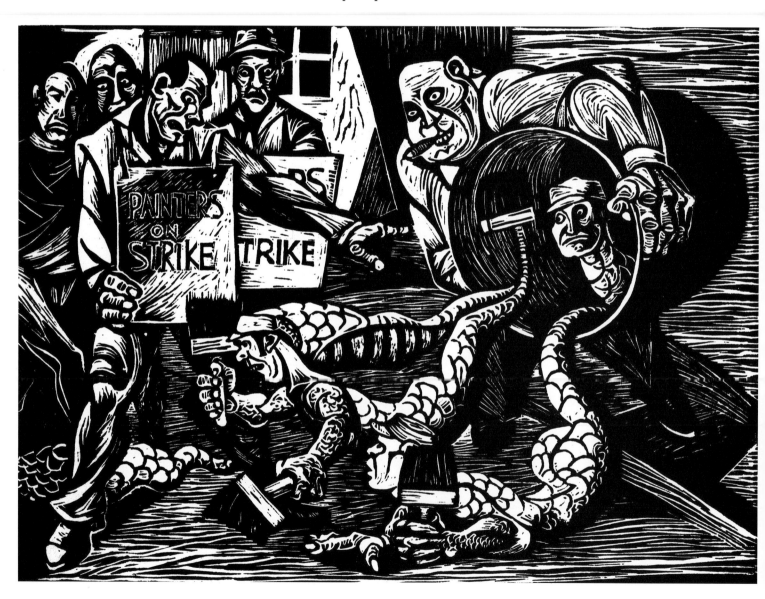

Plate 60. Domingo Ulloa, *Painters on Strike*, 1948, linocut, 10¹/8" x 14³/8"

EDWARD BIBERMAN's *Labor Day Parade,* like Modotti's *Campesinos (Workers Parade)* [see page 15], focuses on the bodies of the men and women carrying signs and placards, rather than on their faces, signifying once again that unity is more powerful than solitary expression.

Edward Biberman had been educated in both economics and art in Pennsylvania before moving to Los Angeles in 1936, where he taught and authored several books about painting.

Plate 61. Edward Biberman, *Labor Day Parade,* 1940, oil on canvas, 31¾" x 39¼"

SUPPORT THE STRIKING MINERS IN STEARNS, KENTUCKY

BENEFIT WITH BILL WORTHINGTON SPEAKING, MUSIC AND FILM

DONATION $1.50

BORN IN HARLAN COUNTY, BILL WORTHINGTON HAS WORKED IN THE MINES 33 YEARS AND IS REGIONAL DIRECTOR OF THE BLACK LUNG ASSOCIATION. HE WILL SPEAK ON BLACK LUNG AND THE STEARNS MINERS YEAR LONG STRIKE FOR A CONTRACT THAT WILL GUARANTEE HEALTH AND SAFETY.

THURS. FEB. 2ND 8PM FRI. FEB. 3RD 8PM

AT **La Peña** cultural center 3105 SHATTUCK AVE BERKELEY AT **MISSION CULTURAL CENTER** 2868 MISSION ST. SAN FRANCISCO

SPONSORED BY THE FRIENDS OF THE STEARNS MINERS, 2160 LAKE ST. SF 94121/PROCEEDS WILL GO TO THE STEARNS STRIKE

NOT FOR SALE - PLEASE POST PUBLICLY - San Francisco Poster Brigade, PO BOX 31428, SF CA 94131 INKWORKS LABOR DONATED

THE GRAPHIC ARTS
Workshop outlived the California Labor
School and has a rich visual history of its own,
although the political focus eventually fell
away. Other printmaking collectives have since
surfaced with similar goals and graphic styles.
The San Francisco Poster Brigade (the then-
anonymous effort of artists Wilfred Owens,
Rachel Romero, and others) revived the high-
contrast woodcut style associated with
Mexican *tallers* in works that promoted inter-
national worker solidarity. Similarly, Ruckus,
Art and Revolution, and other recent anony-
mous artist collectives have organized agit-
prop street theater and installations akin
to Kenneth Rexroth's Blue Blouse Troupe of
seventy-five years earlier and Woody Guthrie's
flatbed truck concerts with Cisco Houston dur-
ing the 1930s.

Plate 62. San Francisco Poster Brigade, *Support the Kentucky Miners,*
ca. 1978, poster, 16¾" x 11"
Plate 63. Art and Revolution, *Burn the Boss (May Day Parade in San Francisco),*
2000, digital image

El Valle Central: A Chicano Art Perspective

Tere Romo

> Some works exist forever invoked, always in performance. Invoked art is communal and speaks of everyday life.
>
> *Gloria Anzaldúa*[1]

The Chicano Movement began in the 1960s when political activism in California was reaching a new peak. The movement sought to forge a new, more positive sense of identity for California's Chicano population. Labor issues were central to this cause, and César Chávez, Dolores Huerta, and other Latino labor leaders emerged as icons struggling not simply for improved working conditions but for self-determination and community pride. The movement's powerful sociopolitical goals in turn inspired a number of artists-turned-activists to launch an art movement. These artists produced work that promoted their rights as workers and citizens, blurring the lines between art and politics and also between notions of "high" and "low" art. Much of this work also established the indigenous ties of Chicanos/as to the American continent and affirmed their historical presence in California.

The contested history of Mexican America can be traced back to the 1848 Treaty of Guadalupe Hidalgo, when the territory known as Alta California ceased to exist. After the Mexican American War, land that had been under Mexican jurisdiction was seized by the United States. Although the treaty promised the new U.S. citizens political and property rights, the reality proved to be very different.[2] By 1880, much of the land the Californios had owned had been sold in order to meet the expenses involved in confirming land titles after the conquest. In the years that followed, the balance was lost through violence, intermarriage, and lack of "legal documents."[3]

During the course of California's subsequent agricultural and industrial development, the fortunes of its Mexican population, never quite accepted as equal, rose and fell according to the demand for cheap labor. Between 1900 and 1920, Mexicans became the major source of agricultural labor in California as the Mexican Revolution drove thousands into the United States.[4] But in the 1930s, as the country grappled with the Depression, thousands of Mexicans—many of them American citizens—were repatriated to Mexico. This is not to say that farm laborers did not resist exploitation through unionizing efforts in these

Plate 64. Francisco J. Domínguez,
Infrared Photograph of Agricultural Worker,
ca. 2000, photograph, 13½" x 9"

very difficult times. As early as 1913, workers had protested in Wheatland and there were bloody encounters recorded in 1928 in the Imperial Valley. For Mexicans, unions were an outgrowth of groups such as the patriotic committees and funeral associations that formed in this country out of necessity. An example of one such organization was the Los Angeles–based Confederación de Uniones Obreras Mexicanas, which formed in 1927 and was active in the Imperial Valley.[5] In 1933 near Corcoran, eighteen hundred cotton workers, the majority of them Mexican, went on strike. In the face of the murder of two strikers by vigilante groups paid by the growers, the strikers won an increase in wages.[6] Three years later, lettuce pickers in the Salinas Valley mounted a strike that, although unsuccessful, continued the fight for better wages, living conditions, and societal visibility.

In the wartime economy, the demand for labor was so high that farm laborers—called *braceros,* derived from the Spanish word for "arms"—were shipped in from Mexico, beginning with fifteen hundred workers who arrived in Stockton in 1942.[7] Over the duration of the program, which lasted until 1964, more than four million Mexicans came to work in the fields and to maintain the railways of the United States.[8] Braceros served as a phantom labor force without any civil rights, since their contracts were controlled by independent farmers' associations and the federal Farm Bureau. A steady, low-wage workforce without the protection of unionization, they perfectly fulfilled the goal of agribusiness, limiting the ability of native-born laborers to unionize. Even Lee G. Williams, the U.S. Department of Labor officer who oversaw the program, described it as a system of "legalized slavery."[9]

Mexicans in California have been cast as foreigners in their own home, initially as a conquered people to be assimilated and, more recently, as subhuman laborers available on demand. Mexican American laborers were thus rendered powerless, serving as the subservient workforce of factories and farms, as a silent, nonvoting block of the population, and as the passive recipients of inadequate living conditions, poor education, and generational poverty.

The Chicano Movement of the mid-1960s was to challenge this longstanding notion of the Mexican American as the "sleeping giant." California's Central Valley, home to large concentrations of Mexicans and people of Mexican descent as well as to the state's capital, became an epicenter for many of the defining moments of the Chicano Movement.

> We shall unite. . . . We must use the only strength we have, the force of our numbers. The ranchers are few; we are many. United we shall stand [and] we shall strike. . . . The time has come for the liberation of the poor farm worker.
>
> *United Farm Workers, "El Plan de Delano"*[10]

The Chicano Movement, *El Movimiento,* emerged as activists drew national attention to the social and economic plight of the Mexican American in this country. In California,

La Causa began with the events that led to the formation of the United Farm Workers and the union's struggle to gain recognition. First for the Community Service Organization and then for his own Farm Workers Association, a tireless César Chávez had been meeting with farm workers in groups and in their homes. Longtime activist Dolores Huerta joined him in 1962 when the National Farm Workers Association (NFWA) was formally established. On September 8, 1965, Larry Itliong, a Filipino organizer for the Agricultural Workers Organizing Committee (AWOC), organized a strike by Filipino and Mexican grape pickers in Delano, a small town north of Bakersfield. When the growers began to bring in Mexican workers to break the strike, Itliong approached Chávez to join the mostly Filipino strikers. Chávez called a meeting of the NFWA on September 16 at Our Lady of Guadalupe Church in Delano to discuss the strike action and vote on it. The vote was unanimously in support of joining the strike.

The NFWA was very successful in galvanizing national political and economic support from other labor leaders, students, artists, and community activists. A key issue, along with decent wages and housing, was the spraying of hazardous pesticides on farm workers as they toiled in the fields. When Schenley Farms intentionally sprayed strikers, Chávez decided to lead a march to Sacramento. Beginning in Delano on March 17, 1966, with seventy strikers, the *peregrinación* (the pilgrimage) gathered hundreds of participants along the 340-mile walk. They arrived on Easter morning and held a demonstration in front of the state capitol. There Chávez was able to announce to the ten thousand protesters who had joined him that Schenley had agreed to sign an agreement with the NFWA. That summer, the NFWA and AWOC voted to became one union, which became known as the United Farm Workers Organizing Committee (UFW). By 1970, with over fifty thousand members, the UFW had become the largest union of farm workers in the United States. In 1973, at its first convention in Fresno, 346 delegates represented a membership of sixty thousand.

In California's Central Valley, Chicano/a artists played a seminal role in the development of the Chicano movement for civil rights, especially within the UFW struggle. The Central Valley was home to pivotal cultural centers and artist collectives, such as La Brocha del Valle in Fresno and the Royal Chicano Art Force of Sacramento. In 1965, aspiring playwright Luis Valdez left the San Francisco Mime Troupe to join César Chávez's organization in Delano. Using theater techniques from vaudeville and *teatro de carpa* (tent theatre) popular in the nineteenth century, he created the theater group El Teatro Campesino. On a flatbed truck, the Teatro would travel to different camps and perform one-act plays that educated farm workers about the value of unionizing.

This kind of artistic activism in the Central Valley helped to inspire a re-articulation of Mexico's cultural legacy by Chicano artists within the state. This was expressed through the proliferation of two public art forms that became synonymous with Chicano art: murals

and posters. Very often artists used these media to portray the ongoing plight of farm workers. In fact, the first documented Chicano mural, by Antonio Bernal, was painted in 1968 on the wall of the Teatro Campesino's headquarters in Del Rey, a small town outside of Fresno.[11] Prominently featured in a procession of illustrious leaders of the Mexican Revolution and U.S. civil rights movement is César Chávez waving the UFW flag. Subsequent murals painted in rural and urban neighborhoods celebrated Mexican cultural images and promoted awareness of the farm workers' struggles.

The evolution of Chicano poster art also began in 1965, as collectives such as La Brocha del Valle and the Royal Chicano Air Force became active centers for the production of posters on behalf of the UFW's organizing efforts. Individual artists such as Rupert García, Ester Hernández, and Malaquías Montoya also produced posters in support of the UFW. The UFW thunderbird logo grew in prominence through its use as the primary or sole image on all official UFW graphics, as well as its inclusion on unofficial posters by Chicano artists in support of the union's efforts.

Combined, the work of Central Valley artists shares many of the attributes of Chicano art throughout the Southwest: bicultural sources (Mexico and the United States); emphasis on community-based control; and a goal of enhancing and advancing cultural self-determination.[12] However, in creating art from the perspective of the Central Valley farm worker, these artists expanded the definition of "Chicanismo" beyond the urban political centers of the Southwest and greatly influenced the development of Chicano artistic iconography.

Like other Chicano artists of this period, the Central Valley Chicano artists were heavily influenced by the Mexican artists before them who had "dedicated themselves to art not for its intrinsic value alone, but also for its value as social criticism."[13] In recapturing this Mexican artistic legacy, they succeeded in creating a new, uniquely Chicano aesthetic that spoke of the experience of America, and within that, California's Central Valley. Their significance can be measured by the varied artistic styles and techniques that have secured a place for them within Chicano art history. Certainly, the international recognition they brought to the Central Valley is notable. Perhaps more importantly, their art made the Mexican population, especially the workers of this state, visible again. In drawing attention to the historically invisible workers of the land, they have invoked a living and human history on this landscape called *el valle central.*

notes

1. Gloria Anzaldúa, *Borderlands /La Frontera: The New Mestiza,* (San Francisco: Aunt Lute Press, 1987).
2. Carey McWilliams, *North From Mexico* (Philadelphia, J. B. Lippincott Co., 1949; reprint, New York: Greenwood Press, 1968), 51 (page citations are to the reprint edition).

3. McWilliams, *North from Mexico*, 91.

4. Ernesto Galarza, *Farm Workers and Agri-business in California, 1947–1960*, (Notre Dame: University of Notre Dame Press, 1977), 8.

5. Ibid., 13.

6. www.farmworkers.org/strugcal.html.

7. McWilliams, *North from Mexico*, 266.

8. Though the Bracero Treaty ended on May 30, 1963, Mexican agricultural laborers were utilized until 1964.

9. www.farmworkers.org/bracerop.html.

10. Luis Valdez and Stan Steiner, eds., "The Plan of Delano" in *Aztlan: An Anthology of Mexican American Literature* (New York: Vintage Books, 1972), 200-201.

11. Richard Griswold del Castillo, Teresa McKenna, and Yvonne Yarbro-Bejarano, eds., *Chicano Art: Resistance and Affirmation, 1965–1985* (Los Angeles: University of California at Los Angeles Wight Art Gallery, 1991), 143.

12. Ramón Favela, *Chicano Art: A Resource Guide, Proyecto CARIDAD* [Chicano Art Resources Information Development and Dissemination], (Santa Barbara: University of California, California Ethnic and Multicultural Archives (CEMA), 1991), 2.

13. Griswold del Castillo et al., *Chicano Art*, 118.

THE EXPERIENCES of multi-ethnic migrant workers in California's agricultural communities have been the focus of art since before the Dust Bowl migration. However, the experiences of Mexican American laborers have proven especially inspirational to the artists of that community, to the extent that the results have been referred to as the California Chicano Art Movement. Whether or not the immigrant workforce came to California "legally," as was the case in the federally managed *bracero* program, the physical and psychological conditions that affect workers have been portrayed powerfully .

DOCUMENTARY PHOTOGRAPHER Leonard Nadel captured a shocking moment of indignity in 1956: *bracero* workers being paraded naked in a line to be deloused, sprayed in the face with DDT. Nadel traveled five thousand miles from California through Mexico and back to document conditions in the camps, which included, in his words, "filthy living quarters, overcrowded conditions, inadequate and disease-ridden sanitary facilities. [T]he faces of the men . . . mirrored their problems and their complaints." Arrested in Mexico for taking pictures of *bracero* recruitment, Nadel later recalled that the "conditions I had witnessed stirred me deeply."

Plate 65. Leonard Nadel, *Untitled, from the Braceros series (men being sprayed with DDT)*, 1956, photograph, 11" x 14"

In Domingo Ulloa's oil painting *Bracero*, we sense the hardships imposed by a program that limited economic and social opportunity for thousands. The substandard housing seen in the background of this painting gives an indication of the conditions that were common. Ulloa observed that the workers "were detained in barbed wire corrals, living in little wooden shacks, and the temperature would hit 110 degrees."

In August 1993 Ulloa was recognized by the California State Assembly as the "Father of Chicano Art," yet his achievements are still little known.

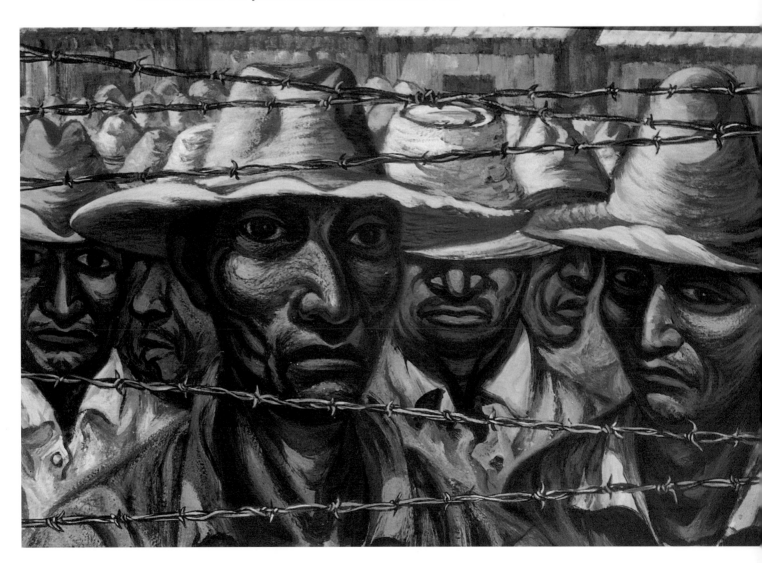

81

Plate 66. Domingo Ulloa, *Bracero,*
ca. 1960, oil on canvas, dimensions unavailable, present location unknown

MALAQUÍAS MONTOYA's *Yo Vengo del Otro Lado* reminds us of the diverse communities of Central America and Mexico represented in the California workforce, and it protests the scape-goating of immigrant workers that often occurs during hard times.

Montoya was raised in a family of California farm workers and is currently a professor in the Chicano Studies program at the University of California, Davis. He is widely known for screenprints and murals that often incorporate text with powerful imagery.

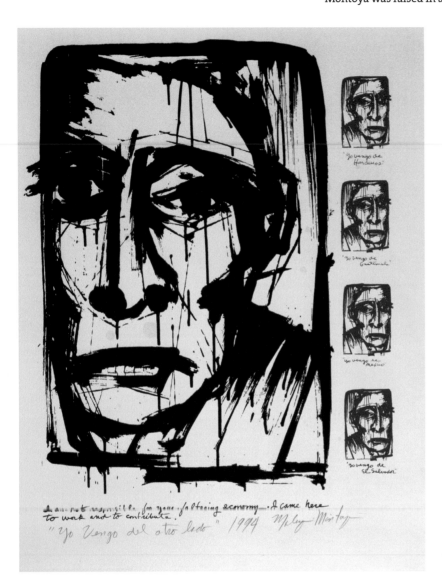

Plate 67. Malaquías Montoya, *Yo Vengo del Otro Lado (I Come from the Other Side)*, 1994, screenprint, 20" x 22"

A Red Palm

You're in this dream of cotton plants.
You raise a hoe, swing, and the first weeds
Fall with a sigh. You take another step,
Chop, and the sigh comes again,
Until you yourself are breathing that way
With each step, a sigh that will follow you into town.

That's hours later. The sun is a red blister
Coming up in your palm. Your back is strong,
Young, not yet the broken chair
In an abandoned school of dry spiders.
Dust settles on your forehead, dirt
Smiles under each fingernail.
You chop, step, and by the end of the first row,
You can buy one splendid fish for wife
And three sons. Another row, another fish,
Until you have enough and move on to milk,
Bread, meat. Ten hours and the cupboards creak.
You can rest in the backyard under a tree.
Your hands twitch on your lap,
Not unlike the fish on a pier or the bottom
Of a boat. You drink iced tea. The minutes jerk
Like flies.

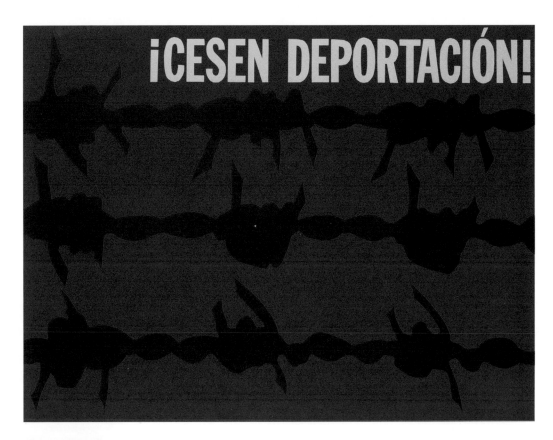

¡CESEN DEPORTACIÓN!

It's dusk, now night,
And the lights in your home are on.
That costs money, yellow light
In the kitchen. That's thirty steps,
You say to your hands,
Now shaped into binoculars.
You could raise them to your eyes:
You were a fool in school, now look at you.
You're a giant among cotton plants.
The lung-shaped leaves that run breathing for miles.

Now you see your oldest boy, also running.
Papa, he says, it's time to come in.
You pull him into your lap
And ask, What's forty times nine?
He knows as well as you, and you smile.
The wind makes peace with the trees,
The stars strike themselves in the dark.
You get up and walk with the sigh of cotton plants.
You go to sleep with a red sun on your palm,
The sore light you see when you first stir in bed.

Gary Soto

GRAPHIC WORKS are some of the greatest achievements of the Chicano Art Movement. Rupert García, an international figure in political graphic art, here isolates the jagged forms of barbed wire as a metaphor for the cruelly contradictory California economy that exploits undocumented workers and then deports them. García's silk-screened posters played an inspirational role during the 1968 strike at San Francisco State University.

83

Plate 68. Rupert Garcia, *Cesen Deportación!*, 1973, screenprint, 18¾" x 25"

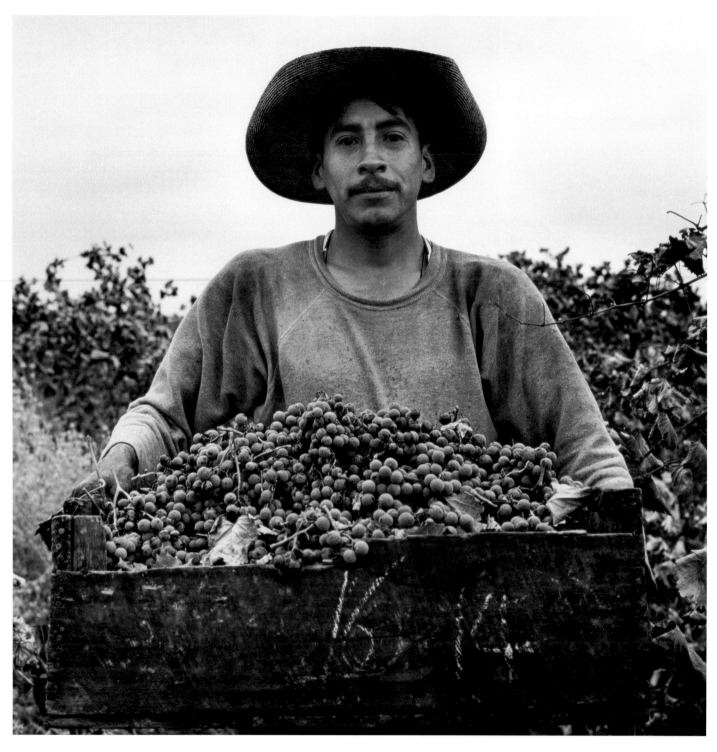

BEFORE GRAPES BECAME the catalyst for the developing farm workers' movement, Pirkle Jones created, in collaboration with Dorothea Lange, the photographic essay known as the *Berryessa* series. The series documents work in a Northern California rural community that later was flooded by a dam. This 1956 portrait of a laborer cradling succulent grapes belies the hardships that lie ahead for him.

Plate 69. Pirkle Jones, *Grape Picker, Berryessa Valley, California*, 1956, selenium toned gelatin silver print, 14" x 11"

ESTER HERNÁNDEZ's famous screenprint *Sun Mad Raisins* is an insider's perspective on iconography similar to that of Jones's photograph. Here, awareness of the insecticides, miticides, herbicides, and fungicides commonplace in corporate farming has transformed the image of bounty into one of irony and death.

Celebrated for her compelling portraits of women, Ester Hernández has also worked as a teacher, including at Creativity Explored of San Francisco, a visual art center for developmentally disabled adults.

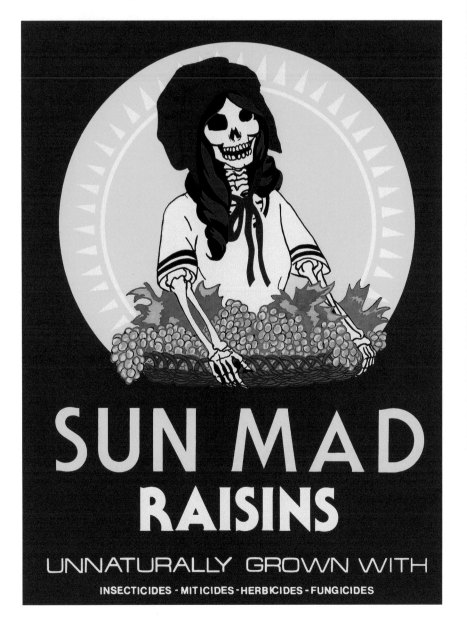

Turning Trays

Each vineyard is a world of crosses.
They sink in fog each winter, in summer
dangle green redemption. Late August,
grapes sugar even as you cut. You must cut
and lay and spread and turn each tray
again and again. Flesh shrivels,
browns in the sun. Bronzed nuggets
fall from the stem, and you,
as far from the beginning as the end,
cannot walk away.
You cannot escape turning trays.
One row ends; another begins.
You must finish this row
and the next
and the next.

I once feared I'd end up stuck mid-row,
a line of brown paper trays behind me,
neat bunches of grapes splayed across
each tray. Raisin grapes trailed me,
pearls the size of my fingertips.
Here is where I tackled imagery:
taut flesh between my teeth,
sweet liquid down my throat.
Here is where I struggled for the end
of each line, no dirt roads or dry canals
to turn me back. I learned to savor
strands of words, weigh their ripe perfection.
I learned to measure a scrub jay's call,
a dragonfly's rainbow flight.
I learned there is no stepping away,
no leaving behind what remains:
one more row to turn,
unfinished lines to tend.

Diana García

Plate 70. Ester Hernández, *Sun Mad Raisins*, 1982, screenprint, 22" x 17"

THE SPIRITUAL dimension of solidarity is sensed in much of the graphic art associated with the farm workers' movement. Although this poster advertising a dance in support of the farm workers is identified as the work of an anonymous collective, the Royal Chicano Air Force (RCAF), it was actually created by one of the members, Luis "Louie the Foot" González. The image is based on a photograph by the artist's brother, Hector González, of José Montoya, activist and founder of the RCAF.

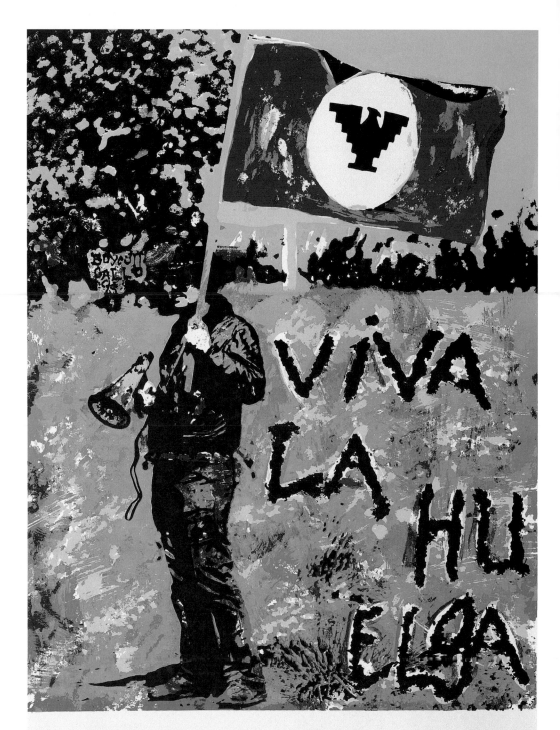

VIVA LA HU ELGA

UFW Benefit Dance/Baile
April 24, 1976 »Vengan« 8:00 pm
NEWMAN CENTER·· across 'J' street from CSU-S
MUSIC by......FREDDY'S BAND
SPONSORED BY Mecha AND THE U.F.W. Support Committee
DON. $1.50 «RCAF» ¡HUELGA!

Plate 71. Royal Chicano Air Force (Luis "Louie the Foot" González), *UFW Benefit Dance/Baile*, 1976, screenprint, 25" x 17"

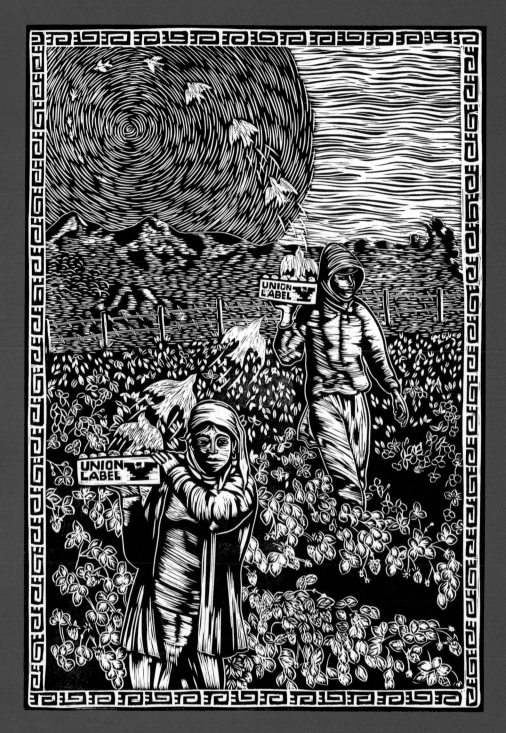

IN *Piscando en Pájaro,* by Juan R. Fuentes, flats of fruit emblazoned with the thunderbird insignia of the United Farm Workers are balanced on the shoulders of two laborers. From these flats rise a spiral of birds, filling the sky. This image can be linked to one of the first encounters between Spanish explorers and the Ohlone Indians at what is now the Pajaro River. The Spanish were amazed by the Ohlones' use of condor-feather capes in religious ceremonies. In Fuentes's work, the sacred bird is again able to soar, as the spirit of the community is restored through solidarity. Juan R. Fuentes directs the Mission Grafica print workshop at the Mission Cultural Center in San Francisco.

Plate 72. Juan R. Fuentes, *Piscando en Pájaro,* 2001, linocut, 20" x 14"

THE CONTINUING IMPORTANCE of César Chávez and Dolores Huerta is evidenced in the many artworks, including murals, prints, and photographs, that depict them. Francisco J. Domínguez has spent most of his career photographing farm laborers—field hands and cannery workers—in California's Central Valley. This photographic portrait of Chávez in the year of his death captures this inspiring leader with finger outstretched, recalling one of the most famous images of Malcolm X.

As one looks at the millions of acres in this country that have been taken out of agricultural production; and at the millions of additional acres that have never been cultivated; and at the millions of people who have moved off the farm to rot and decay in the ghettos of our big cities; and at all the millions of hungry people at home and abroad; does it not seem that all these people and things were somehow made to come together and serve one another? If we could bring them together, we could stem the mass exodus of rural poor to the big city ghettos and start it going back the other way; teach them how to operate new farm equipment; and put them to work on those now uncultivated acres to raise food for the hungry. If a way could be found to do this, there would be not only room but positive need for still more machinery and still more productivity increase. There would be enough employment, wages, profits, food and fiber.

César Chávez

Plate 73. Francisco J. Domínguez, *César Chávez*, 1993, gelatin silver print, 14" x 11"

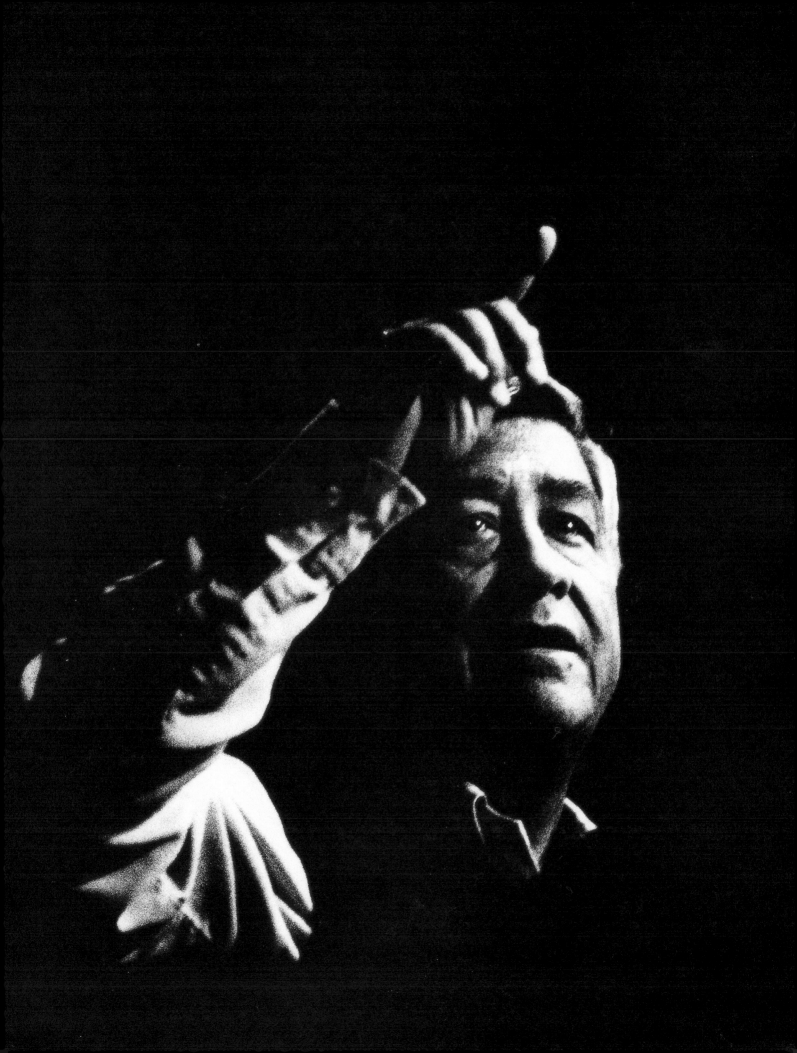

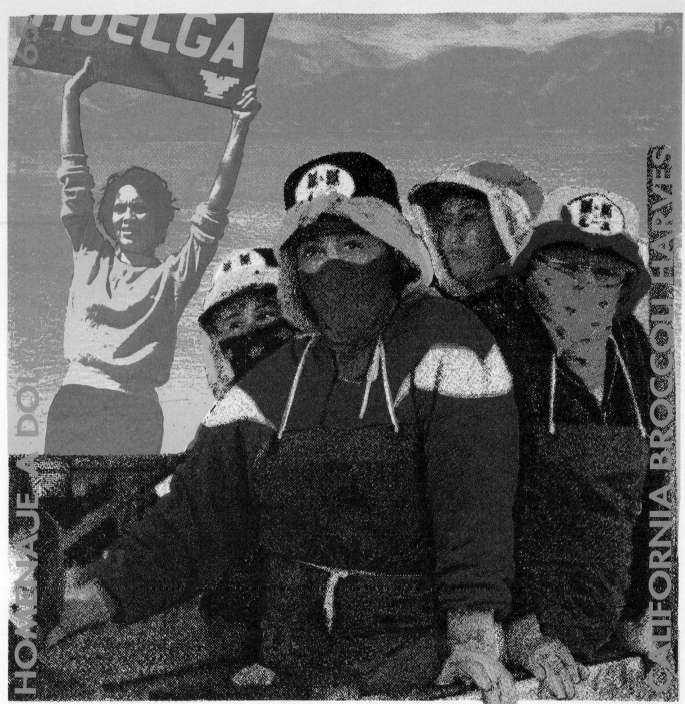

Plate 74. Yolanda M. López, *Homage to Dolores Huerta: Woman's Work Is Never Done,*
1995, digital print, 20" x 20"

Y OLANDA M. LÓPEZ's tribute to Huerta from her series *Woman's Work Is Never Done* juxtaposes an image of Dolores Huerta as an activist in 1965 with an image taken from the 1995 broccoli harvest. To protect their lungs from dust and pesticides, the women in this print wear bandanas, which actually provide little if any protection. Lopez has said that while the scarves might evoke visual memories of masked Zapatistas, it is important to remember that these women are not romantic heroines, but rather California food workers who are aware of the need for a safer work environment.

López is a leading figure in the Chicano/a Art Movement and has taught and lectured widely. She has said about this series, "*Woman's Work Is Never Done* look[s] at the physical and intellectual risks that women take in fighting for social, political, and economic justice. It is about the work women do that is rarely recognized."

What Is a Movement?

What is a movement? It is when there are enough people with one idea so that their actions are together like a huge wave of water which nothing can stop. It is when a group of people begin to care enough so that they are willing to make sacrifices.

The movement of the Negro began in the hot summer of Alabama ten years ago when a Negro woman refused to be pushed to the back of the bus. Thus began a gigantic wave of protest throughout the South. The Negro is willing to fight for what is his: an equal place under the sun.

Sometime in the future they will say that in the hot summer of California in 1965 the movement of the farm workers began. It began with a small series of strikes. It started so slowly that at first it was only one man, then five, then one hundred.

This is how a movement begins. This is why the farm workers association is a "movement" more than a "union." Once a movement begins it is impossible to stop. It will sweep through California and it will not be over until the farm worker has the equality of a living wage and decent treatment. And the only way it will be done is through organization. The farm worker must organize to fight for what is his.

What is a movement? It is the idea that someday the farm worker will be respected. It is the idea that someday he will earn a living wage.

It is when the silent hopes of many people begin to become a real part of life.

from *El Malcriado*,
newspaper of the United Farm Workers Organizing Committee

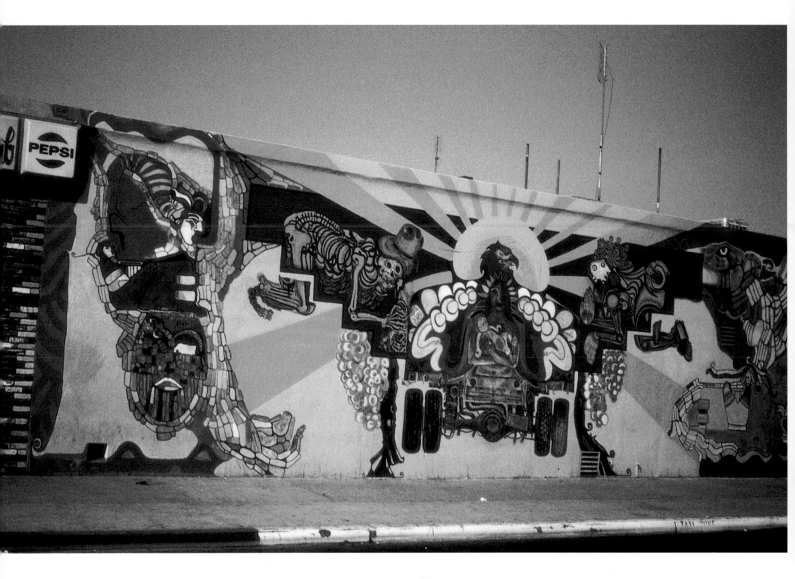

CHICANO MURALISM has flourished in both urban and rural areas. Ernesto Palomino's huge and complex mural for the side of a building in Fresno shows the UFW thunderbird at its center, with massive bunches of grapes hanging from its outstretched wings. Superimposed over the image of a truck filled with seated workers, the bird can be seen as a protective talisman. Glyphs, jade scales, and other icons derived from Mayan culture flank this scene, adding complexity from the ancient world.

Palomino has lived in the San Joaquin Valley for most of his life and is a professor emeritus at California State University, Fresno.

Plate 75. Ernesto Palomino (with Lee Orona), *Campesinos*, 1972, oil mural, Tulare and F Street, Fresno

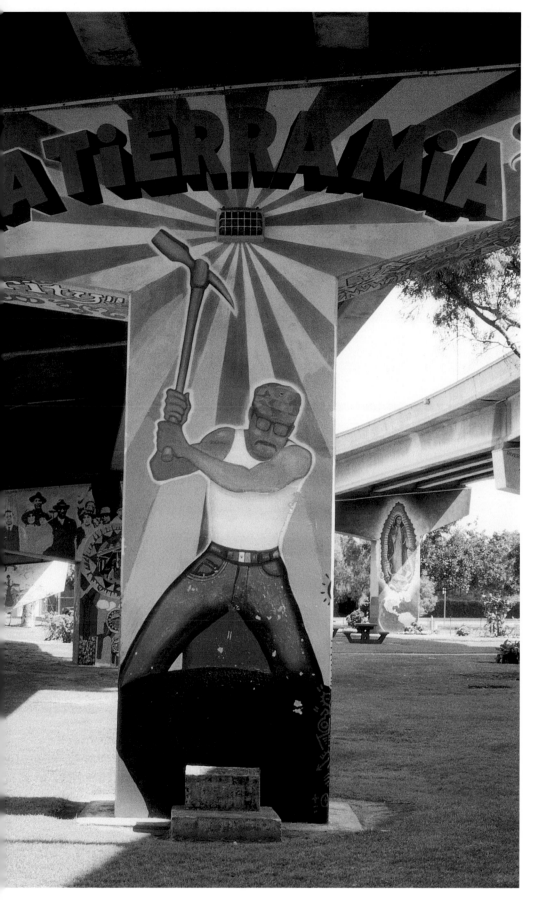

THE FREEWAY PILLAR murals from San Diego's Chicano Park similarly juxtapose religious images and secular scenes of work. The Virgin of Guadalupe can be seen on the right background pillar, floating above a map of the Americas. On the pillar in the foreground, a contemporary laborer in t-shirt with pickax serves as a symbol of the struggle for Chicano Park. A triumph of community organizing, the park began in the late 1960s when members of the local community organized a demonstration to occupy the site and block the construction of a California Highway Patrol station there. It was eventually transformed with murals and plantings into a neighborhood park, and local Chicano art groups worked together to fill the freeway pylons with inspiring imagery. This mural was painted later, in 1986, after the passing of José Gómez, one of the park's founding organizers. The image of a man digging with a pickax is taken from an actual photograph of Gómez preparing the earth to plant the first tree on the newly liberated Chicano Park in 1970; the mural memorializes Gómez, but it also serves to remind us that community activism often requires a lot of physical labor.

Plate 76. Mario Torero (with Tony Vargas), *La Tierra Mia*, 1986, fresco, Chicano Park, San Diego

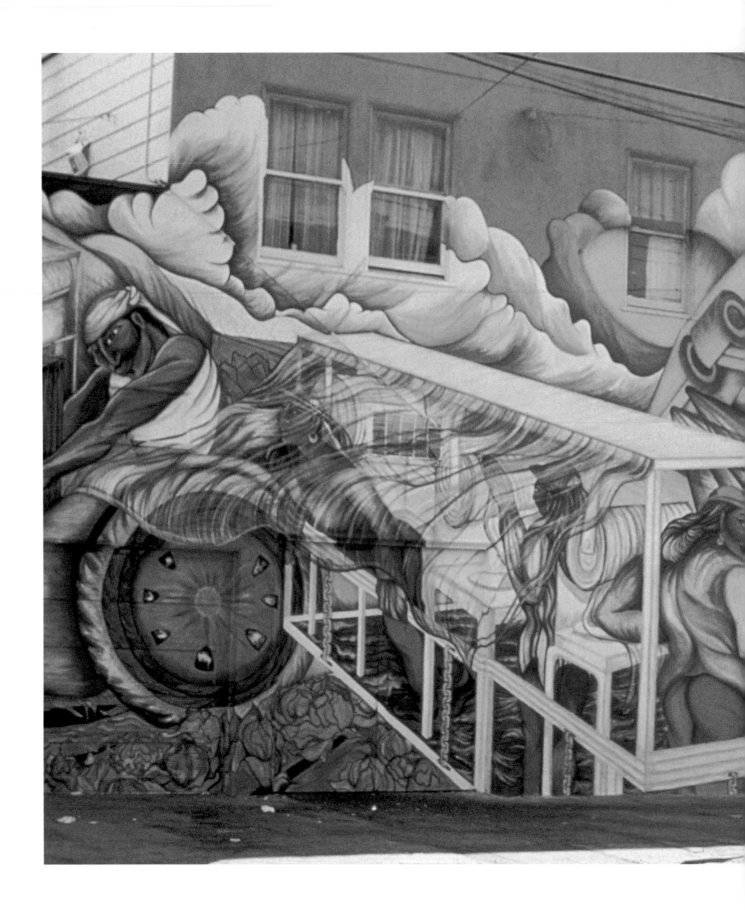

Plate 77. Juana Alicia, *Las Lechugeras (The Women Lettuce Workers),*
1983, acrylic mural on stucco, York and 24th Street, San Francisco, 30' x 50'

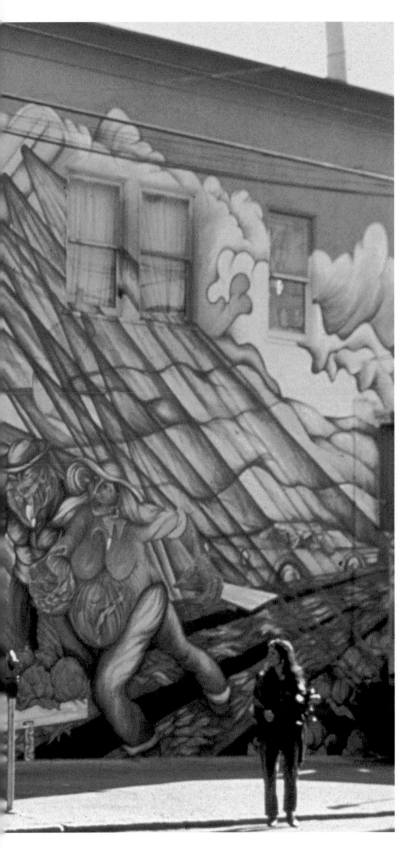

In Juana Alicia's *Las Lechugeras,* one of the San Francisco Mission District's best-loved murals, a crop duster flies over a scene from California's lettuce harvest. The diagonal and elliptical forms of the plane and the shapes of the green clouds of pesticide that it sprays recall the forms of Diego Rivera's famous mural for Rockefeller Center, *Man at the Crossroads,* a notoriously controversial work. The depiction of sheer fabric and the anatomy of the pregnant woman and her unborn child at the lower right are brilliant executions of transparency. This work will be destroyed in 2003, and it will be replaced with another work by Juana Alicia, this time about the politics of water in California.

Juana Alicia has painted murals nationwide, including at the United Electrical and Machine Workers Union Hall in Erie, Pennsylvania.

I

N PATRICIA RODRÍGUEZ's digital mural depicting the strawberry harvest, rows of strawberries are edged by DNA helixes with children trapped inside. The image suggests that pesticide toxins have become encoded in human DNA and are recycled across generations. From the distant hills and inside the earth, the living forces of the landscape and the spirits of ancestors bear witness to this unnatural scene, while the slogan "Si Se Puede" (it can be done), provides a spark of hope for the future.

Rodríguez is a founding member of the Mujeres Muralistas, a women's mural collective, and she is the curator of the gallery at San Francisco's Mission Cultural Center. She has taught and lectured widely and has created installations, sculptural works, and paintings as well as murals. She created this mural in collaboration with students at California State University, Monterey; mural making is an important part of the contemporary curriculum at several California universities.

Plate 78. Patricia Rodriguez, *La Fruta del Diablo*,
1997, digital mural, Monterey (in collaboration with students from California State University, Monterey Bay)

KNOWN FOR HIS international projects examining human suffering, Sebastião Salgado is the most famous political photographer working today. He is not a California artist, but his works include a series, from which this image is taken, about the California/Mexico border. Here we see several undocumented workers being arrested in the dark of night. The dramatic lighting—chiaroscuro reminiscent of Caravaggio—isolates each person, giving the scene added poignancy.

Plate 79. Sebastião Salgado, *U.S. Border Patrol Agents Arrest Illegal Migrants along the Border between California and Mexico,* July 1977, gelatin silver print, 20" x 24"

Plate 80. Jonathan Borofsky, *Hammering Man*,
1991, handmade paper with collage and screenprint, 144" x 69" x 3"

Contemporary Expressions

Mark Dean Johnson

A colossal silhouette with cobbler's hammer in hand has become one of the icons of inter-national contemporary art. One of Jonathan Borofsky's many versions of the figure in this print—*Hammering Man* sculptures are installed in both Northern and Southern California as well as in other parts of the United States and around the world—stands seventy feet tall, a motorized steel sculpture that slowly and methodically raises and lowers its arm as if to strike a plate held by its mate. Borofsky says the work celebrates the worker:

> He or she is the village craftsman, the South African coal miner . . . the underpaid worker in this new, computerized revolution. The migrant worker who picks the food, the construction worker who builds our buildings, the maid who cleans offices every evening, the shoemaker—they all use their hands like artists.[1]

And yet, while the scale and gesture can be related to the workers in Douglas Tilden's *Mechanics Memorial* from the turn of the twentieth century and to Pirkle Jones's *Worker* (from *Story of a Winery, Saratoga*) from mid-century, clearly something has changed. This emaciated and sightless cyborg robotically repeating a single gesture seems elegiac, like an oversize shadow. And indeed Borofsky has related its meaning to the waning of the mech-anistic age. The image's international popularity reflects the changes in the conception of "work" and "worker" that accompany this phenomenon all over the world.

In the United States, the change in consciousness that developed in the late twentieth century can be linked to technology that brought every corner of the earth and even the moon into America's living room. But there has been another change in the national psyche, a profound cynicism in response to the political scandal and spin that fill the headlines. The resulting ironic stance typifies the post-1970 period that has become known as post-modernism.

In art, postmodernism is associated with approaches and tactics that include working in large-scale and complex formats, sometimes incorporating architectural installation, and a theoretical approach that focuses on analysis and critique, often incorporating writ-ten text. "Appropriation," or recycling of imagery from any period of culture, has become

commonplace—reflecting the apparent accessibility of everything in the information age. As in Lincoln Cushing's satirical *Fiftieth National Bourgeois Art Exhibit* poster, which takes its circular motif from Robert Irwin's famous numinously white wall sculpture of the mid-1960s, black humor is often the subtext being served up.

In contemporary California art, labor remains strong as a theme, although its tone has shifted significantly. While we find many of the visual traditions from earlier periods being extended in interesting ways, including powerful documentary photography, sophisticated graphic art and fine-art printmaking, and politically pointed painting and muralism, we also see increasing evidence of the postmodern trends of the international art world. These include densely layered conceptual explorations as well as theoretical orientations that have sometimes deepened the disconnect between artists and their subjects. But work is one of the subjects that bridges this rift; the commitment professed by artists of earlier generations to create imagery accessible to workers is reflected in contemporary art as well. For example, the earlier public art forms of murals and outdoor sculpture have expanded to include billboards, city buses, and other advertising formats. And the fact that the audience for art has never been greater suggests that contemporary expressions, in all of their demanding complexity, are reaching a popular audience.

California art, like contemporary art in general, has increased in complexity in tandem with changes in the sociopolitical environment. It can be difficult from our position inside the moment to identify the issues that shape our contemporary political and economic landscape. Nevertheless, it seems important to point out three factors that have had major impacts on labor since 1970: political pressures, new technological production, and international trade.

At the beginning of this period, the idealism of the civil rights movement and opposition to the war in Vietnam produced a period of intense labor activism. At roughly the same time, the state's demographics were permanently transformed, as Asian immigrants moved to California in record numbers after passage of the 1965 Immigration Act. National

Fifticth National Bourgeois Art Exhibit

From the personal collection of the Fortune 500, a display of high art which perpetuates the dominance of form over content and reduces artistic creativity to marketable commodities.

August 2–30, 1981 La Jolla Museum of Art

Plate 81. Lincoln Cushing, *Fiftieth National Bourgeois Art Exhibit*, 1981, poster, 24½" x 18"

affirmative action policies helped nonwhite workers gain greater access to rights and privileges. Women returned to the workforce in large numbers for the first time since the Second World War, in response both to the liberating ideas of the women's movement and to the exigencies of the economy, and buoyed by the 1967 expansion of affirmative action to cover discrimination based on gender. Their presence helped extend the dialogue about equal opportunity to issues of maternity leave and child care. Strike activity in the 1970s often centered around benefits, job security, and better health and safety standards. Congress responded by establishing the Occupational Safety and Health Administration (OSHA) in 1970. The California OSHA program even employed photographer Ken Light, in the spirit of the 1930s programs that enlisted Dorothea Lange and others.

But a marked change in attitude could be discerned by 1978. California assumed its prominent position in the attack on affirmative action in that year when the U.S. Supreme Court decided for Allan Bakke in his "reverse discrimination" case against the University of California. Also in 1978, the passage of California's Proposition 13 heralded the conservative movement against big government in America, sharply reducing state revenues and initiating a period of fiscal crisis. On the national front, many OSHA programs were terminated in 1980 when Ronald Reagan became president, antitrust regulations were relaxed, and the government sought to reduce its role in social welfare. Reagan's massive dismissal of 11,500 air traffic controllers in 1981 demonstrated the federal government's hostility toward collective organizing.

The emergence of a huge high-technology sector represents the next major shift in contemporary California labor history. This growth was most evident in the area around the Santa Clara Valley, where computer manufacturing and programming companies sprang up. The Internet expanded this economy as people everywhere went online. But while millions of people were acquiring personal computers and many quick fortunes were being made, most of the workers hired for chip and computer fabrication—many of whom were immigrant women—were getting paid less than workers in other industries. The fact that only a small percentage of technology workers belonged to unions facilitated a trend toward part-time or contract work. Job security fell by the wayside as layoffs moved to the top of the list of strategies for cutting costs.

The third dramatic change in California labor came after the 1994 North American Free Trade Agreement (NAFTA) went into effect. Many California companies established relationships with *maquiladoras,* factories often clustered along the border with Mexico that manufacture goods for the United States, usually operating with fewer environmental restrictions and lower labor costs. NAFTA has affected employment in California by reducing manufacturing opportunities, leaving the dead-end service economy as one of the few options available for many. Most of the jobs gained here are low-paying, nonunion

positions with limited benefits. From 1980 to 1993, the number of people whose medical insurance was fully funded by employers dropped nationally from 71 to 37 percent.[2]

Due to these tremendous shifts in the job marketplace and in attitudes about labor, American union membership fell to only 14 percent of American workers by the mid-1990s, from a high of nearly 40 percent in the 1950s.[3] Nevertheless, recent union successes in California include the "comparable worth" strike by women municipal workers in San Jose and the state Supreme Court decision, precipitated by Los Angeles sanitation workers, enabling public employee strikes. The AFL-CIO's "New Voice" campaign in the 1990s instituted a rekindled commitment to the needs of diverse groups, including women, undocumented workers, and people of color. The 1996 class action filed and won by Los Angeles garment workers in protest of sub-minimum wages and harassment for organizing, and the 1998 defeat of Proposition 226, which intended to curb the political power of organized labor, attest to the effectiveness of this campaign.

It is significant that many recent union successes were achieved in Southern California, previously known for its open shop environment. With 135,000 workers added to its ranks over the three-year period ending in 2002, the Los Angeles County Federation of Labor, led by former farm worker Miguel Contreras, has become a significant political force. Many of the new union members in this region are from immigrant communities and bring a new enthusiasm and voice with their vote, leading the *Los Angeles Times* to state, "What's happening in Los Angeles today probably will be in the textbooks on labor history tomorrow."[4] The Los Angeles organization has even initiated a new and unprecedented program of organizing exhibitions to display the art of its constituent workers. Interestingly, much of the most daring new art produced about labor also comes from Southern California. And much of this work addresses the implications of a global economy for workers both at home and abroad.

Like *Hammering Man*, whose meaning changes not only with the places in which he appears—from Los Angeles and Berkeley to Frankfurt and Seoul—but also with the times, the dialogue between labor and art is never static. Some of the highlights of this exchange have occurred in times of great stress: the Depression, the McCarthy era, and the farm workers' movement, for example. As we experience increased unemployment, wage and benefit rollbacks, and fresh attacks on organized labor at the dawn of the twenty-first century, we can take some encouragement from the new developments in both art and labor organizing that continuously surface. Labor consciousness, in the form of collective organizing, and art are alike in their ability to ameliorate alienation and frustration. With the potential to humanize and inspire, they restore our vitality in difficult times.

notes

1. Mark Rosenthal and Richard Marshall, *Jonathan Borofsky* (New York: Harry N. Abrams, 1984).

2. Priscilla Murolo and A. B. Chitty, *From the Folks Who Brought You the Weekend: A Short, Illustrated History of Labor in the United States* (New York: The New Press, 2001).

3. Ibid.

4. Nancy Cleeland, "With Spotlight on L.A., Unions Put New Strategies to Test," *Los Angeles Times*, 12 October 2000.

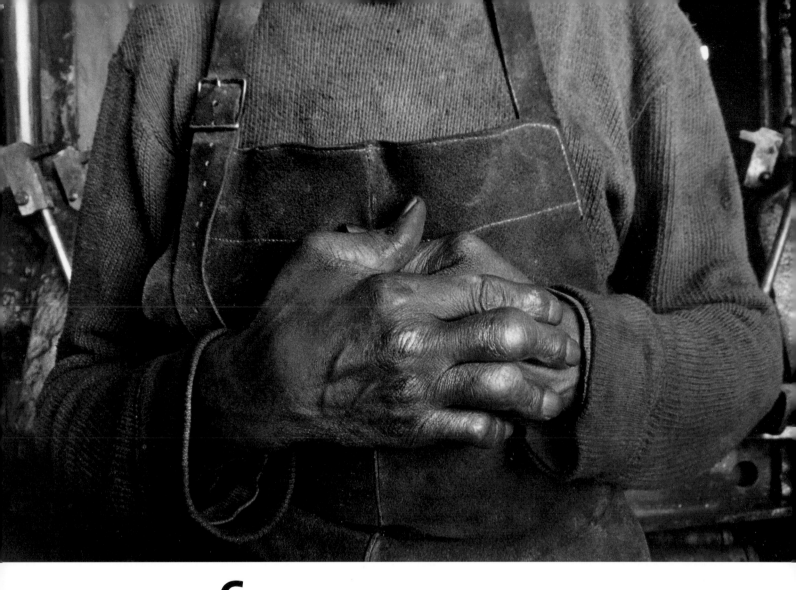

CALIFORNIA ART since 1970 has maintained a powerful focus on labor issues. Painting, photography, and printmaking as well as installation art, the use of other new media, and new approaches to public art have expanded definitions and expectations about the blending of labor and cultural consciousness.

Ken Light created *Moulder* as part of "Workers in California," a project developed under the auspices of the Comprehensive Employment and Training Act. Drawing inspiration from the Farm Security Administration (FSA) program of the 1930s and 1940s, Light focused on safety issues. The foundry worker depicted here was injured when he slipped and a molding press came down on his hand—yet he continued working the same job after the accident.

Makeshift Mask was photographed four years later, while Light worked on educational manuals about health and safety issues for the Labor Occupational Health Program at the University of California, Berkeley. In this portrait, a graphic example of poorly enforced or nonexistent safety rules, the sandblaster wears an empty sand sack for protection.

Light considers himself a social documentary photographer and has published several books that document working conditions. He has also taught widely, both in California and nationally. The sepia tone of his prints serves to connect these recent images with work created under the FSA. By relating them to days allegedly gone by, he makes a vivid point about the continuing lack of safety in the workplace.

Plate 82. Ken Light, *Moulder, 29 Years Industrial Accident, Oakland, California, 1975,*
1978, gelatin silver print, 8" x 12"

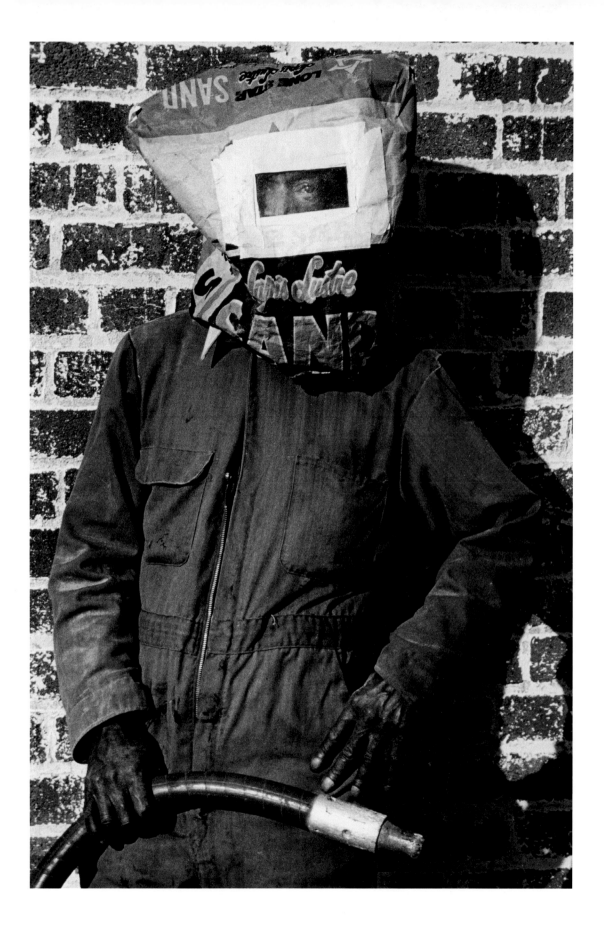

Plate 83. Ken Light, *Makeshift Mask*,
1979, gelatin silver print, 12" x 8"

Plate 84. Claude Clark Sr., *Paydirt*,
1970, oil on masonite panel, 30" x 24"

One feature of the societal transformation initiated by the civil rights struggles of the sixties was the growth of the Black Arts Movement as artists like David Hammons, Betye Saar, and Ruth Waddy created provocative work with a politicized perspective on education, employment opportunity, and other issues.

In response to the activism of the Black Panther Party, Oakland's Merritt College hired painter Claude Clark to teach there in 1968. Clark, already a respected proponent of Black Art, had studied at the Barnes Foundation, near Philadelphia. Desiring to use this training to create relevant art, he had developed a style that incorporated lush paint handling and the use of rich, vibrant color to depict African American subjects. In response to the charged environment he encountered at Merritt College, Clark began to do work that was more explicitly political. One series critiquing U.S. government support for multinational corporations has proven to be especially prescient.

In 1970, Clark began an extensive series of paintings of African American workers. He was inspired by the construction of the Bay Area Rapid Transit system but motivated by the fact that so few African Americans had been hired to do the work. Visiting the worksite to sketch, he would then return to the studio and insert renderings of African Americans on the job. *Paydirt* shows Clark's painting at its best and features a masterful composition of balanced forms and angles with brilliant magenta tones in the shadows. The title of this painting refers to the dirt that fills the wheelbarrow, gleaming like gold and painted with a palette knife in very thick layers. But this idiomatic word also refers to the great value that African American employment at every level of construction would yield—for employers as well as workers.

THE FINE ART of printmaking was at the center of California labor imagery throughout the twentieth century. Many prints were created at studios—most recently including Self-Help Graphics in Los Angeles, Mission Grafica in San Francisco, and Inkworks in Berkeley—helping establish California studios and workshops as among the most productive in the nation.

The importance of the use of text in these prints has only increased in the postmodern period. Without text explaining that Nancy Hom's delicately colored rendering of a protective caregiver and young children was done for a symposium on immigrant rights, the work might be misconstrued as a simple study of mother and children. Hom has worked as the director of the Kearny Street Workshop for decades and has witnessed countless immigrants' labor struggles firsthand.

Bruce Kaiper's clock imagery warns about the perils of "speed-ups"; the mirrored reflection of a multi-armed worker conveys the dizzying potential of relentless production without breaks.

Jos Sances has worked as a master printer for many artists but has also produced a vast body of political prints himself. His portrait of a public school teacher points to the abysmal retirement benefits that await most teachers, compounding the difficulties caused by the low salaries that make teaching a career choice based on compassion to the exclusion of economic security.

© N. HOM 1985

Asian Law Caucus

IMMIGRANT RIGHTS:
CIVIL RIGHTS ISSUE
OF THE 80'S

Friday, May 31, 1985
Palace of Fine Arts

Hon. John Conyers
Congressman (D-MI)

Honorees:
Plaintiffs, Oakland Bilingual
Education Lawsuit

Jack Elder,
Texas Sanctuary Movement

Plate 85. Nancy Hom, *Immigrant Rights*,
1985, screenprint, 24" x 18"

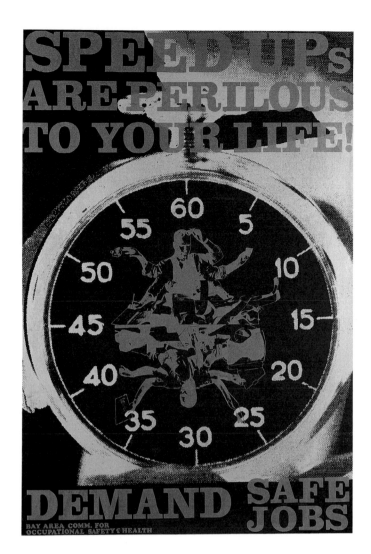

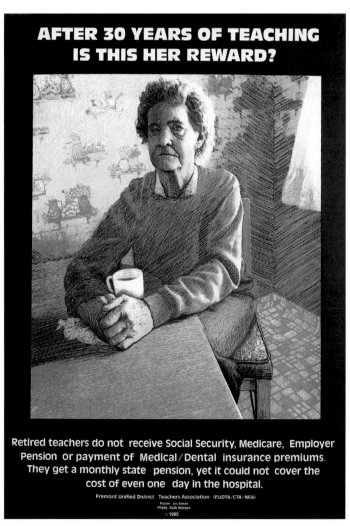

Plate 86. Bruce Kaiper, *Speed-Ups Are Perilous to Your Life!*,
ca. 1980, screenprint, 27½" x 19¼"

Plate 87. Jos Sances, *After 30 Years of Teaching Is This Her Reward?*
1990, screenprint, 24¾" x 18¼"

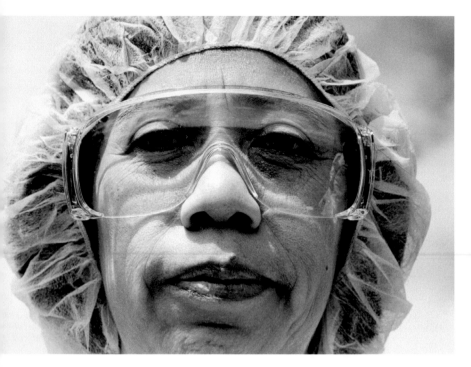

WOMEN HAD ALWAYS been a significant part of the California workforce, participating in important labor struggles throughout the twentieth century, but the women's liberation movement and feminist theory helped bring about a sharp increase in the visibility of working women.

Electronics Worker, an image from the Silicon Valley, is part of an extensive series by David Bacon that documents contemporary California manufacturing, often featuring portraits of immigrants and women. The woman in this photograph, wearing protective goggles and a hairnet, seems far removed from the dot-com millionaires commonly associated with the growth of technology; this image offers a grimmer view of economic opportunities during the explosive growth of the 1990s.

A factory worker and union organizer, David Bacon gradually shifted his career to photography and journalism. His work often focuses on labor and includes imagery about strikes, border issues, and the workplace.

Yolanda M. López's *The Nanny* is an actual uniform to which the artist has added symbols drawn from Aztec mythology as well as more contemporary reproductions and objects. A painted necklace of human hands, hearts, and skull associated with the goddess Coatlique rings the uniform's neckline, while an image of the Virgin of Guadalupe rises from the top pocket. A photograph of a baby appears over the area that covers the womb. One of the dress's pockets reveals a dollar bill safety-pinned inside, and the snake-like god of creation, Quetzalcoatl, slithers out from the other. The back of the uniform is filled with snapshots from the personal life of a woman who might wear it, completing the depiction of, in the artist's words, "the intersection of commerce and child care." López has presented this work in installations with large photographs of idealized Mexican folkloric costume, illustrating the difference between the real and the romantic.

Plate 88. David Bacon, *Electronics Worker,* 1999, gelatin silver print, 8" x 10"

Plate 89. Yolanda M. López, *The Nanny,* 1996, painted fabric with collage, 46" x 26"

from Woman Sitting at the Machine, Thinking

she thinks about everything at once without making a mistake.
no one has figured out how to keep her from doing this thinking
while her hands and nerves also perform every delicate complex
function of the work. this is not automatic or deadening.
try it sometime. make your hands move quickly on the keys
fast as you can, while you are thinking about:

the layers, fossils. the idea that this machine she controls
is simply layers of human work-hours frozen in steel, tangled
in tiny circuits, blinking out through lights like hot, red eyes.
the noise of the machine they all sometimes wig out to, giddy,
zinging through the shut-in space, blithering atoms;
everyone's hands paused mid-air above the keys
while Neil or Barbara solo, wrists telling every little thing,
feet blipping along, shoulders raggly.

she had always thought of money as solid, stopped.
but seeing it as moving labor, human hours, why that means
it comes back down to her hands on the keys, shoulder aching,
brain pushing words through fingers through keys, trooping
out crisp black ants on the galleys. work compressed into
instruments, slim computers, thin as mirrors, how could
numbers multiply or disappear, squeezed in sideways like that
but they could, they did, obedient and elegant, how amazing.
the woman whips out a compact, computes the cost,
her face shining back from the silver case
her fingers, sharp tacks, calling up the digits.

when she sits at the machine, rays from the cathode stream
directly into her chest. when she worked as a clerk, the rays
from the xerox angled upward, striking her under the chin.
when she waited tables, the micro oven sat at stomach level.
when she typeset for Safeway, dipping her hands in processor
chemicals, her hands burned and peeled and her chest ached
from the fumes.

well we know who makes everything we use or can't use.
as the world piles itself up on the bones of the years,
so our labor gathers.

while we sell ourselves in fractions. they don't want us all
at once, but hour by hour, piece by piece. our hands mainly
and our backs. and chunks of our brains. and veiled expressions
on our faces, they buy. though they can't know what actual
thoughts stand behind our eyes.

then they toss the body out on the sidewalk at noon and at five.
then they spit the body out the door at sixty-five.

Karen Brodine

AT FIRST GLANCE, this large-scale color photograph appears to capture the benign image of a suburban living room. Then small details lead the viewer to wonder what, exactly, is going on in the background beyond the sliding glass doors, where nude limbs rise from the patio in front of a camera and light meter. We suddenly realize that this must be the set of a pornographic film in the making. Sultan's image points to the very real existence of gray- and black-market economies that unquestionably employ a significant percentage of Californians today.

The mundane familiarity of the house in the photograph belies the purpose for which it was rented. Sultan's study of the pornography industry has illuminated a workplace few people can imagine, often involving grueling schedules, with labor issues as mundane as those of other professions. At this moment, Tasha has just been bitterly complaining to her mother on the telephone that she was misled about payment. An important component of the artist's investigation is just this—he deflects the obvious potential for voyeurism by emphasizing the humanity of the workers.

Larry Sultan is an influential teacher of photography at the California College of Arts and Crafts. His photographic projects often look at what lies behind the surface of the California dream.

Plate 90. Larry Sultan, *Tasha's Third Film*, 1998/99, chromogenic print, 50" x 60"

IN THE 1940s and 1950s, labor unions in California commissioned artists to provide public art for local halls. Painted murals and bas-relief sculptures filled many lobbies and building facades, and some have survived to the present. This connection between organized labor and public art also finds significant expression in the contemporary period.

The fotonovela form, particularly popular in Italy and Latin America, dates back to the 1940s. With film noir–style narrative, dialogue boxes, and thought balloons, *La Gran Limpieza,* a 64-page, two-color fotonovela, recounts a personal story set against the tale of a management plot against union organizers, spot-lighting the working conditions of janitorial workers in Los Angeles. Like *The Four Immigrants Manga* [see page 10] from seventy years earlier, this illustrated work incorporates bilingual text and a delicate balance of fact and fiction. But unlike Kiyama's work, *La Gran Limpieza* reflects the spirit of collective organizing: the Justice for Janitors movement.

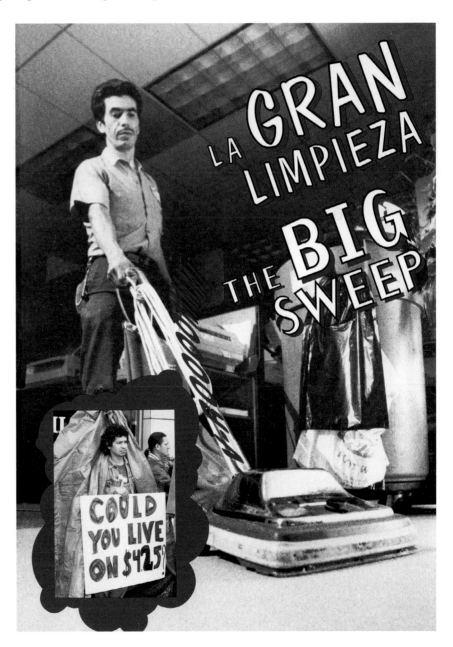

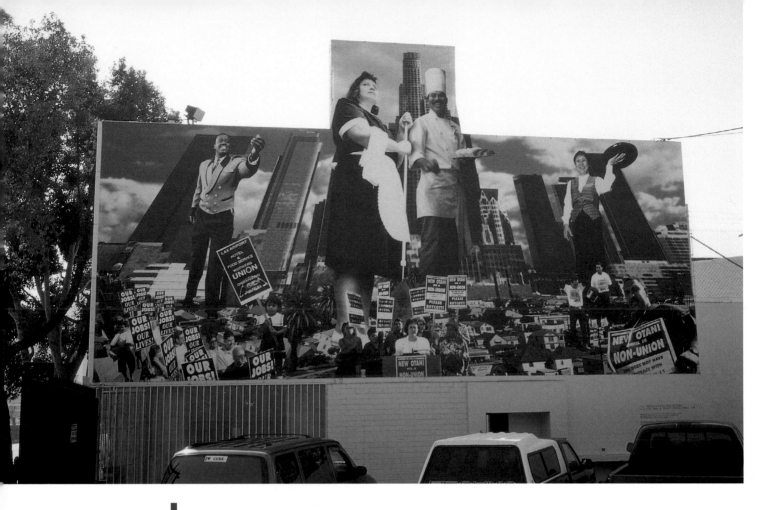

J UDITH FRANCISCA BACA, one of the first Chicana professors at the University of California, began participating in community mural projects during the early 1970s as a personal response to the limited art opportunities in the Boyle Heights Chicano neighborhood of Los Angeles. She cofounded SPARC, the Social and Public Art Resource Center, as a means to increase innovation and institutional support for mural making.

This dramatic outdoor mural for the Hotel and Restaurant Workers Union building reflects the use of digital technology; it is printed rather than painted. Unlike the giant on the 1916 cover of *The Blast* magazine discussed earlier [see page 11], these giants truly serve the people: huge waiters, chefs, maitre d's, and cleaning staff loom like skyscrapers above a sea of union demonstrators. The image reminds us that individual employees are supported by the efforts of collective struggle.

Plate 92. Judith Francisca Baca, Patrick Blasa, SPARC Digital Mural Lab, *In Our Victories Lies Our Future (Local 11)*, 1998, digital mural, 29' x 31', Los Angeles

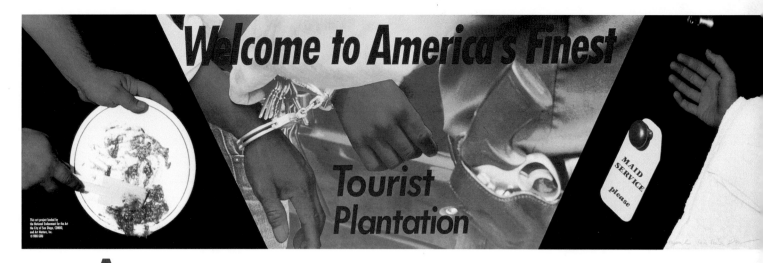

Aᴌᴛʜᴏᴜɢʜ ᴍᴜʀᴀʟs ᴀʀᴇ still the most common format for public art about labor, exciting new formats have emerged in recent years. The installation of media art in public locations has proven to be among the most accessible, if controversial, of these.

Known for his challenging performance art focusing on race and immigration, David Avalos collaborated with media artist Louis Hock and photographer Elizabeth Sisco on the creation and staging of *Welcome to America's Finest Tourist Plantation,* a mock public advertisement that appeared on one hundred San Diego Transit buses. The images—a dishwasher, a hotel sign calling for maid service, and the border patrol arresting an immigrant—were set against the provocative title, linking the plight of undocumented workers to the slaves of the antebellum South. By arranging for the ad to appear during the week when San Diego was hosting the 1988 Super Bowl, the artists spotlighted the real source of labor that supports the tourist industry in that community. City officials called for the removal of the controversial posters, but the transit board allowed them to remain in place.

Tʜᴇ ᴘᴏsᴛᴇʀ *Guess Who Pockets the Difference* was displayed throughout Los Angeles during the period when garment workers sewing for Guess were struggling to organize. In 1996 Guess settled a class action lawsuit for failure to comply with minimum wage and overtime laws, one of the major victories of the anti-sweatshop movement.

The Guess poster is a study in contrasts. On one side, a sweatshop worker, labeled with her less-than-minimum-wage salary, sits at a sewing machine; on the other, a shirtless man poses suggestively, labeled with the high price of his designer jeans: "$75 a pair." The settlement of the suit and the popularity of the poster suggest that this brilliant mirroring of advertising logic was effective in shaping consumer opinion.

Plate 93. Elizabeth Sisco, David Avalos, Louis Hock, *Welcome to America's Finest Tourist Plantation*, 1988, poster, 24" x 72"
Plate 94. Common Threads Group, *Guess Who Pockets the Difference*, 1995, poster, 11" x 28"

IN THESE PIECES we can see that contemporary artists are using illustration conventions from comics and earlier graphics to convey darker perspectives on labor issues. In Allan Sekula's illustration, we confront a kind of food chain/labor pyramid. The icons depicting various jobs—maid, fireman, filing clerk, teacher, chemist, and so on—suggest a lighthearted tone. But after realizing the significance of the symbols on the left, which represent the hierarchy of educational institutions from high school through elite private university, we see what Sekula is suggesting: our educational system is part of the system that limits social mobility in this country.

This analysis reflects the artist's interest in structural semiotics, as well as his actual experience as a junior college instructor. It also references a 1916 statement from a public school administrator: "It is the business of the school to build its pupils . . . [so they are] shaped and fashioned into products." We are left wondering to what extent this goal for education continues to be operative today.

Plate 95. Allan Sekula, Untitled illustration from *Photography Against the Grain*, 1984

Tom Tomorrow's widely known comics also appropriate illustrational styles from an earlier period. Long before he was a nationally syndicated cartoonist, Dan Perkins, whose pen name is Tom Tomorrow, published his first anti-establishment comics in *Processed World,* a radical San Francisco–based magazine for disenfranchised office workers.

In this sequence, Perkins exposes the magnitude of contemporary prison labor, from manufacturing to telemarketing. That Uncle Sam, police, and business leaders are all complicit in this exploitative relationship provides pointed evidence as to why the number of prisons in California continues to grow so quickly.

Plate 96. Tom Tomorrow (Dan Perkins), *Prison Labor,* 1995, from *The Wrath of Sparky* (St. Martin's Press, 1996)

MIKE KELLEY is one of California's most widely recognized contemporary artists. Associated with the movement known as abject art, he has created hilarious installations that blend broad humor with dark sociopolitical messages. Incorporating office jokes and copy-room nihilism, Kelley's architectural installations have lampooned work environments from boardrooms to office cubicles.

Kelley has described the architectural installation *From My Institution To Yours* as a shrine to contemporary workers. At its center, a black fist of solidarity is stenciled against a brilliant red wall. But instead of the inspiring labor slogans, we find pathetic outpourings of workplace desperation on the walls. "Shall I rush your rush job before I start the rush job I was rushing when you rushed in?" appears immediately under a drawing of an exhausted rat facing away from an agitated chipmunk, while text along the border reads, "Bow to the chipmunk you who are the rat." A critique of the decadent corporate mind-set wherein a sense of pride in one's work has been trivialized, this installation—so sardonic that it initially seems to mock the very workers it claims to enshrine—invites viewers to empathize with the situations of office workers everywhere.

Plate 97. Mike Kelley, *From My Institution to Yours*,
1987, installation of acrylic on paper, ribbon, carrot, 16' x 15' x 10'

A S SEEN IN Diego Rivera's *The Tortilla Maker* [see page 17], food—for its role in our survival as well as the labor that goes into its preparation—is an apt subject for labor art. Wooden paddles like the cast aluminum one shown here are used by the native people of northwest California to stir red-hot rocks into a mixture of acorn meal and water in order to cook it. The geometrically scalloped edges evoke the spiritual traditions of the region. George Blake based its form on an example that he saw in storage at the Smithsonian Institution in Washington, D.C.

Blake is a Native American artist of Yurok and Hupa descent who has lived for most of his life on the Hoopa Indian Reservation. Nationally recognized as a leader in the revival of traditional arts associated with California Indian peoples, he has taught carving to generations of young people, besides working as a cement layer and jeweler to support his family.

Untitled

a woman serves somebody else's food and
stands by
while they eat her own children sit up
hungry late
irons nice and flat the ruffles on
somebody's clothes
you didn't see her she was the color of the
shadow she waited in
she came in the back door early in the morning
back in the honeysuckle days of your
nostalgia
she was young and pretty and had gold
teeth
on hands and knees she scrubbed your
floors with a brush
now she sweeps trash from the corners of
your streets
with a broom and a workfare vest

Sarah Menefee

Plate 98. George Blake, *Acorn Paddle*,
1987, cast aluminum, 43" x 4" x 1"

LIKE RIVERA and Blake, Julio Morales explores the cultural dimension of food in relationship to aesthetic taste. A teacher and community activist who has worked to promote cultural exchange with Mexico, Morales often works with new photographic forms. *Paletero* is a diptych comprised of two lightboxes. One of these features the outline of a *paletero,* or popsicle vendor, pushing his cart. The second lightbox shows the abstract tracing of the route that the vendor follows in San Francisco's Mission District, giving us insight into the mapping of the neighborhood that he calls home.

Plate 99. Julio Morales, *Paletero,*
2002, two lightboxes with digital images, each 16" x 20"

APPROPRIATION IS often cited as one of the most important signifiers of postmodernism. Recycling images and ideas, appropriation can cause us to rethink how history is written and inherited.

Using two thin strips of imagery extracted from Tina Modotti's famous photograph *Campesinos (Workers Parade)* [see page 15], Sergio de la Torre's *Go Unnoticed* can be interpreted as challenging California to recognize the importance of its own Latino workforce. But this diptych also invites us to consider labor art's rich historical lineage, which has been so little documented.

Plate 100. Sergio de la Torre, *Go Unnoticed*, diptych digital photos, each 47¾" x 35"

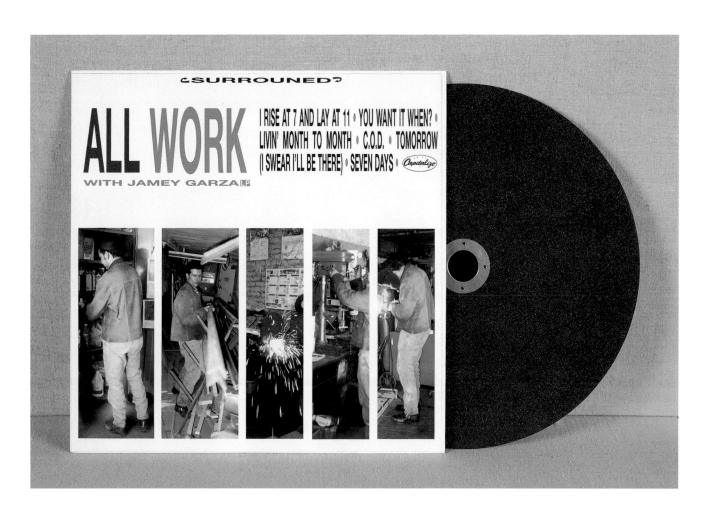

INSTEAD OF a vinyl LP, Jamey Garza's album jacket actually houses an abrasive disk of the type used to cut steel. The artist created the look of a limited edition release, but the jacket's images are from his own fabrication shop. Song titles like "You Want it When?" and "Tomorrow (I Swear I'll Be There)" refer to his personal experiences as a third-generation welder and as an artist who supports himself through other trades.

This appropriation of the record jacket format is a reminder of the relationship between labor history and song, and the many instances in which labor art has been used on the jackets of recordings about work. Examples include the reproduction in 1950 of Lucienne Bloch's *Land of Plenty* [see page xvi] on Pete Seeger's *Songs of Struggle and Protest,* and the reproduction of works by Ben Shahn on albums by Woody Guthrie.

123

Plate 101. Jamey Garza, *All Work with Jamey Garza,*
1996, album jacket and disk, 12¼" x 12¼"

AFTER THE PASSING of NAFTA, *maquiladoras* burgeoned in communities along the border in Mexico, where goods and crops can be produced inexpensively under minimal health and safety regulations and then shipped to California.

Fred Lonidier has produced a vast body of work in photographic installations about labor issues. In 2001, visiting a community near Ensenada that farms tomatoes and strawberries, he witnessed the same sort of substandard housing that Domingo Ulloa depicted in his 1960 painting *Bracero* [see page 81]. He presents these images in *Maquiladoras,* a two-panel photographic collage. In the second panel (not reproduced here) he shows the only new and freshly painted structure at this workplace, the church provided by the company for the workers.

A professor at the University of California, San Diego, Lonidier has been deeply involved in labor activities, including the production of *Labor Link TV,* a monthly cable television program, and he has been active in teachers' unions.

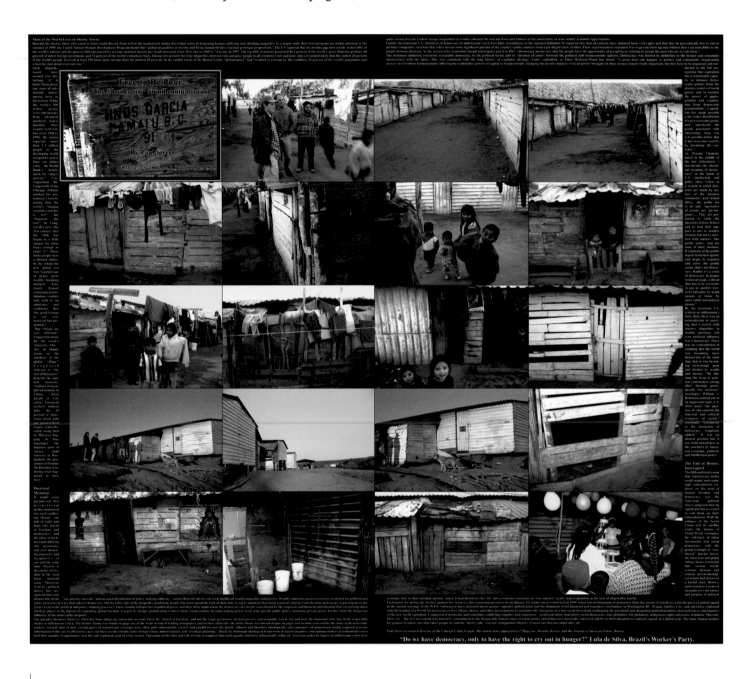

Plate 102. Fred Lonidier, *Free to Be Poor: The "Devil's Gift" at Millenium's Turn/Libre Para Ser Pobre: El "Regalo del Diablo" a la Vuelta del Milenio,* 2002, photographs with text

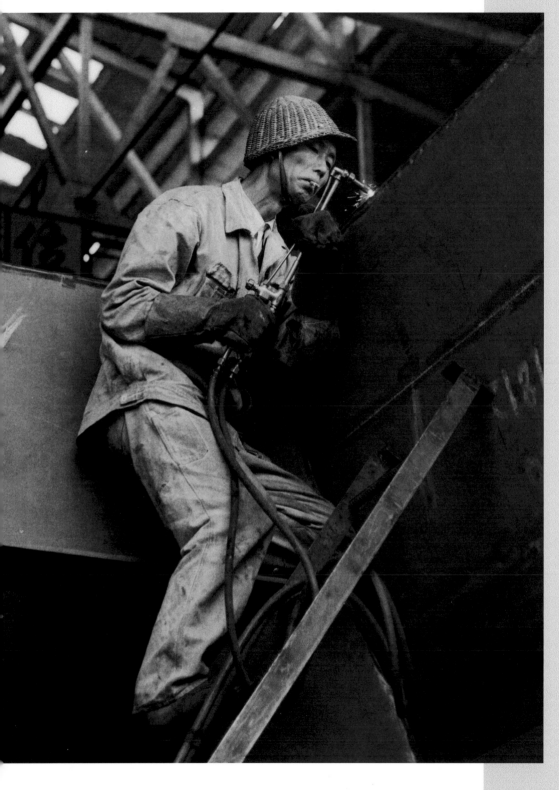

COMPLEX ISSUES of multinational manufacturing and economic disparity are deeply enmeshed in this work and the next, though the relationship between California and these two images of Chinese workers may not be immediately apparent.

Joseph A. Blum's photograph captures a typical scene of industrial labor in the complex and exploitative process that goes by the name of globalization. A welder in Jiangyin, China, works on the construction of a gigantic container crane that will be shipped to and used in the United States to unload immense ships that daily bring tons of inexpensive Asian products to West Coast ports. The precarious position of the worker on the top of the ladder and the lack of eye protection and other safety measures underline one aspect of labor exploitation.

Plate 103. Joseph A. Blum, *Chinese Burner,* 2001, gelatin silver print, 10" x 8"

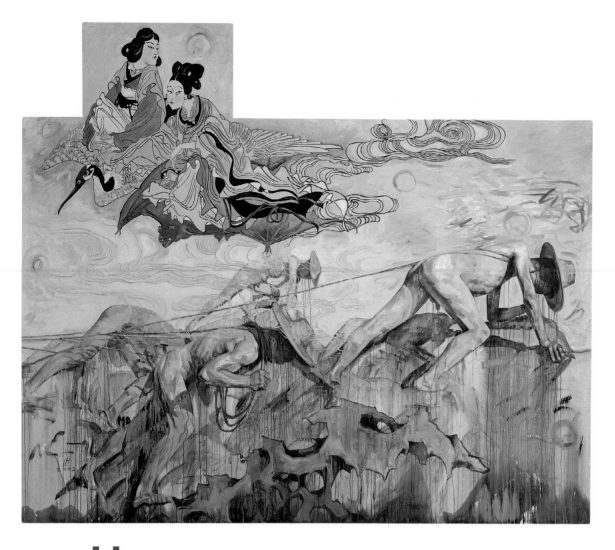

HUNG LIU's monumental oil painting evokes the heroic scale of imagery from the last century. In this complex work, drawn in part from a historical photograph from China, she makes a searing and poignant commentary on the disparity between privilege and deprivation in any class hierarchy while metaphorically referencing America's increasing economic stratification. Stooped, nude men wearing only straw hats pull a barge (not visible in the painting) along the Yangtze River while, flying over their heads, two elaborately dressed women ride on the backs of a crane and a bat. For this upper portion, the artist referenced a painting by Qing Dynasty painter Ren Bonian (1840–1896) in which the immortals travel to a party for the Queen Mother of the West. In this context, the women appear to be aristocrats far above the toils of laborers. The misery of the barge-pullers is so palpable that the paint, filled with drips and circles, seems to weep for them and their difficult existence. Liu puts this in broader terms: "It is a collective weeping for the tragic/heroic history of mankind—we must always go forward, yet always make sacrifices through our labor."

Although Liu is an internationally regarded artist and currently teaches at Mills College in Oakland, she was herself a laborer sent to the countryside for "proletariat re-education" during the Cultural Revolution in China. She was expected to work in rice and wheat fields seven days a week, but she kept her sketchbook by her side.

Plate 104. Hung Liu, *Interregnum*,
2002, oil on canvas, 96" x 114"

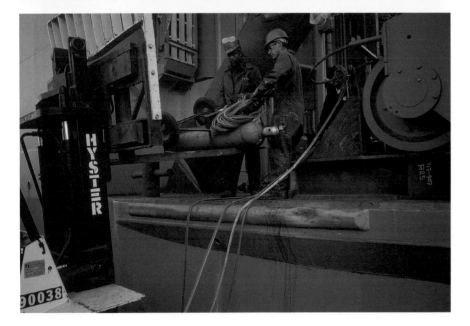

ALLAN SEKULA's *Freeway to China* series explores, as do the works of Liu and Blum, Pacific Rim relationships in contemporary labor. Sekula is known for photographic installations that achieve an almost cinematic presence through the sequencing of their images and Sekula's use of text. This series of eighteen photographs explores the economics of container ships, and the images range from a portrait of Louisa Gratz, president of ILWU Local 26, to pictures of protests and a lockout, and aesthetic abstractions of the giant cranes. Following a Belgian ship sailing from Abu Dhabi and unloaded by Russian seamen in Long Beach, Sekula positions the harbor as the site of contemporary international labor issues, simultaneously recalling the history of labor organizing along California's waterfront.

Sekula, one of California's most internationally celebrated and widely exhibited artists, bridges aesthetic and political concerns in the text that accompanies the photographs in the installation. Writing about the cranes, seen against a sky shifting to twilight, Sekula notes:

Orange and blue are the utopian colours of Southern California, the colour of the region's first great agricultural export product and the colour of the water stolen and transported two hundred miles by aqueduct to make that product grow. Irrevocably connected to these larcenous beginnings, these complementary colours were adopted by the Los Angeles–based oil giant Unocal, which nowadays builds for a lucrative future in Burma. Orange is also the colour of rust, and curiously enough, of rust-resistant paint as well. Orange is also the colour of the fires of hell, unless you read Milton, who imagined otherwise. Blue is the colour of the sea.

As the work of Sekula, Kelley, Liu, and the other contemporary artists in this chapter demonstrates, the strength that California art about labor gained in the 1930s has not dissipated. Labor consciousness continues to fuel some of California's most important and powerful art, and the results continue to lend their power to California's workers.

Plates 105–107. Allan Sekula, "The *Teal* Berthed at Pier with Cranes," Ilfochrome print, 20" x 40";
"Container Cranes Welded and Braced Aboard the *Teal*," Ilfochrome print, 20" x 40";
"Loading Welding-gas Canisters Aboard the *Teal*," Ilfochrome print, 29" x 40";
all from the series *Freeway to China*, February 1997

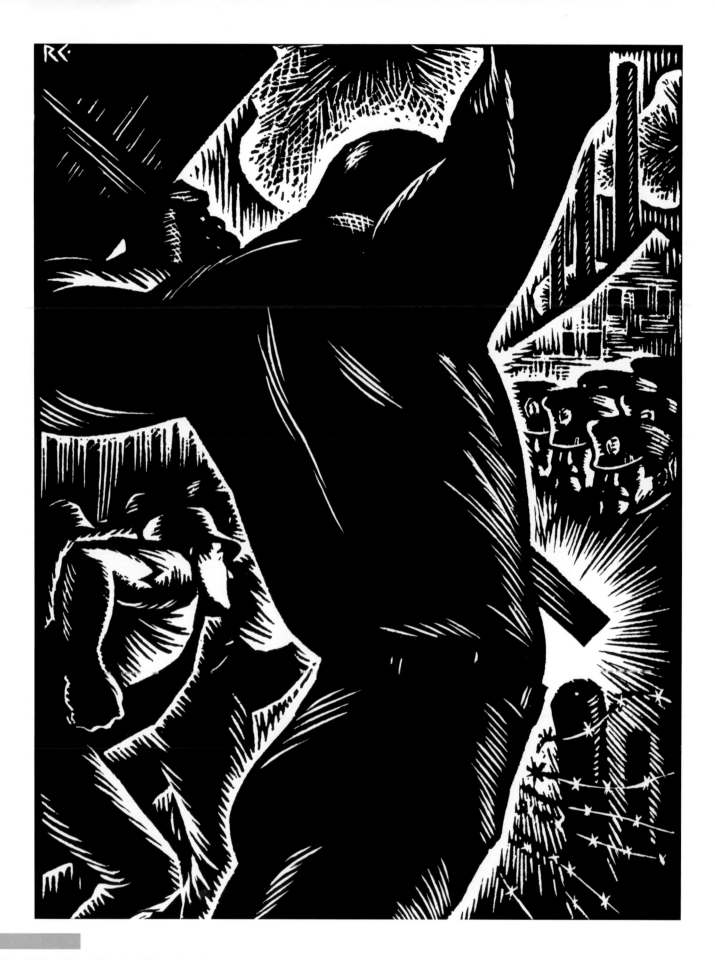

Plate 108. Richard V. Correll, *For Labor's Right to Organize*,
1934, woodcut, dimensions unavailable, present location unknown

Afterword

TILLIE OLSEN

Remembering the '34 Time and What Came After

I'm ninety years old now, and whole waves of memories come to mind when we talk about art and labor. Some of my own first professional experiences as a writer came out of the 1934 time, when the Longshoremen were getting organized. I was invited to write several pieces about the strike from an eyewitness perspective—one appeared in the second issue of the *Partisan Review.* And at the same time, I was writing for leaflets; in fact I not only authored the text but ran off copies on a mimeograph machine.

This was a time when very visible labor struggles were taking place and artists were engaged in their own battle, trying to be included in the WPA. There was a sense of solidarity between art and labor. At one union meeting that I attended, several artists were being introduced to the crowd, and the amount of applause and cheering that went on was tremendous. That kind of passion was common, and you felt it most when you went to meetings.

Song was so important to those unions. A kind of spirit just surged up with the music, which often originated with Latino workers. Songs about events or individuals like Joe Hill provided the opening to talk about labor history. The visual artists were important in portraying the dignity of individual workers; it is always a pretty wonderful thing to find something from one's own life experience inspiring a beautiful photograph or shaping art history.

Looking back, I wish I had written more about the importance of organizing and its relationship to human potentiality. I think about what was lost in terms of human capacity: in my generation, we ended up going to work very early in life to help support our families; most of us were out of school by the eighth grade. There was not much in school, either, to give an individual a feeling of potentiality. I once wrote, "For was it not through books they had been taught that they were dumb, dumb, dumb?" But individual unions took responsibility for providing an education for their members, even before the California Labor School. It was thrilling to see this educational model being set up. Members were taught to read the newspaper—the want ads, but also what was behind the headlines. Many people got involved with union newspapers—their gossip columns were very, very popular.

Unions should also be acknowledged for holding bilingual meetings, enabling people to say publicly what was on their minds, and encouraging literacy for women.

The next great change in this country came with the GI Bill. So many of the men coming back from the war never thought of themselves as anything; they didn't think they'd finish high school, much less that they were college material. It was a happy coincidence that the California Labor School was around during that time to give a sense of confidence to these workers, even encourage them to study art. My guy Jack was involved with the school at that time, and he thought it was important to give union members a time when they could go to classes and expand their sense of themselves. People could end up working in areas that were beyond the conception of their parents. This changed their futures; it's another case of union organizing expanding human potentiality, and almost nothing has been written about it.

Today we are a long distance from 1934. Less and less is taught about labor art, and I am sometimes afraid that so much of the rich legacy of labor consciousness will be lost. Yet obviously this cannot be allowed to happen, because the interweaving of art and labor has made such a difference in the lives of so many people. Certain aspects of history are so important for people to remember, to embolden us when it comes to a struggle. It's important to remember that we didn't get things just because they were handed over to us; everything had to be fought for and won.

Timeline: California Labor History since 1900

1901

San Francisco teamsters join with sailors and long-shoremen in a nine-week strike against the anti-union Employers' Association. Police brutality toward strikers raises public indignation and helps spark the creation of the Union Labor Party, which goes on to win several city elections during its eleven-year life.

More than 1,000 waitresses and cooks demanding higher wages close nearly 200 San Francisco restaurants.

The California State Federation of Labor forms, dedicated to advancing the political goals of the state's labor movement.

1903

California's first recorded farm workers' strike breaks out in Oxnard when 1500 Japanese American and Mexican American sugar beet workers protest exploitative conditions. The American Federation of Labor (AFL) refuses to grant the workers a charter due to its ban on Asian members.

1905

San Francisco labor leaders form the Asiatic Exclusion League to limit Japanese and Chinese immigration.

1907

Twenty-five workers are killed and hundreds wounded in battles with strikebreakers during the San Francisco Streetcar Workers Union's failed strike for an eight-hour day.

Female trade unionists in Los Angeles and San Francisco form the Wage Earners Suffrage League.

1910

An October 1 explosion at the Los Angeles Times Building kills twenty people, interrupting a bitter strike by the city's metal trades unions. John McNamara, secretary-treasurer of the Structural Iron Workers, and his brother James are arrested and eventually confess, dealing a severe blow to union legitimacy in Los Angeles.

1912

In San Diego, members of the International Workers of the World (IWW) are arrested and beaten by police and vigilantes for organizing on street corners.

1913

A Marysville district attorney, a deputy sheriff, and two workers are killed during the "Wheatland hop riot" at Ralph Durst's ranch in Yuba County on August 3. The "riot"—a clash between migrant workers and a local posse—results in the conviction of two IWW members for second-degree murder but draws attention to the oppression of California's agricultural workers.

1916

A bomb explodes during a Preparedness Day parade in downtown San Francisco on July 22, killing ten and injuring forty. Left-wing trade unionists Tom Mooney and Warren Billings are convicted of murder but evidence of perjury convinces many of their innocence. "Free Tom Mooney" becomes a *cause célèbre* and international rallying cry.

1919

California teacher union locals form the California State Federation of Teachers.

Thirteen hundred female telephone operators in San Francisco successfully strike for the right to bargain collectively.

The California Legislature passes the Criminal Syndicalism Act, facilitating the harassment and imprisonment of hundreds of IWW members, unionists, and radicals.

1920–1921

The Better America Federation in Los Angeles and the Industrial Association in San Francisco form to combat labor activism. Nearly a decade of declining union power and membership throughout California ensues.

1929

The stock market plummets in late October, signifying the beginning of the Great Depression.

1930

More than 100 farm workers are arrested for organizing in Imperial Valley.

1931

Police use tear gas and fire hoses to break up a meeting of women cannery workers in the Santa Clara Valley.

1932

Aided by the Communist Party, 300 tree pruners stage a strike in Vacaville for higher wages. Vigilantes seize, beat, and coat with red paint six of the strike leaders.

1933

More than 18,000 cotton workers strike throughout the Central Valley, winning temporary pay raises.

The International Ladies Garment Workers Union (ILGWU), led by Rose Pesotta, organizes Latina cloakmakers and dressmakers in Los Angeles and successfully strikes for a wage increase.

1934

The International Longshoremen's Association (ILA), led by Harry Bridges, goes on strike on May 9 in all Pacific Coast ports for higher wages and to end the corrupt, employer-controlled "shape-up" hiring system. On July 5, later known as "Bloody Thursday," San Francisco police officers and National Guardsmen clash with 5,000 strikers, resulting in sixty-four injuries and two deaths. Unions in San Francisco and Alameda Counties stage a four-day general strike, prompting renewed police and vigilante violence. On October 12, a federal arbitrator ends the longshoremen's strike, empowering the ILA with union hiring halls and the right to bargain collectively.

The San Francisco Artists' and Writers' Union forms a picket line around Coit Tower to protect its murals from government censorship.

1936–1937

The Maritime Federation of the Pacific stages a nonviolent three-month strike of dockworkers and seamen along the West Coast, reinforcing and expanding the union victories of 1934.

1937

Several unions leave the AFL to form the California Congress of Industrial Organizations (CIO) Council, focused on industrial unionism and a greater commitment to civil rights.

1939

Culbert Olson, the first Democratic California governor in the twentieth century, pardons Tom Mooney.

John Steinbeck's *The Grapes of Wrath* and Carey McWilliams's *Factories in the Fields* are published, stimulating public sympathy for the plight of California farm workers.

1941–1945

During the American involvement in World War II, the San Francisco Bay becomes the world's largest shipbuilding site. At the peak of production in 1943, the California shipbuilding industry employs nearly 300,000 civilians. The state's aircraft industry employs another 280,000 that year.

1941

A strike by workers at North American Aviation in Inglewood is broken up by federal troops when President Roosevelt seizes the plant.

1942

The governments of the United States and Mexico agree to the *bracero* program, beginning the annual importation of hundreds of thousands of Mexican laborers to work in California agriculture.

The Tom Mooney Labor School, later renamed the California Labor School, opens in San Francisco. Supported by the Communist Party, labor unions, and local philanthropists, the school is devoted to providing "workers' education."

1945–1946

Grievances by set and prop builders trigger a series of strikes by movie workers in Hollywood. Studio bosses manage to pit the anticommunist International Alliance of Theatrical Stage Employees (IATSE) against the radical Conference of Studio Unions (CSU), decimating the CSU and paving the way for the Hollywood blacklist.

1946

AFL unions shut down Oakland for two days by staging a general strike in support of striking clerks.

1947

The U.S. House Committee on Un-American Activities issues a list of suspected Communists in the Hollywood film industry. In subsequent years, about 250 actors, directors, and writers are blacklisted for alleged Communism.

1947–1950

National Farm Labor Union Local 218, led by Ernesto Galarza, engages in a protracted strike against the DiGiorgio Fruit Corporation in Kern County. A U.S. House investigating subcommittee (which includes Richard Nixon) supports DiGiorgio, helping to crush the union.

1949

The International Longshoremen's and Warehousemen's Union (ILWU) agrees to leave the CIO rather than be expelled for alleged Communism.

1951

U.S. Congress passes Public Law 78 and the Migrant Labor Agreement of 1951, sustaining and expanding the *bracero* program.

1955

The AFL and CIO merge with an estimated membership of fifteen million American workers.

1957

The California Labor School is closed by the Internal Revenue Service for nonpayment of taxes.

1958

The California State Federation of Labor becomes the California Labor Federation, AFL-CIO, reuniting AFL and CIO unions. The organization helps defeat Republican Senator William Knowland's gubernatorial campaign and his antiunion "right to work" Proposition 18.

1960

The ILWU signs the landmark coast-wide Mechanization and Modernization Agreement, guaranteeing job security in exchange for granting employers the right to implement labor-saving new technologies.

1964

Mechanization and swelling illegal immigration prompt the end of the *bracero* program, which in total imported more than 3 million Mexican workers to the U.S., most to California.

1965–1966

The National Farm Workers Association, led by César Chávez and Dolores Huerta, joins with the Agricultural Workers Organizing Committee, AFL-CIO, in a strike against thirty-three grape growers near Delano. The strike wins support for organized labor and expands to become a national boycott. The DiGiorgio Corporation and Schenley Industries, the two largest growers, concede and recognize the two unions, which merge to form the United Farm Workers (UFW).

1970

The UFW's five-year grape boycott comes to an end on July 29 when most of California's large growers agree to union contracts.

1971–1972

Harry Bridges and the ILWU shut down all Pacific Coast ports during a six-month strike for higher wages and increased job security.

1975

The California legislature creates the Agricultural Labor Relations Board to oversee farm workers' union representation elections. The legislature also passes the Rodda Act, requiring school districts to engage in collective bargaining with teachers' unions. The Rodda Act represents the culmination of a decade of organizing in public education.

1977

The UFW and the Teamsters Union sign an agreement putting an end to years of bitter jurisdictional disputes.

1980–1981

Fifteen hundred office workers at Blue Shield Insurance Company in San Francisco stage a four-month strike. Blue Shield successfully waits out the strike and hires back only about 150.

1981

Female municipal workers in San Jose conduct the country's first "comparable worth" strike, demanding pay raises to match the salaries for similarly trained men's occupations.

1985

The state Supreme Court settles a dispute between sanitation workers and the government of Los Angeles County in favor of the striking workers, ending the illegality of public employee strikes in California.

1990

Police officers interrupt a demonstration by Los Angeles janitors, injuring or arresting several dozen. Public outrage over the incident helps the janitors' union win recognition from cleaning contractor ISS. The day of the confrontation, June 15, is annually celebrated as Justice for Janitors Day.

1994

The United States, Canada, and Mexico implement the North American Free Trade Agreement (NAFTA), creating the largest free trade area in the world. California loses thousands of jobs to Mexico but others are created to support the state's surging exports.

1996

Los Angeles garment workers, supported by the Union of Needletrades, Industrial and Textile Employees (UNITE), file a class action lawsuit against Guess Inc. and nine of its contractors, charging them with paying less than minimum wage and firing workers for organizing. Guess eventually agrees to pay one million dollars to the workers, a major victory for the anti-sweatshop movement.

1998

Organized labor helps to defeat Proposition 226, which aimed to restrict California unions' ability to make political contributions.

1999

Protestors in San Francisco join those in Seattle and other cities in demonstration against the World Trade Organization's refusal to enforce labor and environmental standards in global trade agreements.

Nearly 75,000 home care workers in Los Angeles vote to join the Service Employees International Union (SEIU), the largest organizing drive in California since the 1930s.

2000

The runaway success of the high tech industry, centered in Silicon Valley in northern California, comes to a close as the Nasdaq composite index falls 39 percent for the year.

2001

The September 11 attacks on New York City and Washington, D.C. trigger significant downturns in California's tourism and airline industries. President Bush signs the Aviation and Transportation Security Act requiring airport screeners to be U.S. citizens, threatening the jobs of thousands of unnaturalized security workers in California airports.

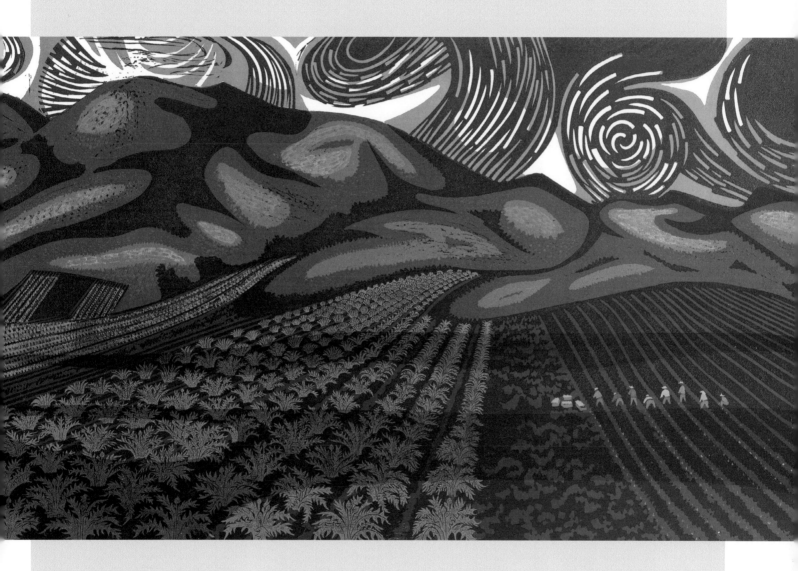

Plate 109. Emmy Lou Packard, *Half Moon Bay*,
ca. 1960, color linocut, 24" x 36"

Plate 110. Rupert Garcia, *Mother Jones,*
1989, screenprint, 30" x 22½"

Artist Biographies and Notes to Plates*

Alicia, Juana

Plate 77, *Las Lechugeras (The Women Lettuce Workers)*, © 1983 All Rights Reserved. Acrylic mural on stucco, York and 24th Street, San Francisco, 30' x 50'. Photo courtesy of Emmanuel C. Montoya and Tim Drescher.
 Born 1953, Newark, NJ.
Selected solo exhibitions: 1989, *La Pistola y el Corazon: Paintings by Juana Alicia*, Galería Posada, Sacramento, CA; 2000, *Juana Alicia: Presencia Monumental*, Coyote Gallery, Butte College, Oroville, CA. **Selected group exhibitions:** 1986, *She*, Berkeley Art Center, Berkeley, CA; 1987, *Mexican-American Show*, Loteriá Nacional, Mexico City; 1989, *Pinturaltura: Vermillion Blues Spilling*, Galería de la Raza, San Francisco. **Selected public works:** *El Lenguaje Mundo del Alma*, Hawthorne Elementary School, San Francisco; *Sanctuary* (with Emmanuel C. Montoya), International Terminal, San Francisco Airport; *Las Lechugeras (The Women Lettuce Workers)*, York and 24th Street, San Francisco.
Selected bibliography:
 "Artist Juana Alicia and the Art of Solidarity." *Heart: Human Equity Through Art*, (Fall 2001): 60-63.
 Griswold del Castillo, Richard. *Chicano Art: Resistance and Affirmation*. Los Angeles: Wight Art Gallery, UCLA, 1991.
 Henkes, Robert. *Latin American Women Artists of the United States: The Works of 33 Twentieth-Century Women*. Jefferson, NC: McFarland, 1999.

Anonymous photographer

Plate 11, *Douglas Tilden Mechanics Memorial after 1906 Earthquake*, photograph. Courtesy of San Francisco History Center, San Francisco Public Library.

Anonymous artist (after Perham Nahl)

Plate 12, *Labor Clarion*, Labor Day 1927, cover illustration, 13½" x 10¼". Courtesy of the Labor Archives and Research Center, San Francisco State University.

Arnautoff, Victor

Plate 30, *Down with Fink Halls*, 1934, woodcut, 10" x 8".
Plate 42, *Family Chores*, ca. 1950, color lithograph, 20" x 16".
Plate 52, *Cable Men*, ca. 1948, oil on canvas, 45" x 49".
All work courtesy private collection, San Francisco.
 Born 1896, Mariupol, Ukraine; died 1979, Leningrad, Russia.
Selected solo exhibitions: 1931, California Palace of the Legion of Honor, San Francisco. **Selected group exhibi-** tions: 1929–39, San Francisco Art Association; 1938, San Francisco Museum of Art; 1939, Golden Gate International Exposition, San Francisco. **Public works:** *City Life*, Coit Tower, San Francisco; Lobby, George Washington High School, San Francisco; Military Chapel, Presidio, San Francisco.
Selected bibliography:
 Hailey, Gene, ed. "Victor Mikhail Arnautoff. . . . Biography and Works." *California Art Research Monographs*, v.20:1, 105-124. San Francisco: Works Progress Administration, 1937.
 Lee, Anthony W. *Painting on the Left: Diego Rivera, Radical Politics, and San Francisco's Public Murals*. Berkeley: University of California Press, 1999.
 Lombardi, Suzanne Woodbury. "Politics and Humanism in the Depression Era Frescoes of Victor Arnautoff." Master's thesis, University of California, Berkeley, 1984.

Art and Revolution

Plate 63, *Burn the Boss (May Day Parade in San Francisco)*, 2000, digital image. Courtesy of the artists.

Judith Francisca Baca, Patrick Blasa, SPARC Digital Mural Lab

Plate 92, *In Our Victories Lies Our Future (Local 11)*, 1998, digital mural, 29' x 31', Los Angeles. © Judith F. Baca and Team. Photo courtesy of Timothy Drescher.

Bacon, David

Plate 88, *Electronics Worker*, 1999, gelatin silver print, 8" x 10". Courtesy of the artist.
 Born 1948, New York, NY.
Selected solo exhibitions: 1999, *Immigrant Workers*, Center for Latin American Studies, UC Berkeley; 2001, *Every Worker is an Organizer*, Oakland Museum of California, Oakland, CA; 2002, *Hunger—What Will You do About it?*, Oakland City Hall, Oakland, CA. **Selected group exhibitions:** 1993, *Selections 93*, Eye Gallery, San Francisco; 1996, *Body and Light*, ADR Gallery, Los Angeles; 2000, *The Impact of Free Trade*, Photocircle Gallery, Seattle, WA. **Selected public works:** California Federation of Teachers, Oakland, CA; California Labor Federation, Sacramento, CA; Dolores Huerta Elementary School, Stockton, CA.
Selected bibliography:
 Bacon, David. "Build a House, Go to Jail." *LA Weekly*, 23 Aug. 2002.
 Bacon, David. "Every Worker Is an Organizer: Califor-

nia Farm Labor and the Resurgence of the United Farm Workers." *Labor's Heritage,* XI, 3 (Spring/Summer 2001): 36-57.

Bacon, David. "Labor Fights for Immigrants," *Nation,* 21 May 2001: 15.

Benton, Thomas Hart

Plate 34, *Hollywood,* 1937, tempera with oil on canvas mounted on panel, 53½" x 81". Courtesy of Nelson-Atkins Museum of Art, Kansas City, MO (Bequest of the artist) F75-21/12. © T. H. Benton and Rita P. Benton Testamentary Trusts/Licensed by VAGA, New York, NY. Photo by Jamison Miller.

Born 1889, Neosho, MO; died 1975, Kansas City, MO. **Selected solo exhibitions:** 1972, *Thomas Hart Benton: A Retrospective of His Early Years, 1907–1929,* Rutgers University Art Gallery, New Brunswick, NJ; 1989, *Thomas Hart Benton: An American Original,* Nelson-Atkins Museum of Art, Kansas City, MO; 1998, *Thomas Hart Benton and the American South,* Morris Museum of Art, Augusta, GA. **Selected group exhibitions:** 1965, *Mid-America in the Thirties: The Regionalist Art of Thomas Hart Benton, John Steuart Curry and Grant Wood,* Des Moines Art Center. **Selected public works:** *Arts of Life in America,* New Britain Museum of American Art, New Britain, CT; *A Social History of the State of Missouri,* Missouri State Capitol, Jefferson City, MO; *Independence and the Opening of the West,* Harry S. Truman Library in Independence, MO.
Selected bibliography:

Baigell, Matthew. *Thomas Hart Benton.* New York: Abrams, 1974.

Burroughs, Polly. *Thomas Hart Benton, a Portrait.* Garden City, NY: Doubleday, 1981.

Foster, Kathleen A. *Thomas Hart Benton and the Indiana Murals.* Bloomington: Indiana University Art Museum in association with Indiana University Press, 2000.

Biberman, Edward

Plate 61, *Labor Day Parade,* 1940, oil on canvas, 31¾" x 39¼". Courtesy of Gallery "Z," Suzanne W. Zada, Beverly Hills, CA.

Born 1904, Philadelphia, PA; died 1986, Los Angeles, CA.
Selected solo exhibitions: 1929, Galerie Zak, Paris; 1936, Reinhardt Gallery, New York; 1952, *Retrospective,* Palm Springs Desert Museum and Los Angeles Municipal Art Gallery. **Selected group exhibitions:** 1927, Salon d'Automne, Paris; 1929, *Forty Six Under Thirty Five,* Museum of Modern Art, New York; 2000, *Made in California,* Los Angeles County Museum of Art. **Selected public works:** *Kinney's Dream,* U.S. Post Office, Venice, CA; Ceiling Mural, U.S. Federal Building, Los Angeles.
Selected bibliography:

Biberman, Edward. *The Best Untold: A Book of Paintings.* New York: Blue Heron Press, 1953.

Biberman, Edward *Time and Circumstance, Forty Years of Painting.* Los Angeles: Ward Ritchie Press, 1968.

Blake, George

Plate 98, *Acorn Paddle,* 1987, cast aluminum, 43" x 4" x 1". Courtesy of the artist.

Born 1944, Hoopa, CA.
Selected solo exhibitions: 1978, *George Blake,* Gorman Museum, University of California, Davis; 1980, *The Artistry of George Blake,* Museum of the Plains Indian

and Craft Center, Browning, MT. **Selected group exhibitions:** 1995, *Indian Humor,* American Indian Contemporary Arts Gallery, San Francisco; 1995, *Carving Traditions of Northern California,* Phoebe Hearst Museum of Anthropology, University of California, Berkeley; 2002, *Dialogue on Paper,* Mission Cultural Center, San Francisco.
Selected bibliography:

American Indian and Alaska Native Arts and Crafts. Washington, DC: Indian Arts and Crafts Board, U.S. Dept. of the Interior, 1995.

Dubin, Lois Sherr. *North American Indian Jewelry and Adornment from Prehistory to the Present.* New York: Abrams, 1999.

Ortiz, Bev. "George Blake: A Traditional/Contemporary Artist." *News from Native California,* 8, 4, (Spring 1995).

Bloch, Lucienne

Plate 5, *Land of Plenty,* ca. 1936, woodcut, 10½" x 9". Courtesy of Lucienne Allen.

Born 1909, Geneva, Switzerland; died 1999, Gualala, CA.
Selected solo exhibitions: 1998, Mendocino Art Center, Mendocino, CA. **Selected group exhibitions:** 1976, *Seven American Women, The Depression Decade: Rosalind Bengelsdorf, Lucienne Bloch, Minna Citron, Marion Greenwood, Doris Lee, Elizabeth Olds, Concetta Scaravaglione,* Vassar College Art Gallery, Poughkeepsie, NY.
Public works: College of the Redwoods, Mendocino, CA; St. Mary's Church, San Francisco.
Selected bibliography:

Bloch, Lucienne. "Murals for Use." In *Art for the Millions,* edited by Francis V. O'Connor. Greenwich: New York Graphic Society, 1973.

Moore, Sylvia, ed. *Yesterday and Tomorrow: California Women Artists.* New York: Midmarch Arts Press, 1989.

Blum, Joseph A.

Plate 103, *Chinese Burner,* 2001, gelatin silver print, 10" x 8". Courtesy of People and Work Photography, Joseph A. Blum.

Born 1941, New York, NY.
Selected solo exhibitions: 2000, *Bay Area Blum Collar: Documenting The Labor Process,* SomArts Gallery, San Francisco; 2002, *Working People,* J. Paul Leonard Library, San Francisco State University; 2002, *Working Iron From Shanghai To San Francisco,* SomArts Gallery, San Francisco. **Selected group exhibitions:** 2001, *Cuban Styles 2001,* SomArts Gallery, San Francisco; 2001, *Pixel and Grain,* San Francisco Photography Center; 2002, *Constructing The 1930s,* Berkeley Art Museum, Berkeley, CA.
Selected bibliography:

Blum, Joseph. "Degradation Without Deskilling: Twenty-Five Years in the San Francisco Shipyards." In *Global Ethnography.* Berkeley: University of California Press, 2000.

Strasburg, Jenny. "Focusing on Laborers' Lives." *San Francisco Examiner,* 23 July 2000.

Borofsky, Jonathan

Plate 80, *Hammering Man,* 1991, handmade paper with collage and screenprint, 144" x 69" x 3". © 1990 Jonathan Borofsky and Gemini G.E.L., Los Angeles, California.

Born 1942, Boston, MA.
Selected solo exhibitions: 1984, *Jonathan Borofsky,*

Whitney Museum of American Art, New York; 1986, *Jonathan Borofsky Drawings,* Milwaukee Art Museum. **Selected group exhibitions:** 1978, *Jon Borofsky, Megan Williams,* University Art Museum, Berkeley, CA; 1982, *Eight Artists: The Anxious Edge,* Walker Art Center, Minneapolis, MN; 1992, *Parallel Visions: Modern Artists and Outsider Art,* Los Angeles County Museum of Art. **Selected bibliography:**

Borofsky, Jonathan. *Prints and Multiples by Jonathan Borofsky, 1982–1991.* Hanover, NH: Hood Museum of Art, Dartmouth College, 1992.

Borofsky, Jonathan. *Jonathan Borofsky, Dreams 1973–81.* London: Institute of Contemporary Arts, 1981.

Borofsky, Jonathan. *The God Project.* Waltham, MA: Rose Art Museum, 1997.

Stephen Callis, Leslie Ernst, Sandra Ramirez, Rubén Ortiz Torres

Plate 91, *La Gran Limpieza (The Big Sweep),* 1993, book cover. Courtesy of Jane Reed. Reproduced by permission of the artists.

Chun, David

Plate 24, *Waiting for a Job,* ca. 1938, lithograph, 7 ¾" x 10⅝". Courtesy of Fine Arts Museums of San Francisco, Achenbach Foundation for Graphic Arts, Courtesy of the Fine Arts Collection, Office of the Chief Architect, U.S. General Services Administration, L43.2.62.

Born 1898, Honolulu, HI; died 1989, San Francisco, CA.

Selected solo exhibitions: 1939, San Francisco Museum of Art; 1940–41, San Francisco Museum of Art. **Selected group exhibitions:** 1935, 1942–45, *Chinese Art Association,* M. H. de Young Memorial Museum, San Francisco; 1939, Golden Gate International Exposition, San Francisco; 2000, *Made in California,* Los Angeles County Museum of Art.

Selected bibliography:

Brown, Michael D. *Views from Asian California.* San Francisco: Michael D. Brown, 1992.

Clark, Claude Sr.

Plate 84, *Paydirt,* 1970, oil on masonite panel, 30" x 24". Courtesy of the family of Claude Clark.

Born 1915, Rockingham, GA; died 2001, Oakland, CA. **Selected solo exhibitions:** 1972, *A Retrospective Exhibition 1937–1971, Paintings by Claude Clark.* Carl Van Vechten Gallery of Fine Arts, Fisk University, Nashville, TN; 1996, *Claude Clark: On My Journey Now: A Selection of Paintings from 1940–1986,* The Apex Museum, Atlanta, GA. **Selected group exhibitions:** 1939–40, New York World's Fair; 1975, *Amistad II, Afro-American Art,* Carl Van Vechten Gallery of Fine Arts, Fisk University, Nashville, TN; 1997, *A Visual Heritage 1945–1980: Bay Area African-American Artists,* Triton Museum of Art, Santa Clara, CA.

Selected bibliography:

Burgard, Timothy Anglim. "Claude Clark's Guttersnipe: From 'The Talented Tenth' to The Man on the Street." *International Review of African American Art,* 17, 4 (2001): 23-29.

"Claude Clark, Sr.: A Reminiscence." *International Review of African American Art,* 10, 3 (1993): 40-47, 58-59.

Driskell, David C. *Hidden Heritage: Afro-American Art, 1800–1950.* San Francisco: Art Museum Association of America, 1985.

Clements, Grace

Plate 26, *Winter 1932,* 1933, oil on canvas, 42" x 34". Courtesy of Fine Arts Museums of San Francisco, Museum Collection, x1982.20.

Born 1905, Oakland, CA; died 1969, Los Angeles, CA. **Selected solo exhibitions:** 1931, *An Exhibition of Modern Paintings by Grace Clements,* Los Angeles Museum. **Selected group exhibitions:** 1932, Oakland Art Gallery, Oakland, CA; 1935, *Post-Surrealists,* San Francisco Museum of Art; 1942, Whitney Museum of American Art, New York.

Selected bibliography:

Clements, Grace. "New Content—New Form." *Art Front* 2 (March 1936): 8-9.

Ehlich, Susan, ed. *Pacific Dreams: Currents of Surrealism and Fantasy in California Art, 1934–1957.* Los Angeles: UCLA at the Armand Hammer Museum of Art and Cultural Center, 1995.

Trenton, Patricia, ed. *Independent Spirits: Women Painters of the American West, 1890–1945.* Berkeley: University of California Press, 1995.

Common Threads Group

(Roxanne Auer, Judy Branfman, Eva Cockroft, Leslie Ernst, Mary Linn Hughes, Alessandra Moctezuma, Sheila Pinkel, Leda Ramos)
Plate 94, *Guess Who Pockets the Difference,* 1995, poster, 11" x 28". Courtesy of Common Threads Artist Group.

Connell, Will

Plate 35, *Editing,* from the book *In Pictures,* 1937. Courtesy of the Will Connell Collection, UCR/California Museum of Photography, University of California, Riverside.

Born 1898, McPherson, KS; died 1961, Los Angeles, CA. **Selected solo exhibitions:** 1981, *Will Connell: Hollywood Photographer,* San Francisco Museum of Modern Art. **Selected group exhibitions:** 1927, 1928, 1930, Camera Pictorialists of Los Angeles; 1995, *Pacific Dreams: Currents of Surrealism and Fantasy in California Art, 1934–1957,* UCLA at the Armand Hammer Museum of Art and Cultural Center, Los Angeles.

Selected bibliography:

Connell, Will. *About Photography.* New York: T. J. Maloney, 1949.

Connell, Will. *In Pictures: A Hollywood Satire.* New York: T. J. Maloney, 1937.

Connell, Will. *The Missions of California.* New York: Hastings House, 1941.

Correll, Richard V.

Plate 108, *For Labor's Right to Organize,* 1934, woodcut, dimensions unavailable, present location unknown. Courtesy of Leslie Correll.

Born 1904, Springfield, MO; died 1990, Oakland, CA. **Selected solo exhibitions:** 1940, Pacific Gallery, Seattle, WA; 1972, Lucien Labaudt Gallery, San Francisco; 1984, Berkeley Art Center, Berkeley, CA. **Selected group exhibitions:** 1940, San Francisco Museum of Art; 1942, *Artists for Victory,* Metropolitan Museum of Art, New York; 1991, *Politics in Prints,* University of Oregon Museum of Art. **Selected public works:** *Paul Bunyan,* Arlington High School, Bremerton, WA.

Selected bibliography:

Foner, Philip Sheldon, and Reinhard Schultz. *The Other America: Art and The Labour Movement in the United States.* London: Journeyman Press, 1985.

Cushing, Lincoln. "Senior Progressive Printmaker." *Community Murals Magazine,* (Winter 1984): 19–20.

Cross Eriksson, Adelyne
Plate 31, *Funeral March,* ca. 1950, woodcut, 22¼" x 5¼". Courtesy of the Labor Archives and Research Center, San Francisco State University.

Born 1905, Kingston, WI; died 1979, Upsala, Sweden. **Selected group exhibitions:** 1989, *Graphic Arts Workshop Commemorative Exhibition,* Graphic Arts Workshop, San Francisco; 2002, *Proof(s) of Life: Graphic Arts Workshop 1952–2002,* Meridian Gallery, San Francisco. **Selected bibliography:**
Cross Eriksson, Adelyne. *Grafik.* Stockholm: Fram bokförlag.
Hallström, Olle. *Människor är skapande!: en bok om Adelyne Cross-Eriksson, den amerikanska konstnären som skapade Levande verkstad.* Stockholm: InterText, 1996.
Konstlexikon: Swedish Art for 100 Years. Stockholm: Natur och Kultur, 1974.

Cushing, Lincoln
Plate 81, *Fiftieth National Bourgeois Art Exhibit,* 1981, poster, 24½" x 18". Courtesy of the artist.

Born 1953, Havana, Cuba
Selected solo exhibitions: 1982, La Peña Cultural Center, Berkeley, CA; 1984, Grassroots Cultural Center, San Diego, CA; 1985, Modern Times Bookstore, San Francisco. **Selected group exhibitions:** 1982, *From Issue to Image* (with Doug Minkler), Pro Arts Gallery, Oakland, CA; 1981–85, Bay Area Traveling Union Hall Exhibition; 1990–2003, Western Workers Labor Heritage Festival, San Francisco.
Selected bibliography:
Cushing, Lincoln. *¡Revolución! Cuban Poster Art.* San Francisco: Chronicle Books, 2003.

deLappe, Pele
Plate 47, *California Labor School Faculty,* ca. 1945, offset, 7½" x 9½". Courtesy of the Labor Archives and Research Center, San Francisco State University.
Plate 49, *Uptown Theater Picket Line,* ca. 1945, dimensions unavailable, present location unknown. Courtesy of the artist.

Born 1916, San Francisco, CA.
Selected solo exhibitions: 1994, Labor Archives and Research Center, San Francisco State University. **Selected group exhibitions:** 1936, San Francisco Art Association; 1989, Women's Museum, Washington, DC; 1999, M.H. deYoung Memorial Museum, San Francisco. **Selected bibliography:**
deLappe, Pele. *Pele: A Passionate Journey Through Art and the Red Press.* Petaluma, CA: Pele deLappe, 2002.
Treuhaft, Decca. *Lifeitselfmanship, or, How to Become a Precisely Because Man, an Investigation into Current L (or Left-Wing) Usage.* Illustrated by Pele deLappe. Oakland, CA: Decca Treuhaft, 1956.

de la Torre, Sergio
Plate 100, *Go Unnoticed,* diptych digital photos, each 47¾" x 35". Courtesy of the artist.
Born 1967, Tijuana, Mexico.
Selected solo exhibitions: 2003, *While You Were Gone,* Headlands Center for the Arts, Sausalito, CA; 2003, *Thinking About Expansion,* Lizabeth Oliveria Gallery, San Francisco. **Selected group exhibitions:** 1999,

Museum Pieces, M.H. deYoung Memorial Museum; 1999, *Bienal Barro de America,* Museo de Bellas Artes, Caracas, Venezuela; 2003, *2nd Detroit International Video Festival,* The Museum of New Art, Detroit, MI. **Selected public works:** 1997, *Correr,* SFSU municipal railway station bus shelters, San Francisco. **Selected bibliography:**
Alba, Victoria. "thehousingproject." *Artweek,* (April 2002): 13.
Cardenas Raul. *The Vertex, a collection of visual art, music, fashion and design exploring ideas of global culture.* ToroLab, 2002.
Helfand, Glen. *Museum Pieces.* San Francisco: M.H. de Young Memorial Museum, 1999.

Deutsch, Boris
Plate 45, *1848 Gold!* In *1848 The Great Trek for Gold,* 1946, mural study, detail, watercolor and gouache mounted on cardboard, 24" x 24". Collection of Judah L. Magnes Museum, gift of Boris Deutsch estate.

Born 1892, Kransnagorka, Lithuania; died 1978, Los Angeles, CA.
Selected solo exhibitions: 1926, University of California, Los Angeles; 1992, *The Legacy of Boris Deutsch: A Centennial Exhibition,* Judah L. Magnes Museum, Berkeley, CA. **Selected group exhibitions:** 1929, East West Gallery, San Francisco; 1932, *Works by Western Artists,* Oakland Art Gallery; 1949, Scripps College, Claremont, CA. **Selected public works:** Post Office, Reedley, CA; Post Office, Hot Springs, NM; Terminal Annex Post Office, Los Angeles.
Selected bibliography:
Judaic and Biblical Themes: Paintings by Max Band, Boris Deutsch and Peter Krasnow. Los Angeles: Westside Jewish Community Center, 1966.

Dixon, Maynard
Plate 22, *Free Speech,* 1934–36, oil on canvas, 40" x 48". Courtesy of Brigham Young University Museum of Art. All rights reserved.
Plate 28, *Keep Moving,* 1934, charcoal on paper, 30" x 44". Courtesy of ILWU, San Francisco.

Born 1875, Fresno, CA; died 1946, Tucson, AZ.
Selected solo exhibitions: 1916, Palace of Fine Arts, San Francisco; 1934, Haggin Memorial Museum, Stockton, CA; 1968, M.H. deYoung Memorial Museum, San Francisco. **Selected group exhibitions:** 1915, Panama Pacific International Exposition, San Francisco; 1928, Pasadena Art Museum, Pasadena, CA; 1933, 1935, Corcoran Art Gallery, Washington DC. **Selected public works:** Frieze in nine sections (in collaboration with Frank Van Sloun), Room of the Dons, Mark Hopkins Hotel, San Francisco; *Pageant of Tradition,* Main Reading Room, California State Library, Sacramento, CA; *The Road to El Dorado,* Post Office, Martinez, CA. **Selected bibliography:**
Hailey, Gene, ed. "Maynard Dixon. . . . Biography and Works." *California Art Research Monographs,* v. 8, 1–101. San Francisco: Works Progress Administration, 1936–1937.
Maynard Dixon: A Bicentennial Retrospective. Fresno, CA: The Fresno Arts Center, 1975.
The Drawings of Maynard Dixon. San Francisco: Achenbach Foundation for Graphic Arts, Fine Arts Museums of San Francisco, 1985.

Domínguez, Francisco J.

Plate 64, *Infrared Photograph of Agricultural Worker,* ca. 2000, photograph, 13½" x 9".

Plate 73, *César Chávez,* 1993, gelatin silver print, 14" x 11". All work courtesy of the artist.

Born 1959, Sacramento, CA.

Selected solo exhibitions: 1993, *Cinco de Mayo,* Sacramento City College Library, Sacramento, CA; 1997, *Field of Sweat: Portraits of Struggle,* Yuba College, Woodland, CA; 2001, *Farmworkers in the Valley,* Golden State Museum, Sacramento, CA. **Selected group exhibitions:** 1994, *Allen In and Out of Town, An Intimate Look at Allen Ginsberg Through the Eyes of Strangers,* Boulder Public Library, Boulder, CO; 1998, *Valley Grown: Mexican American Visions and Voices from the Central Valley,* CSU Stanislaus, Turlock, CA; 2000, *Dare to Dream, The Life and Work of Cesar E. Chavez,* in conjunction with the Smithsonian Institution, The Mexican Heritage Plaza, San Jose, CA

Fuentes, Juan R.

Plate 72, *Piscando en Pájaro,* 2001, linocut, 20" x 14". Courtesy of the artist.

Born 1950, Artesia, NM.

Selected solo exhibitions: 1976, *Realismo Chicano: Drawings by Juan R. Fuentes,* University of California, Chicano Studies Library, Berkeley; 1997, *Lifelines: Linocut Prints by Juan R. Fuentes,* Studio 24 Gallery, San Francisco; 1999, *Faces from the Neighborhood, A Glimpse of Newcomb Avenue,* Bayview Branch Library, San Francisco. **Selected group exhibitions:** 1977, *Political Poster Show,* San Francisco Art Commission, Capricorn Asunder Gallery, San Francisco; 1995, *A Defiant Legacy 1970–1995: Galeria de la Raza 25th Anniversary Exhibition,* Center for the Arts, Yerba Buena Gardens, San Francisco; 2000, *Obra Grafica: Rolling the Ink, Spreading the Message,* Carnegie Arts Center, Turlock, CA.

Selected bibliography:

Griswold del Castillo, Richard. *Chicano Art: Resistance and Affirmation.* Los Angeles: Wight Art Gallery, UCLA, 1991.

García, Rupert

Plate 68, *Cesen Deportación!,*1973, screenprint, 18¾" x 25". Courtesy of Fine Arts Museums of San Francisco, Achenbach Foundation for Graphic Arts, Gift of Mr. and Mrs. Robert Marcus, 1990.1.111.

Plate 110, *Mother Jones,* 1989, screenprint, 30" x 22½". Courtesy of the artist, Rena Bransten Gallery, San Francisco, CA, and the Galerie Claude Samuel, Paris, France. © Rupert Garcia 2003. Courtesy of Fine Arts Museums of San Francisco, Achenbach Foundation for Graphic Arts, Gift of Mr. and Mrs. Robert Marcus, 1990.1.170.

Born 1941, French Camp, CA.

Selected solo exhibitions: 1978, *Rupert Garcia/Pastel Drawings,* San Francisco Museum of Modern Art; 1990, *Rupert Garcia: Prints and Posters, 1967–1990,* Achenbach Foundation for the Graphic Arts, Fine Arts Museums of San Francisco; 1993, *Aspects of Resistance: Rupert Garcia,* Alternative Museum, New York. **Selected group exhibitions:** 1975, *Images of an Era: The American Poster 1945-75,* Corcoran Gallery of Art,Washington DC; 1986, *Por Encima del Bloqueo,* II Bienal de la Habana, Centro Wifredo Lam; 1995, *Art, A Defiant*

Legacy 1970–1995: The Gallery de la Raza, Yerba Buena Center for the Arts, San Francisco.

Selected bibliography:

Favela, Ramón. *The Art of Rupert Garcia: A Survey Exhibition.* San Francisco: Chronicle Books, 1986.

Rupert Garcia (Distinguished Artist Series). Stockton, CA: The Haggin Museum, 1988.

Rupert Garcia: Prints and Posters, 1967–1990, San Francisco: Achenbach Foundation for the Graphic Arts, Fine Arts Museums of San Francisco, 1990.

Garza, Jamey

Plate 101, *All Work with Jamey Garza,* 1996, album jacket and disk, 12¼" x 12¼". Courtesy of the artist and Gallery 16, San Francisco, CA.

Born 1964, Austin, TX.

Selected solo exhibitions: 1998, *Jamey Garza, New Works,* Gallery 16, San Francisco; 2000, *Jamey Garza: New Work,* Kapinos, Berlin, Germany; 2001, *Jamey Garza: Another Story,* Acuna-Hansen Gallery, Los Angeles. **Selected group exhibitions:** 1996, *Working Histories,* L.A.C.P.S., Los Angeles; 1997, *Between Culture and Commerce,* Gallery 16, San Francisco; 2000, *L.A. Art in the Early 90s: ReCharge,* Laguna Art Museum, Laguna Beach, CA.

Selected bibliography:

Darling, Michael. "Fruits of Labor." *Los Angeles Reader,* 12 July 1996.

Knaff, Deborah. "Working Histories at L.A.C.P.S." *Artweek,* (July 1996): 26.

Roche, Harry. "Jamey Garza at Gallery 16." *Artweek,* (July/August 2000): 17–18.

Lydia Gibson and Robert Minor

Plate 14, *The Blast* (August 15, 1916), cover illustration, 12¾" x 9¾". Courtesy of the Labor Archives and Research Center, San Francisco State University.

Gilbert, Louise

Plate 48, *Study Sculpture with Ralph Stackpole,* ca. 1945, original art for poster, 9¼" x 12¼". Courtesy of the Labor Archives and Research Center, San Francisco State University.

Plate 51, *Fisherman,* ca. 1950, screenprint, 19" x 16¾". Private collection, San Francisco.

Born 1913, Portland, OR.

Selected group exhibitions: 1950, *San Francisco Art Association, 14th Annual Drawing and Print Exhibition,* San Francisco Museum of Art; 1989, *Graphic Arts Workshop Commemorative Exhibition,* Graphic Arts Workshop, San Francisco; 2002, *Proof(s) of Life: Graphic Arts Workshop 1952-2002,* Meridian Gallery, San Francisco.

Selected bibliography:

Foner, Philip Sheldon and Reinhard Schultz. *The Other America: Art and the Labour Movement in the United States.* London: Journeyman Press, 1985.

Hagel, Otto (see also Hansel Mieth)

Plate 10, *Tom Mooney,* 1936, gelatin silver print, 14" x 11".

Plate 27, (with Hansel Mieth), *Outstretched Hands,* 1934, gelatin silver print, 10" x 13".

Plate 33, (with Hansel Mieth), *Salinas Lettuce Strike, Night Meeting,* 1939, gelatin silver print, 13" x 10".

All work courtesy of the Labor Archives and Research Center, San Francisco State University. © Center for

Creative Photography, The University of Arizona Foundation.

Born 1909, Fellbach, Germany; died 1973, Santa Rosa, CA.
Selected solo exhibitions: 1989, *A Lifetime of Concerned Photography,* Eye Gallery, San Francisco; 1994, *Otto Hagel and Hansel Mieth: A Love Story in Photography,* International Center for Photography, New York.
Selected group exhibitions: 1955, *Family of Man,* Museum of Modern Art, New York; 2001–02, *De Foto en de Amerikaanse Droom: De Stephen White Collectie II, 1840–1940,* Van Gogh Museum, Amsterdam.
Selected bibliography:
Goldblatt, Louis. *Men and Machines.* San Francisco: International Longshoremen's & Warehousemen's Union, 1963.
Inouye, Mamoru. *The Heart Mountain Story: Photographs by Hansel Mieth and Otto Hagel of the World War II Internment of Japanese Americans.* Los Gatos, CA: M. Inouye, 1997.
Reframing America: Alexander Alland, Otto Hagel & Hansel Mieth, John Gutmann, Lisette Model, Marion Palfi, Robert Frank. Essays by Andrei Codrescu and Terence Pitts. Tucson, AZ: Center for Creative Photography, 1995.

Hansen, Armin
Plate 16, *Nino,* ca. 1922, oil on canvas, 50½" x 60⅜". Courtesy of Monterey Museum of Art, Gift of Jane and Dustin Dart.
Born 1886, San Francisco, CA; died 1957, Monterey, CA.
Selected solo exhibitions: 1928, Smithsonian Institution, Washington DC; 1932, M. H. deYoung Memorial Museum, San Francisco; 1986, *Armin Hansen: A Centennial Salute,* Monterey Peninsula Museum of Art, Monterey, CA. **Selected group exhibitions:** 1915, Panama Pacific International Exposition, San Francisco; 1915, 1918, 1919, San Francisco Art Association; 1935, Golden Gate International Exposition, San Francisco.
Selected bibliography:
Armin Hansen: The Jane and Justin Dart Collection. Monterey, CA: Monterey Peninsula Museum of Art, 1993.
Hailey, Gene, ed. "Armin C. Hansen." Biography and Works." *California Art Research Monographs,* v.9, 105–133. San Francisco: Works Progress Administration, 1936–1937.
White, Anthony R. *The Graphic Art of Armin C. Hansen: A Catalogue Raisonné.* Los Angeles: Hennessy and Ingalls, 1986.

Hayden, Bits
Plate 111, *No Help Wanted,* 1948, book illustration for *On the Drumhead,* a selection from the writing of Mike Quin (San Francisco: Pacific Publishing Inc., publishers of *Daily People's World*).

Hernández, Ester
Plate 2, *La Virgen de las Calles (The Virgin of the Streets),* 2001, pastel on paper, 40" x 30".
Plate 70, *Sun Mad Raisins,* 1982, screenprint, 22" x 17". All work courtesy of the artist.
Born 1944, Dinuba, CA.
Selected solo exhibitions: 1988, *The Defiant Eye,* Galería de la Raza, San Francisco; 1998, *Transformations: The Art of Ester Hernández,* MACLA,

the San Jose Center for Latino Arts, San Jose, CA.
Selected group exhibitions: 2000, *Made in California,* Los Angeles County Museum of Art; 2001, *Just Another Poster? Chicano Graphic Arts in California,* Fowler Museum, UCLA; 2002, *Art/Women/California 1950–2000: Parallels and Intersections,* San Jose Museum of Art, San Jose, CA. **Selected public works:** *Gracias a la Vida,* Centro Latino, San Francisco; *Melrose '79,* Melrose School, Oakland, CA; *Wall of Friendship,* 53rd and East 14th Streets, Oakland, CA.
Selected bibliography:
Farris, Phoebe, ed. *Women Artists of Color: A Bio-Critical Sourcebook to 20th Century Artists in the Americas.* Westport, CT: Greenwood Press, 1999.
Mesa-Bains, Amalia. *Ester Hernández.* San Francisco: Galería de la Raza, 1988.
Roth, Moira, ed. *Connecting Conversations: Interviews with 28 Bay Area Women Artists.* Oakland, CA: Eucalyptus Press, 1988.

Hom, Nancy
Plate 85, *Immigrant Rights,* 1985, screenprint, 24" x 18". Courtesy of the artist.
Born 1949, Toisan, China.
Selected solo exhibitions: 1982, Grassroots Cultural Center, San Diego, CA; 1982, *Screenprints by Nancy Hom,* Asian Resource Gallery, Oakland, CA; 2000, *Nancy Hom Retrospective,* ODC Theater Gallery, San Francisco. **Selected group exhibitions:** 1977, *Political Poster Show,* San Francisco Arts Commission, Capricorn Asunder Gallery, San Francisco; 1986, Berkeley Art Center, Berkeley, CA; 1999, *The War Room,* Intersection for the Arts, San Francisco.
Selected bibliography:
Blia Xiong. *Nine-in-one, Grr! Grr! A Folktale From the Hmong People of Laos.* Illustrated by Nancy Hom. San Francisco: Children's Book Press, 1989.
Speak, You Have the Tools: Social Serigraphy in the Bay Area, 1966–1986. Santa Clara, CA: de Saisset Museum, Santa Clara University, 1987.

Howard, John Langley
Plate 29, *Embarcadero and Clay Streets,* 1935, oil on canvas, 35⅞" x 43½". Courtesy of Fine Arts Museums of San Francisco. Museum Purchase, Dr. Leland A. Barber and Gladys K. Barber fund, 2002.96.
Born 1902, Montclair, NJ; died 1999, San Francisco, CA.
Selected solo exhibitions: 1939, San Francisco Museum of Art; 1941, Carnegie Institute, Pittsburgh, PA; 1983, Academy of Sciences, San Francisco. **Selected group exhibitions:** 1939, Golden Gate International Exposition, San Francisco; 1943, Corcoran Gallery, Washington DC; 1946, California Palace of the Legion of Honor, San Francisco. **Selected public works:** *California Industrial Scenes,* Coit Tower, San Francisco.
Selected bibliography:
John Langley Howard: A Life in Art. San Francisco: Fine Arts Museums of San Francisco, 1991.
John Langley Howard: Elemental Drifts. Logan, UT: Nora Eccles Harrison Museum of Art, Utah State University, 1987.
Hailey, Gene, ed. "John Langley Howard.... Biography and Works." *California Art Research Monographs,* v.17, p.54-92. San Francisco: Works Progress Administration, 1936-1937.

Jones, Pirkle

Plate 41, *Worker,* from *Story of a Winery, Saratoga,* 1958, gelatin silver print, 14" x 11".
Plate 69, *Grape Picker, Berryessa Valley, California,* 1956, selenium toned gelatin silver print, 14" x 11".
All work courtesy of the artist.
 Born 1914, Shreveport, LA.
Selected solo exhibitions: 1952, Ansel Adams Studio, San Francisco; 1971, *Pirkle Jones Portfolio,* San Francisco Museum of Art; 2001, *Pirkle Jones, Sixty Years in Photography,* Santa Barbara Museum of Art. **Selected group exhibitions:** 1954, *Perceptions,* San Francisco Museum of Art; 1975, *The Land: Twentieth-Century Landscape Photographs,* Victoria and Albert Museum, London; 2000, *Made in California,* Los Angeles County Museum of Art.
Selected bibliography:
 Baruch, Ruth-Marion, and Pirkle Jones. *The Vanguard, a Photographic Essay on the Black Panthers.* Boston: Beacon Press,1970.
 Jones, Pirkle. *California Photographs.* New York: Aperture, 2001.
 Lange, Dorothea, and Pirkle Jones. *Death of a Valley.* Rochester, NY: Aperture, 1960.

Joseph, Emmanuel

Plate 39, *Rosies,* ca. 1943, gelatin silver print, 8" x 10". Courtesy of the African American Museum and Library at Oakland (AAMLO), E. F. Joseph Collection.
 Born 1900, St. Lucia, West Indies; died 1979, Oakland, CA.
Selected bibliography:
 Moore, Joe Louis. "In Our Own Image: Black Artists in California 1880–1970." *California History,* (Fall 1996): 265, 268.

Kaiper, Bruce

Plate 86, *Speed-Ups Are Perilous to Your Life!,* ca. 1980, screenprint, 27½" x 19¼". Courtesy of Timothy Drescher. Reproduced by permission of the artist.
 Born 1944, Tulsa, OK.
Selected solo exhibitions: 1978, *The Working Imagination: Photo Silkscreen Prints, Posters, Collages by Bruce Kaiper,* Laney College Library Gallery, Oakland, CA; 1976, *Surplus Value and Alienation—A Visual Exploration of Monopoly Capital: Photo Silkscreen Prints and Collages by Bruce Kaiper,* California College of Arts and Crafts Gallery, Oakland, CA. **Selected group exhibitions:** 1983, *The Other America—Art and the Labour Movement in the United States,* Staatkiche Kunsthalle, Berlin.
Selected bibliography:
 Foner, Philip Sheldon and Reinhard Schultz. *The Other America: Art and the Labour Movement in the United States.* London: Journeyman Press, 1985.

Kanaga, Consuelo

Plate 15, *Untitled (Nets),* ca. late 1910s, gelatin silver print, 7" x 5". Courtesy of Culver Pictures.
 Born 1894, Astoria, OR; died 1978, Yorktown Heights, NY.
Select solo exhibitions: 1974, Blue Moon Gallery, New York; 1976, The Brooklyn Museum; 2001, *Intimate Eye: The Paintings and Photographs of Consuelo Kanaga,* The Friends of Photography, San Francisco. **Selected group exhibitions:** 1932, *Group f.64,* M.H. de Young Memorial Museum, San Francisco; 1948, *50 Photographs by 50 Photographers: Landmarks in Photographic History,* Museum of Modern Art, New York; 1982, *Images of America: Precisionist Painting and Modern Photography,* San Francisco Museum of Modern Art.
Selected bibliography:
 Consuelo Kanaga, Photographs: A Retrospective. New York: Blue Moon Gallery, 1974.
 Millstein, Barbara Head, and Sarah M. Lowe. *Consuelo Kanaga: An American Photographer.* Brooklyn: The Museum in association with University of Washington Press, 1992.
 Mitchell, Margaretta K. *Recollections: Ten Women of Photography.* New York: Viking, 1979.

Kelley, Mike

Plate 97, *From My Institution to Yours,* 1987, installation of acrylic on paper, ribbon, carrot, 16' x 15' x 10'. Courtesy of the artist.
 Born 1954, Detroit, MI.
Selected solo exhibitions: 1991, *Half a Man,* Hirshhorn Museum, Washington, DC; 1993, *Mike Kelley: Catholic Tastes,* Whitney Museum of American Art, New York; 1997, *Mike Kelley: 1985–1996,* Museu d'Art Contemporani de Barcelona. **Selected group exhibitions:** 1985, 1989, 1991, 1993, 1995, *Whitney Biennial,* Whitney Museum of American Art, New York; 1987, *Avant-Garde in the Eighties,* Los Angeles County Museum of Art; 1997, *Documenta X,* Kassel, Germany.
Selected bibliography:
 Kelley, Mike. *Mike Kelley, Three Projects: Half a Man, From My Institution to Yours, Pay for Your Pleasure.* Chicago: University of Chicago, 1988.
 Monk, Philip. *Mike Kelley and Paul McCarthy: Collaborative Works.* Toronto: Power Plant Contemporary Art Gallery at Harbourfront Centre, 2000.
 Welchman, John C. *Mike Kelley.* London: Phaidon, 1999.

Kent, Rockwell

Plate 54, *Save This Right Hand,* 1949, color lithograph, 15½" x 11". Courtesy of the Labor Archives and Research Center, San Francisco State University.
 Born 1882, Tarrytown, NY; died 1971, Plattsburgh, NY.
Selected solo exhibitions: 1942, *Know and Defend America,* Wildenstein Galleries, New York; 1960, Hermitage Museum, Leningrad; 1969, *Rockwell Kent: The Early Years,* Bowdoin College Museum of Art, Brunswick, ME. **Selected group exhibitions:** 1939, New York World's Fair; 1987, *From Native Soil: A Selection of American Regionalist Prints,* Claremont Colleges, Claremont, CA; 1991, *Rockwell Kent, George Bellows, Leon Kroll,* Allison Gallery, New York.
Selected bibliography:
 Jones, Dan Burne. *The Prints of Rockwell Kent: A Catalogue Raisonné.* Chicago: University of Chicago Press, 1975.
 Martin, Constance. *Distant Shores: The Odyssey of Rockwell Kent.* Chesterfield, MA: Chameleon Books, 2000.
 West, Richard V. *An Enkindled Eye: The Paintings of Rockwell Kent, a Retrospective Exhibition.* Santa Barbara, CA: Santa Barbara Museum of Art, 1985.

Kiyama, Henry Yoshitaka

Plate 13, "Turlock Incident, 1922" from *The Four*

Immigrants Manga, 1931, illustrated book. © Copyright Estate of Yoshitaka Kiyama, 2003.

Born 1885, Neu, Tottori, Japan; died 1951, Neu, Tottori, Japan.

Selected solo exhibition: 1927, Golden Gate Institute (Kinmon Gakuen) San Francisco; 1933, Yonago City Art Museum, Tottori, Japan. **Selected group exhibition:** 1921, Palace of Fine Arts, San Francisco; 1920, 1925, San Francisco Art Association.

Selected bibliography:

Hughes, Edan Milton. *Artists in California, 1786–1940.* San Francisco, CA: Hughes Publishing, 1989.

Kiyama, Henry. Translated and with notes by Frederik L. Schodt. *The Four Immigrants Manga: A Japanese Experience in San Francisco, 1904–1924.* Berkeley: Stone Bridge Press, 1998).

Kiyama, Yoshitaka. *Manga Yonin Shosei.* San Francisco: Yoshitaka Kiyama Studios, 1931.

Lange, Dorothea

Plate 1, *Shipyards—End of Day Shift at Yard One,* 1943, gelatin silver print, 10" x 8".

Plate 25, *White Angel Bread Line, San Francisco,* 1933, gelatin silver print, 10" x 8". Courtesy of the San Francisco Museum of Modern Art. Gift of Steven M. Raas and Sandra S. Raas.

Plate 32, *Filipino Field Hands—Stoop Labor,* 1936, gelatin silver print, 10" x 8".

Plate 40, *Kaiser Shipyard—Shift Change 3:30,* 1942, gelatin silver print, 10" x 8".

Plates 1, 32, and 40 courtesy of the Oakland Museum of California.

All works copyright the Dorothea Lange Collection, Oakland Museum of California, City of Oakland. Gift of Paul S. Taylor.

Born 1895, Hoboken, NJ; died 1965, San Francisco, CA.

Selected solo exhibitions: 1960, *Death of a Valley,* San Francisco Museum of Art; 1966, *The Dorothea Lange Retrospective,* Museum of Modern Art, New York; 1996, *Dorothea Lange: Archive of an Artist,* Oakland Museum of California. **Selected group exhibitions:** 1949, *Six Women Photographers,* Museum of Modern Art, New York; 1955, *The Family of Man,* Museum of Modern Art, New York; 1975, *Women of Photography: A Historical Survey,* San Francisco Museum of Art.

Selected bibliography:

Heyman, Therese Thau, Sandra S. Phillips, and John Szarkowski. *Dorothea Lange: American Photographs.* San Francisco: San Francisco Museum of Modern Art in association with Chronicle Books, 1994.

Meltzer, Milton. *Dorothea Lange: A Photographer's Life.* New York: Farrar, Straus & Giroux, 1978.

Partridge, Elizabeth, ed. *Dorothea Lange: A Visual Life.* Washington, DC: Smithsonian Institution Press, 1994.

Light, Ken

Plate 82, *Moulder, 29 Years Industrial Accident, Oakland, California, 1975,* 1978, gelatin silver print, 8" x 12".

Plate 83, *Makeshift Mask,* 1979, gelatin silver print, 12" x 8".

All work courtesy of San Francisco State University Library, Special Collections, and © Ken Light.

Born 1951, Bronx, NY.

Selected solo exhibitions: 1978, *Images of Work: An Exhibition of Photographs by Ken Light,* San Jose Museum of Art; 1979, *The Working World: Ken Light,*

Intersection Gallery, San Francisco; 1997, Manuel Alvarez Bravo Gallery, Guadalajara, Mexico. **Selected group exhibitions:** 1983, *In the Fields: Ken Light, Roger Minick, Reesa Tansey,* The Chicago Center for Contemporary Photography of Columbia College, Chicago, IL; 2000, *Child Labor,* Rotunda, U.S. Senate Office Building, Washington, DC; 2000, *Automobile Images and American Identities,* California Museum of Photography, Riverside, CA.

Selected bibliography:

Light, Ken. *Delta Time: Mississippi Photographs.* Washington, DC: Smithsonian Institution Press, 1995.

Light, Ken. *Texas Death Row.* Jackson: University Press of Mississippi, 1997.

Light, Ken. *To the Promised Land.* New York: Aperture in association with the California Historical Society, 1988.

Liu, Hung

Plate 104, *Interregnum,* 2002, oil on canvas, 96" x 114". Courtesy of the artist and the Rena Bransten Gallery, San Francisco, CA.

Born 1948, Changchun, China.

Selected solo exhibitions: 1994, *Jiu Jin Shan,* de Young Memorial Museum, San Francisco; 1998, *Hung Liu: A Survey, 1988–1998,* The College of Wooster Art Museum, Wooster, OH; 2001, *Between History and Me: New Painting by Hung Liu,* Arizona State University Art Museum, Tempe, AZ. **Selected group exhibitions:** 1978, *Portraiture Exhibition,* Winter Palace Gallery, Beijing, China; 1992, *43rd Annual Corcoran Biennial,* Corcoran Gallery of Art, Washington, DC; 2002, *Art/Woman/ California: Parallels and Intersections, 1950–2000,* San Jose Museum of Art, CA. **Selected public works:** 1981, *The Music of the Great Earth,* Foreign Students Dining Hall, Central Academy of Fine Arts, Beijing, China; 1986, *Art and the Tao,* Media Center and Communications Building, University of California, San Diego; 1988, *Reading Room,* Community Room, Chinese for Affirmative Action, Kuo Building, San Francisco, CA.

Selected bibliography:

Gender Beyond Memory: The Works of Contemporary Women Artists. Tokyo: Metropolitan Museum of Photography, 1996.

In Plural America: Contemporary Journeys, Voices and Identities. Yonkers, NY: Hudson River Museum, 1992.

Asia/America: Identities in Contemporary Asian American Art. New York: Asia Society, 1994.

Lonidier, Fred

Plate 102, *Free to Be Poor: The "Devil's Gift" at Millennium's Turn/Libre Para Ser Pobre: El "Regalo del Diablo" a la Vuelta del Milenio,* 2002, photographs with text. Courtesy of the artist.

Born 1942, Lakeview, OR.

Selected solo exhibitions: 1977, Whitney Museum of American Art, New York; 1992, *For Labor, About Labor, By Labor . . . ,* Walter/McBean Gallery, San Francisco Art Institute; 2000, *N.A.F.T.A.,* Mission Cultural Center for Latino Arts, San Francisco. **Selected group exhibitions:** 1977, 1978, Los Angeles Institute of Contemporary Art; 1981, *The Health and Safety Game,* Bakersfield College, Bakersfield, CA; 1995, *Laborfest '95,* ILWU Local 34 Union Hall, San Francisco.

Selected bibliography:

Dialogue/Discourse/Research. Santa Barbara, CA: Santa Barbara Museum of Art, 1979.

Lonidier, Fred. *A Fragmentary Capsule History of the Ironworkers & Other Unions at NASSCO.* San Francisco: Walter/McBean Gallery, San Francisco Art Institute, 1992.

Secular Attitudes. Los Angeles: Los Angeles Institute of Contemporary Art, 1985.

López, Yolanda M.
Plate 74, *Homage to Dolores Huerta: Woman's Work Is Never Done,* 1995, digital print, 20" x 20".
Plate 89, *The Nanny,* 1996, painted fabric with collage, 46" x 26". All work courtesy of the artist.
Born 1942, National City, CA.
Selected solo exhibitions: 1978, *Works: Yolanda M. Lopez 1975–1978,* Mandeville Center for the Arts, UCSD, and El Centro Cultural de la Raza, San Diego; 1993, *Cactus Hearts/Barbed Wire Dreams,* MACLA Center for Latino Arts, San Jose, CA; 1998, *Work About Work: A Woman Working in San Diego 1919–1998,* California State University, San Marcos. **Selected group exhibitions:** 1982, *From Issue to Image: Poster Art for Social Change,* Pro Arts, Oakland, CA; 1990, *The Decade Show: Frameworks of Identity in the 1980s,* The New Museum of Contemporary Art, New York; 2002, *Art/Women/California 1950–2000: Parallels and Intersections,* San Jose Museum of Art, San Jose, CA.
Selected bibliography:
LaDuke, Betty. *Women Artists: Multi-Cultural Visions.* Trenton, NJ: Red Sea Press, 1992.
Lopez, Yolanda M. and Moira Roth. "Social Protest: Racism and Sexism." In *The Power of Feminist Art: The American Movement of the 1970s, History and Impact,* edited by Norma Broude and Mary D. Garrard. New York: Abrams, 1999.
Three Stories: Flo Wong, Jean LaMarr, Yolanda Lopez. Chico: California State University, Chico, University Art Gallery, 1993.

Martin, Fletcher
Plate 6, *Trouble in Frisco,* 1938, oil on canvas, 30" x 36". Courtesy of The Museum of Modern Art, New York. Abby Aldrich Rockefeller Fund. Digital Image © 2003 The Museum of Modern Art, New York.
Born 1904, Palisade, CO; died 1979, Guanajuato, Mexico.
Selected solo exhibitions: 1941, Midtown Galleries, New York; 1944, *Oils, Watercolors and Drawings by Fletcher Martin,* California Palace of the Legion of Honor, San Francisco. **Select group exhibitions:** 1935, Los Angeles Museum.
Selected bibliography:
Cooke, H. Lester, Jr. *Fletcher Martin.* New York: Abrams, 1977.
Ebersole, Barbara Warren. *Fletcher Martin.* Foreword by William Saroyan. Gainesville: University of Florida Press, 1954.
Westphal, Ruth Lilly, and Janet Blake Dominik, eds. *American Scene Painting: California, 1930s and 1940s.* Irvine, CA: Westphal Publishing, 1991.

McChesney, Robert
Plate 58, "A Specter Is Haunting Europe," illustration for *The Communist Manifesto in Pictures,* 1948, 10¼" x 7". Courtesy of Robert McChesney, Petaluma, CA.
Born 1913, Marshall, MO.
Selected solo exhibitions: 1949, 1953, San Francisco Museum of Art; 1970, *Robert McChesney: A Decade of Painting, 1960 to 1970,* Sonoma State University, Rohnert Park, CA; 1996, Fresno Art Museum, Fresno, CA. **Selected group exhibitions:** 1955, Third Sao Paulo Biennial, Brazil; 1955, Whitney Museum, New York; 2001, *Pioneers of 20th Century Art,* Robert Green Fine Arts, Mill Valley, CA.
Selected bibliography:
Landauer, Susan. *The San Francisco School of Abstract Expressionism.* Berkeley: University of California Press, 1996.
Robert McChesney: An American Painter. Petaluma, CA: Sonoma Mountain Publishing Company, 1996.
Spencer, Howard DaLee. *Robert McChesney: A Retrospective.* Reno: Nevada Museum of Art, 1994.

McCleary, Dan
Plate 8, *Carl's Junior Worker #2,* 1989, oil on canvas, 10" x 8". Courtesy of Paule Anglim.
Born 1952, Santa Monica, CA.
Selected solo exhibitions: 1982, 1983, 1985, 1986, Newspace, Los Angeles; 1995, Flower Paintings, University of California, Santa Barbara; 2000, Gallery Paule Anglim, San Francisco. **Selected group exhibitions:** 1983, *Figures in LA,* Swope Gallery, Los Angeles; 1986, *Hollywood: Legend and Reality,* Smithsonian Institution, Washington DC; 1994, *Romance,* Art Center College of Art and Design, Pasadena, CA.
Selected bibliography:
Drawing on its Own: Figure Drawings: Dan McCleary, John Nava, Hank Pitcher. Santa Monica, CA: Tatistcheff Gallery, 1991.
Figuration/Imagination: Paintings by Dan McCleary, Hank Pitcher, Mark Stack. San Bernardino, CA: University Art Gallery, California State University, San Bernardino and College of Creative Studies, University of California, Santa Barbara, 1987.
McCleary, Dan. *Sentiment & Obsession.* Newport Beach, CA: Newport Harbor Art Museum, 1983.

Mieth, Hansel (see also Otto Hagel)
Plate 27, (with Otto Hagel), *Outstretched Hands,* 1934, gelatin silver print, 10" x 13".
Plate 33, (with Otto Hagel), *Salinas Lettuce Strike, Night Meeting,* 1939, gelatin silver print, 13" x 10".
Plate 59, *Non-Signers of Levering Act of SF State Faculty,* 1950, gelatin silver print, 14" x 11".
All work courtesy of the Labor Archives and Research Center, San Francisco State University. © Center for Creative Photography, The University of Arizona Foundation.
Born 1909, Fellbach, Germany; died 1998, Santa Rosa, CA.
Selected solo exhibitions: 1989, *A Lifetime of Concerned Photography,* Eye Gallery, San Francisco; 1994, *Otto Hagel and Hansel Mieth: A Love Story in Photography,* International Center for Photography, New York. **Selected group exhibitions:** 1995, *Points of Entry: Reframing America,* Center for Creative Photography, Tucson.
Selected bibliography:
Light, Ken, ed. *Witness in Our Time: Working Lives of Documentary Photographers.* Washington and London: Smithsonian Institution Press, 2000.
Mieth, Hansel. "Return to Fellbach," *Life,* 26 June 1950: 106.
Mieth, Hansel. *The Simple Life: Photographs from America 1929–1971.* Stuttgart: Schmetterling Verlag, 1991.

Modotti, Tina

Plate 17, *Campesinos (Workers Parade),* 1926, gelatin silver print, 8⅜" x 7⅜". Private collection, San Francisco.

Born 1896, Udine, Italy; died 1942, Mexico City.

Selected solo exhibitions: 1995, *Tina Modotti: Photographs,* Philadelphia Museum of Art; 1996–97, *Dear Vocio: Photographs by Tina Modotti,* University Art Gallery, University of California, San Diego. **Selected group exhibitions:** 1977, *California Pictorialism,* San Francisco Museum of Modern Art; 1982, *Frida Kahlo and Tina Modotti,* Whitechapel Art Gallery, London; 1991, *Camera as Weapon: Work Photography Between the Wars,* Museum of Photographic Arts, San Diego.

Selected bibliography:

Albers, Patricia. *Shadows, Fire, Snow: The Life of Tina Modotti.* New York: Clarkson Potter, 1999.

Constantine, Mildred. *Tina Modotti: A Fragile Life, An Illustrated Biography.* New York: Rizzoli, 1983.

Hooks, Margaret. *Tina Modotti, Photographer and Revolutionary.* New York: Da Capo Press, 2000.

Montoya, Malaquías

Plate 67, *Yo Vengo del Otro Lado (I Come from the Other Side),* 1994, screenprint, 20" x 22". Courtesy of the artist.

Born 1938, Albuquerque, NM.

Selected solo exhibitions: 1997, *Malaquias Montoya, Adaline Kent Award Exhibition,* Walter/McBean Gallery, San Francisco Art Institute; 1998, *Malaquias Montoya,* Mexic-Arte Museum, Austin, TX; 2000, *Malaquias Montoya,* Isis Gallery, Riley Hall, University of Notre Dame, Notre Dame, IN. **Selected group exhibitions:** 1990, *Chicano Art: Resistance and Affirmation,* Wight Art Gallery, UCLA; 2000, *Just Another Poster? Chicano Graphic Arts in California,* Jack S. Blanton Museum of Art, University of Texas, Austin, TX; 2000, *Pressing the Point: Parallel Expressions in the Graphics Arts of the Chicano and Puerto Rican Movements,* El Museo del Barrio, New York.

Selected bibliography:

Acuña, Rodolfo. *Occupied America, A History of Chicanos.* New York: Longman, 2000.

No Human Being is Illegal! – Posters on the Myths and Realities of the Immigrant Experience. Los Angeles: Center for the Study of Political Graphics, 2000.

"Hispanics in America at 2000." *Social Science Quarterly,* 81 (March 2000).

Morales, Julio

Plate 99, *Paletero,* 2002, two lightboxes with digital images, each 16" x 20". Courtesy of the artist.

Born 1966, Tijuana, Mexico.

Selected solo exhibitions: 1997, *Carousels,* Franklin Furnace, New York; 1998, *Forgetting,* The Luggage Store, San Francisco; 2000, *Fuzzyland,* AOV Gallery, San Francisco. **Selected group exhibitions:** 1999, *Planeta de Los Burros,* Toronto International Performance Festival, Toronto; 2000, *Passing,* Centro Cultural Casa Lamm, Mexico City; 2001, *Disappearing,* San Diego Museum of Contemporary Art. **Selected public works:** *Roots and Veins,* Juvenile Hall, San Francisco; *CODE 33,* collaborative project with Suzanne Lacy for the city of Oakland and Intersection For The Arts, San Francisco; *99 Actions,* collaborative installation for INSITE 2000, San Diego/Tijuana, Mexico.

Selected bibliography:

Roth, Moira. "The Making of Code 33." in *PAJ: A Journal of Performance and Art.* Baltimore: John Hopkins University Press, 2002.

The Eureka Fellowship Awards. San Jose, CA: San Jose Museum of Art, 1999.

Nadel, Leonard

Plate 65, *Untitled, from the Braceros series (men being sprayed with DDT),* 1956, photograph, 11" x 14". Courtesy of the Smithsonian Institution, National Museum of American History.

Born 1916, New York, NY; died 1990, Los Angeles, CA.

Selected solo exhibitions: 1994, *World of Children,* Glendale Public Library, Glendale, CA. **Selected group exhibitions:** 1990, *Watts '65: To the Rebellion and Beyond,* Southern California Library for Social Studies and Research, Los Angeles; 2002, *Boyle Heights: The Power of Place,* Japanese American National Museum, Los Angeles.

Selected bibliography:

"California Living" supplement, *Los Angeles Examiner,* 2 July 1978.

Nadel, Leonard. "Pueblo del Rio" (unpublished monograph). Research Library, The Getty Research Institute, Los Angeles, CA.

Nadel, Leonard. "Aliso Village USA" (unpublished monograph). Research Library, The Getty Research Institute, Los Angeles, CA.

Norman, Irving

Plate 38, *The Bridge,* 1953, oil on canvas, 76" x 34". © The Norman Trust 1990. Courtesy Tom von Tersch.

Plate 57, *The City,* 1941, pencil on paper, 30" x 24". © The Norman Trust 1990. Courtesy Jan Holloway, Holloway Fine Arts.

Born 1906, Vilna, Russia; died 1989, Half Moon Bay, CA.

Selected solo exhibitions: 1942, *Irving Norman Drawings,* San Francisco Museum of Art; 1945, Tom Mooney Gallery, California Labor School, San Francisco; 1970, *The Wrathful World of Irving Norman, A Retrospective,* The Brooklyn Center, Long Island University, Brooklyn, NY. **Selected group exhibitions:** 1952, *American Watercolors, Drawings, and Prints,* The Metropolitan Museum of Art, New York; 1957, *Contemporary American Painting and Sculpture,* University of Illinois, College of Fine and Applied Art, Urbana, IL; 1984, *The Human Condition,* M.H. de Young Memorial Museum, San Francisco.

Selected bibliography:

"Irving Norman: Dismantling the War Machine." *Juxtapoz,* no. 1 (1997): 34-39.

Irving Norman: The Human Condition: Paintings, 1965–1985. New York: Alternative Museum, 1985.

Junker, Patricia A. *The Measure of All Things: Paintings by Irving Norman.* San Francisco: Fine Arts Museums of San Francisco, 1996.

Okubo, Mine

Plate 21, *Men Working (The Pipe Layers),* ca. 1939, lithograph, 16" x 11½". Courtesy of the Michael D. Brown Collection.

Born 1912, Riverside, CA; died 2001, New York, NY.

Selected solo exhibition: 1940, 1941, San Francisco Museum of Art; 1951, The Mortimer Levitt Gallery, New York; 1972, The Oakland Museum, Oakland, CA.

Selected group exhibition: 1937, 1940–53, San Francisco Museum of Art; 1972, California Historical Society, San Francisco; 1991, National Museum of Women in the Arts, Washington, D.C.
Selected bibliography:
 LaDuke, Betty. *Women Artists: Multi-Cultural Visions.* Trenton, NJ: Red Sea Press, 1992.
 Okubo, Mine. *Citizen 13660.* New York: Columbia University Press, 1946.
 Sun, Shirley. *Mine Okubo, An American Experience.* Oakland, CA: The Oakland Museum, 1972.

Packard, Emmy Lou
Plate 3, *Logging in Mendocino, 1870,* 1969, linocut, 72½" x 15".
Plate 53, *Carpenter,* ca. 1950, woodcut, 16" x 12".
Plate 109, *Half Moon Bay,* ca. 1960, color linocut, 24" x 36". All work courtesy of PackardPrints.com.
 Born 1914, Imperial Valley, CA; died 1998, San Francisco, CA.
Selected solo exhibitions: 1942, *Mexican Oils,* San Francisco Museum of Art; 1945, *Shipyard Paintings,* Gregor Duncan Gallery at the California Labor School, San Francisco; 1960, Pushkin Museum, Moscow.
Selected group exhibitions: 1947, Group Show with Robert McChesney, Ed Corbett and Byron Randall, San Francisco Museum of Art; 2000, *Picturing San Francisco,* M.H. deYoung Memorial Museum, San Francisco. **Selected public works:** Pubic Library, Pinole, CA; Fresno Convention Center Theater, Fresno, CA; Hillcrest Elementary School, San Francisco.
Selected bibliography:
 DePaoli, Geri. *Emmy Lou Packard: 1914–1998.* Davis, CA: John Natsoulas Press, 1998.
 Pfeiffer, Pat. "Emmy Lou Packard's Palette of Paint and Politics." *San Francisco Sunday Examiner and Chronicle,* 2 May 1982.
 Rivera, Diego. *The Paintings of Emmy Lou Packard.* Los Angeles: Stendahl Art Galleries, 1941.

Palomino, Ernesto
Plate 75, (with Lee Orona), *Campesinos,* 1972, oil, Tulare and F Street, Fresno. Courtesy of the artists.
 Born 1933, Fresno, CA.
Selected solo exhibition: 1957, California Palace of the Legion of Honor, San Francisco; 1970, Teatro Campesino, Fresno, CA; 1999, Fresno City Hall, Fresno, CA.
Selected group exhibitions: 1963, Mission Gallery, San Francisco; 1982, *Califas: An Exhibition of Chicano Arts and Culture in California,* UCSC, Santa Cruz, CA; 1990, *Chicano Art: Resistance and Affirmation,* Wight Art Gallery, UCLA. **Selected public works:** *Humanities Mural,* Malaga Community Park, Malaga, CA; *Benito Juarez Portrait,* Farmworkers Office, Selma, CA.
Selected bibliography:
 Palomino, Ernie. *In Black and White: Evolution of an Artist.* Fresno, CA: Academy Library Guild, 1956.

Patri, Giacomo
Plate 56, pages from *White Collar,* 1940, novel in linocuts. Courtesy of the Patri family.
 Born 1898, Arquata Scrivia, Italy; died 1978, San Francisco, CA.
Selected solo exhibitions: 1940, Raymond and Raymond Galleries, San Francisco; 1976, Diablo Valley College; 1980, San Jose Museum of Art. **Selected group exhibitions:** 1935, San Francisco Art Association; 1937, San Francisco Museum of Art.
Selected bibliography:
 Patri, Giacomo. *White Collar: A Novel in Linocuts.* 1940. Reprint, Millbrae, CA: Celestial Arts, 1975.

Refregier, Anton
Plate 4 (detail) and Plate 46, *Maritime and General Strike,* 1946–1948, casein-tempera on white gesso over plaster wall, Rincon Center, San Francisco.
Plate 50, *Untitled,* ca. 1949, color lithograph, 14" x 12½". Courtesy of Fine Arts Museums of San Francisco, 1963.30.3052.
Plate 55, *Fortune,* July 1950, cover illustration. Courtesy of *Fortune,* © 1950 Time Inc. All rights reserved.
 Born 1905, Moscow, Russia; died 1979, Moscow, Russia.
Selected group exhibitions: 1939, WPA building murals, World's Fair, New York; 1948, California Palace of the Legion of Honor, San Francisco; 1950, *National Art Association 60th Annual Exhibition of Contemporary Art,* Sheldon Art Gallery, Lincoln, Nebraska. **Selected public works:** *Home and the Family,* Rikers Island Penitentiary, Visitors Room, New York; Post Office, Plainfield, New Jersey; *The History of California,* Rincon Center, San Francisco, CA.
Selected bibliography:
 Lee, Anthony. *Painting on the Left: Diego Rivera, Radical Politics, and San Francisco's Public Murals.* Berkeley, CA: University of California Press, 1999.
 Refregier, Anton. *Sketches of the Soviet Union.* Moscow: Progress Publishers, 1978.
 Brechin, Gray. "Politics and Modernism: The Trial of the Rincon Annex Murals," in *On the Edge of America: California Modernist Art, 1900–1950,* edited by Paul J. Karlstrom. pp. 68–93. Berkeley: University of California Press, 1996.

Rivera, Diego
Cover and Plate 19, *Allegory of California,* 1931, fresco, Pacific Stock Exchange Luncheon Club, San Francisco. Courtesy of The Empire Group, San Francisco.
Plate 18, *La Tortillera (The Tortilla Maker),* 1926, oil on canvas, 43" x 36". Courtesy of the University of California, San Francisco, School of Medicine. Both works reproduced by permission of Instituto Nacional de Bellas Artes y Literatura; and Banco de México, Fiduciary and Trust of the Estates of Diego Rivera and Frida Kahlo,
 Born 1886, Guanajuato, Mexico; died 1957, Mexico City.
Selected solo exhibitions: 1930 California Palace of the Legion of Honor, San Francisco; 1984–85, *Diego Rivera: Selected Works, 1918–1949,* The Mexican Museum, San Francisco; 1999, *Diego Rivera: Art and Revolution,* Cleveland Museum of Art, Cleveland, OH. **Selected group exhibitions:** 1992, *Crosscurrents of Modernism: Four Latin American Pioneers: Diego Rivera, Joaquín Torres-García, Wifredo Lam, Matta,* Hirshhorn Museum, Washington DC. **Selected public works:** *Allegory of California,* Pacific Stock Exchange Luncheon Club, San Francisco; *Pan-American Unity,* Little Theatre Lobby, City College of San Francisco; *The Making of a Fresco Showing the Building of a City,* Diego Rivera Gallery, San Francisco Art Institute.
Selected bibliography:
 Hamill, Pete. *Diego Rivera.* New York: Abrams, 1999.

Lee, Anthony. *Painting on the Left: Diego Rivera, Radical Politics, and San Francisco's Public Murals.* Berkeley, CA: University of California Press, 1999.
Rivera, Diego. *My Art, My Life: An Autobiography.* New York: Citadel Press, 1960.

Rodríguez, Patricia
Plate 78, *La Fruta del Diablo,* 1997, digital mural, Monterey (in collaboration with students from California State University, Monterey Bay). Courtesy of the artist.
Born 1944, Marfa, TX.
Selected solo exhibitions: 1980, Mission Cultural Center, San Francisco; 1986, La Posada Gallery, Sacramento , CA; 1990, Sonoma State University, Sonoma, CA. **Selected group exhibitions:** 1986, The Mexican Museum, San Francisco; 1990, La Peña Cultural Center, Berkeley, CA; 1994, The Fine Arts Center Museum, Chicago, IL. **Selected public works:** Balmy Alley, San Francisco; Mission Mental Health Center, San Francisco; Women's Building, San Francisco.
Selected bibliography:
Henkes, Robert. *Latin American Women Artists of the United States: The Works of 33 Twentieth-Century Women.* Jefferson, NC: McFarland, 1999.
Vinculos. Whittier, CA: Whittier College, Mendenhall Gallery, 1986.
Drescher, Timothy W. *San Francisco Bay Area Murals: Communities Create Their Muses, 1904–1997.* St. Paul, MN: Pogo Press, 1998.

Rowe, Frank
Plate 23, *Port Chicago Incident,* 1980, woodcut, 25" x 25". Courtesy of the Estate of Frank Rowe.
Born 1921, Portland, OR; died 1985, Pleasant Hill, CA.
Selected solo exhibitions: 1989, *Frank Rowe,* Civic Art Gallery, Walnut Creek, CA; 1999, *Frank Rowe: The Port Chicago Disaster and Other Injustices,* Diablo Valley College, Pleasant Hill, CA. **Selected group exhibitions:** 1974, Nanny Goat Hill Gallery, San Francisco.
Selected bibliography:
Rowe, Frank. *The Enemy Among Us: A Story of Witch Hunting in the McCarthy Era.* Sacramento: Cougar Books, 1980.

Royal Chicano Air Force
Plate 71, *UFW Benefit Dance/Baile,* 1976, screenprint, 25" x 17". Courtesy of Luis "Louie the Foot" González, Royal Chicano Air Force.

Salgado, Sebastião
Plate 79, *U.S. Border Patrol Agents Arrest Illegal Migrants along the Border between California and Mexico,* July 1977, gelatin silver print, 20" x 24". Courtesy of Ursula Gropper. Reproduced by permission of Sebastião Salgado (contact Press Images).
Born 1944, Aimores, Minas Gerais, Brazil.
Selected solo exhibitions: 1990, *An Uncertain Grace,* San Francisco Museum of Modern Art; 1993, *Workers,* Philadelphia Museum of Art; 1993, *In Human Effort,* National Museum of Modern Art, Tokyo.
Selected bibliography:
Salgado, Sebastião. *Other Americas.* New York: Pantheon Books, 1986.
Salgado, Sebastião. *Terra.* New York: Farrar, Straus and Giroux, 1997.

Salgado, Sebastião and Lelia Wanick Salgado. *Migrations: Humanity in Transition.* New York: Aperture Foundation, 2000.

San Francisco Poster Brigade
Plate 62, *Support the Kentucky Miners,* ca. 1978, poster, 16¾" x 11". Courtesy of the Labor Archives and Research Center, San Francisco State University.

Sances, Jos
Plate 87, *After 30 Years of Teaching Is This Her Reward?* 1990, screenprint, 24¾" x 18¼". Courtesy of Timothy Drescher. Reproduced by permission of the artist.
Born 1952, Boston, MA.
Selected solo exhibitions: 1991, *Republican Years, 10 Year Retrospective,* La Peña Cultural Center, Berkeley, CA; 1992, Alternative Museum, NY; 1997, *Recent Prints and Sculpture,* D. King Gallery, Berkeley, CA. **Selected group exhibitions:** 1993, *Mission Grafica,* Retrospective Exhibit, Yerba Buena Center for the Arts, San Francisco; 1994, *Voices of Protest,* Williamson Gallery, Art Center College of Design, Pasadena, CA; 1996, *Art of Northern California,* Oakland Coliseum, organized by Oakland Museum of California. **Selected public works:** Oakland Coliseum; *Malcom X,* Audubon Ballroom, NYC (with Daniel Galvez); San Francisco County Jail, San Bruno, CA.
Selected bibliography:
Artists of Conscience II: Tomie Arai, Peggy Diggs, Bailey Doogan, John Knecht, Ben Sakoguchi, Jos Sances. New York: Alternative Museum, 1992.
Mayfield, Signe. *Directions in Bay Area Printmaking: Three Decades.* Palo Alto, CA: Palo Alto Cultural Center, 1992.
Wye, Deborah. *Committed To Print: Social and Political Themes in Recent American Printed Art.* New York: Museum of Modern Art, 1988.

Sekula, Allan
Plate 95, Untitled illustration from *Photography Against the Grain,* 1984.
Plate 105, "The *Teal* Berthed at Pier with Cranes" from the series *Freeway to China,* February 1997, Ilfochrome print, 20" x 40".
Plate 106, "Container Cranes Welded and Braced Aboard the *Teal,*" from the series *Freeway to China,* February 1997, Ilfochrome print, 20" x 40".
Plate 107, "Loading Welding-gas Canisters Aboard the *Teal,*" from the series *Freeway to China,* February 1997, Ilfochrome print, 29" x 40".
All work courtesy of the artist and the Christopher Grimes Gallery, Los Angeles.
Born 1951, Erie, PA.
Selected solo exhibitions: 1985, San Francisco Camerawork; 1989, Institute of Contemporary Art, Boston; 1993, University Art Museum, Berkeley, CA. **Selected group exhibitions:** 1976, *New American Filmmakers Series: Connell, Sekula and Torres,* Whitney Museum of American Art, New York; 1984, *Art and Ideology,* New Museum of Contemporary Art, New York; 2000, *Made in California,* Los Angeles County Museum of Art.
Selected bibliography:
Sekula, Allan. *Dismal Science: Photo Works, 1972–1996.* Normal, IL: University Galleries, Illinois State University, 1999.

Sekula, Allan. *Fish Story.* Dusseldorf: Richter Verlag, 1995.

Sekula, Allan. *Photography Against the Grain: Essays and Photo Works, 1973–1983.* Halifax, N.S., Canada: Press of the Nova Scotia College of Art and Design, 1984.

Shore, Henrietta

Plate 44, *Artichoke Pickers* 1936, oil on masonite panel, 21" x 72". Courtesy of State Museum Resource Center, California State Parks.

Born 1880, Toronto, Canada; died 1963, Carmel, CA. **Selected solo exhibitions:** 1918, Los Angeles County Museum; 1986-87, *Henrietta Shore: A Retrospective Exhibition 1900–1963,* Monterey Peninsula Museum of Art, Monterey, CA. **Selected group exhibitions:** 1990, *Visions of Their Own: Four Monterey Bay Artists of the Depression Era: Cor deGavere, Leonora Naylor Penniman, Margaret Rogers, Henrietta Shore,* Octagon Museum, Santa Cruz, CA; 1999, *Opening the Door: Women in Art,* Bakersfield Museum of Art, Bakersfield, CA; 1999-2000, *The American Century: Art & Culture 1900–2000,* Whitney Museum of American Art, New York. **Selected public works:** Post Office, Santa Cruz, CA; Post Office, Monterey, CA.

Selected bibliography:

Armitage, Merle, Edward Weston, and Reginald Poland. *Henrietta Shore.* New York: E. Wehye, 1933.

Moore, Sylvia, ed. *Yesterday and Tomorrow: California Women Artists.* New York: Midmarch Arts Press, 1989.

Trenton, Patricia, ed. *Independent Spirits: Women Painters of the American West, 1890–1945.* Berkeley: University of California Press, 1995.

Elizabeth Sisco, David Avalos, Louis Hock

Plate 93, *Welcome to America's Finest Tourist Plantation,* 1988, poster, 24" x 72". Courtesy of the artists.

Stackpole, Peter

Plate 36, *Screenwriter Baker,* ca. 1939, gelatin silver print, 7 ⅜" x 9⅛".

Plate 37, *Building of the Bay Bridge,* ca. 1933, gelatin silver print, 7" x 9¼".

All work courtesy of Ursula Gropper. Reproduced by permission of the Peter Stackpole family.

Born 1913, San Francisco, CA; died 1997, Novato, CA. **Selected solo exhibitions:** 1935, San Francisco Museum of Art; 1987, San Francisco Museum of Modern Art; 1991, *Peacetime to Wartime, Mr. Stackpole Goes to Hollywood,* Oakland Museum of California, Oakland, CA. **Selected group exhibitions:** 1982, *Images of America: Precisionist Painting and Modern Photography,* San Francisco Museum of Modern Art; 1987, *The Hollywood Photographers,* Los Angeles County Museum of Art; 1992, *Seeing Straight: The f64 Revolution in Photography,* Oakland Museum of California, Oakland, CA.

Selected bibliography:

Frye, L. Thomas. *Peacetime, Wartime & Hollywood: Photographs of Peter Stackpole.* Oakland, CA: Oakland Museum, 1992.

Stackpole, Peter. *Peter Stackpole: Life in Hollywood, 1936–1952.* Livingston, MT: Clark City Press, 1992.

Stackpole, Peter. *The Bridge Builders: Photographs and Documents of the Raising of the San Francisco Bay Bridge 1934–1936.* Corte Madera, CA: Pomegranate, 1984.

Stackpole, Ralph

Plate 20, *Bountiful Earth,* 1929–1932, granite, Pacific Stock Exchange, San Francisco.

Born 1885, Williams, OR; died 1973, Chauriat, France. **Selected solo exhibitions:** 1984, Gregory Kondos Art Gallery, Sacramento City College. **Selected group exhibitions:** 1933, Museum of Modern Art, New York; 1935, *Inaugural Exhibition,* San Francisco Museum of Art; 1939, Golden Gate International Exposition, San Francisco. **Selected public works:** *Architecture and Sculpture,* Anne Bremer Library, San Francisco Art Institute; *Contemporary Education,* George Washington High School, San Francisco; *Industries of California,* Coit Tower, San Francisco.

Selected bibliography:

Hailey, Gene, ed. "Ralph Stackpole. . . . Biography and Works." *California Art Research Monographs,* v.14, 1-62. San Francisco: Works Progress Administration, 1936–1937.

Jewett, Masha Zakheim. *Coit Tower, San Francisco: Its History and Art.* San Francisco: Volcano Press, 1983.

Lee, Anthony. *Painting on the Left: Diego Rivera, Radical Politics, and San Francisco's Public Murals.* Berkeley, CA: University of California Press, 1999.

Sultan, Larry

Plate 90, *Tasha's Third Film,* 1998/99, chromogenic print, 50" x 60". Courtesy of the artist and the Stephen Wirtz Gallery, San Francisco, CA.

Born 1946, New York, NY.

Selected solo exhibitions: 1977, Center for Creative Photography, Tucson, AZ; 1990, The Exploratorium, San Francisco, CA; 1994-95, *Pictures from Home,* Corcoran Gallery of Art, Washington, DC. **Selected group exhibitions:** 1989, *California Photography: Remaking Make-Believe,* Museum of Modern Art, New York; 1995, *Moving the Message: Activism and Art,* SF Camerawork, San Francisco; 2000, *Capturing Light: Masterpieces of California Photography, 1850–2000,* Oakland Museum of California.

Selected bibliography:

Grundberg, Andy, and Kathleen Gauss. *Photography and Art: Interactions Since 1946.* New York: Abbeville Press, 1987.

Irmas, Deborah. *Signs of the Times: Some Recurring Motifs in 20th Century Photography.* San Francisco: San Francisco Museum of Modern Art, 1985.

Katzman, Louise. *Photography in California: 1945–1975.* New York: Hudson Hills Press, 1984.

Tilden, Douglas

Plate 9, *Mechanics Memorial,* 1901, cast bronze, San Francisco.

Born 1860, Chico, CA; died 1935, Berkeley, CA. **Selected solo exhibitions:** 1980, *City Sculpture of Douglas Tilden 1891–1908,* M.H. deYoung Memorial Museum, San Francisco; 1989, *Celebration '89: New Discoveries from Douglas Tilden's Studio,* Heller Gallery, University of California, Berkeley. **Selected group exhibitions:** 1893, World's Colombian Exposition, Chicago; 1935, *Thirty Years of California Sculpture,* San Francisco Museum of Art; 1982, *100 Years of California Sculpture,* The Oakland Museum of California, Oakland, CA. **Selected public works:** *Junipero Serra* and *Baseball Player,* Golden Gate Park, San Francisco; *Mechanics*

Memorial, Market Street, San Francisco; *Volunteers,* Dolores and Market Streets, San Francisco.
Selected bibliography:
 Albronda, Mildred. *Douglas Tilden, Portrait of a Deaf Sculptor.* Silver Spring, MD: T. J. Publishers, 1980.
 Albronda, Mildred. *Douglas Tilden: The Man and His Legacy.* Seattle: Emerald Point Press, 1994.
 Hailey, Gene, ed. "Douglas Tilden. . . . Biography and Works." *California Art Research Monographs,* v.6, 95-113. San Francisco: Works Progress Administration, 1936-1937.

Tomorrow, Tom (Dan Perkins)
Plate 96, *Prison Labor,* 1995, from *The Wrath of Sparky* (St. Martin's Press, 1996). Reproduced by permission of the artist.
 Born 1961, Wichita, KS.
Selected group exhibitions: 1999, *Punchline's Artzilla,* Artspace Gallery, Richmond, VA; 2002, *The Blame Show,* White Box, New York; 2002, *Gene(sis): Contemporary Art Explores Human Genomics,* Henry Art Gallery, University of Washington, Seattle.
Selected bibliography:
 Tomorrow, Tom. *Greetings from this Modern World.* New York: St. Martin's Press, 1992.
 Tomorrow, Tom. *Tune in Tomorrow.* New York: St. Martin's Press, 1994.
 Tomorrow, Tom. *When Penguins Attack!* New York: St. Martin's Griffin, 2000

Torero, Mario (with Tony Vargas)
Plate 76, *La Tierra Mía,* 1986, fresco, Chicano Park, San Diego. Photo courtesy of Timothy Drescher. Reproduced by permission of the artists.

Ulloa, Domingo
Plate 60, *Painters on Strike,* 1948, linocut, 10⅛" x 14⅜". Courtesy of Lincoln Cushing.
Plate 66, *Bracero,* ca. 1960, oil on canvas, dimensions unavailable, present location unknown. Courtesy private collection, Lemon Grove, CA.
 Born 1919, Pomona, CA; died 1997, El Centro, CA.
Selected solo exhibitions: 1981, Solart Gallery, San Diego, CA; 1986, Acevedo Art Gallery, San Diego, CA; 1994, *Domingo O. Ulloa: Out of Modernism, A Retrospective of Paintings, Pastels and Prints,* University Art Gallery, SDSU Calexico Campus, Calexico, CA.
Selected group exhibitions: 1978, Gallery 21, Spanish Village Art Center, San Diego, CA; 1979, *Arte en Aztlan,* Community Arts Gallery, San Diego, CA; 1984, *Chicano Art Exhibition,* San Diego City Hall Building.
Selected bibliography:
 Cushing, Lincoln. "Domingo Ulloa, A People's Artist." *Community Murals Magazine,* (Spring 1985): 21-23.
 Lugo, Mark-Elliott. "El Centro's Ulloa an Undiscovered Master?" *San Diego Tribune,* 31 May 1985: C-1, C-8.
 Miller, Elise. "Chicano Artist Portrays the Struggle of His People." *Los Angeles Times,* 28 Jan 1981: 4.

White, Charles
Plate 7, *Harvest,* 1963, lithograph, 22¼" x 30". Collection Leo and Sylvia Wolf, courtesy Heritage Gallery, Los Angeles.
 Born 1918, Chicago, IL; died 1979, Los Angeles, CA.
Selected solo exhibitions: 1967, *Charles White: Drawings. Inaugural Exhibition,* The Gallery of Art,

College of Fine Arts, Howard University, Washington, DC; 1976, *Work of Charles White: An American Experience,* High Museum of Art, Atlanta; 1982, *Images of Dignity: A Retrospective of the Works of Charles White,* Studio Museum in Harlem, New York. **Selected group exhibitions:** 1970, *Five Famous Black Artists, Romare Bearden/Jacob Lawrence/Horace Pippin/Charles White/ Hale Woodruff,* Museum of the National Center of Afro-American Artists, Roxbury, CT; 1971, *Three Graphic Artists: Charles White, David Hammons, Timothy Washington,* Los Angeles County Museum of Art; 2000, *An Exuberant Bounty: Prints and Drawings by African Americans,* Philadelphia Museum of Art. **Selected public works:** Hampton University, Hampton, Virginia; Howard University, Washington, DC; *Mary McLeod Bethune,* Exposition Park Public Library, Los Angeles.
Selected bibliography:
 Barnwell, Andrea D. *Charles White, The David C. Driskell Series of African American Art: Volume 1.* San Francisco: Pomegranate Books, 2002.
 Drawings & Prints by Charles White. Atlanta: Spelman College, 1975.
 Images of Dignity: The Drawings of Charles White. Foreword by Harry Belafonte. Los Angeles: W. Ritchie Press, 1967.

Zakheim, Bernard
Plate 43, *Library,* 1934, fresco, Coit Tower, San Francisco. Courtesy of Masha and Nathan Zakheim.
 Born 1896, Warsaw, Poland; died 1985, San Francisco, CA.
Selected solo exhibitions: 1968, UCSF School of Medicine, San Francisco; 1973, Magnes Museum, Berkeley, CA; 1986, Temple Emanuel, San Francisco.
Selected group exhibitions: 1935, *Inaugural Exhibition,* San Francisco Museum of Art; 1939, *Golden Gate International Exposition,* Treasure Island, San Francisco; 2002, George Krevsky Gallery, San Francisco. **Selected public works:** *Agriculture and Industry,* Post Office, Rusk, TX; *History of Medicine,* Toland Hall, UCSF Medical Center, San Francisco; *Library,* Coit Tower, San Francisco.
Selected bibliography:
 Hailey, Gene, ed. "Bernard Zakheim. . . . Biography and Works." *California Art Research Monographs,* v.20:2, 32-113. San Francisco: Works Progress Administration, 1936-1937.
 Jewett, Masha Zakheim. *Coit Tower, San Francisco: Its History and Art.* San Francisco: Volcano Press, 1983.
 Jewett, Masha Zakheim. *The Art of Medicine: The Zakheim Frescoes at UCSF.* San Francisco: M. Zakheim, 1991.

Acknowledgments

The planning for this exhibition and book has spanned several years, and a host of people have been enormously helpful throughout this period. From the outset, the project represented a unique opportunity for collaboration. We appreciate the initial and sustained encouragement of Tom Rankin, president of the California Labor Federation, Malcolm Margolin of Heyday Books, and Stephen Becker of the California Historical Society, who saw the rich potential in this innovative partnership. We have been honored by funding from the California Historical Society Press and its funders as well as from The James Irvine Foundation and The Walter and Elise Haas Foundation. We further recognize the efforts of Kevin Shelley in advancing support from the State of California.

This project has benefited greatly from its unique collaborative structure. The literary contributions of Gray Brechin, Tillie Olsen, and chapter authors Joshua Paddison and Tere Romo are invaluable. We acknowledge the critical role played by developmental editors Joshua Paddison and Genoa Shepley and coordinating editor Sharon Spain throughout the planning and production of the book, as well as their work with the authoring of captions and appendices.

Also of key importance was the dream-team curatorial committee that shaped the contents of the project. This team included Robert Cherny, Lincoln Cushing, Steve Dickison, Tim Drescher, Jeff Lustig, Joe Louis Moore, Shirley Moore, Catherine Powell, Tere Romo, Harvey Schwartz, Susan Sherwood, and Sally Stein. Their guidance cannot be overestimated.

The unique and outstanding collection at San Francisco State University's Labor Archives and Research Center provided the foundation for *At Work,* and individuals including Lynn Bonfield, Carol Cuenod, Deborah Masters, Catherine Powell, and Susan Sherwood deserve our thanks for their integral support. The exhibition has been expertly enabled by SFSU's gallery manager, Sharon Bliss, who has coordinated the almost innumerable details of this project. And this publication owes much to the brilliant photography of Wei Chang and Tim Drescher.

We extend our gratitude for the leadership of SFSU President Robert A. Corrigan, Vice President Leroy Morishita, Vice President Jim Collier, and Dean Keith Morrison, as well as Judith Bettelheim, Susan Hall, Susanne Panasik, Jennifer Severin, Michelle Squyer, and Sylvia Walters, from the university. Chris Treadway deserves special recognition for her energy and enthusiasm. Others at SFSU who were extraordinarily helpful include graduate students John Skvogard and Eunice Eichelberger, and seminar participant Susan Kelly. It is impossible to credit all of the students whose research carried this project forward, but some of those who played an important role include: Chrissie Bradley, Hallie Brignall, Norma Campbell, Jasmine Granados, Raymond Haywood, Dennice Ibarra, Hyun-Young Jung, Jolynn Krystosek, Christopher Lane, Geralyn Luzadas, Helen MacDiarmid, Robert Melton, Frank Moreno, Paul Myers, Mary Orth, Mia Patterson, Anissa Paulsen, Chris Perez, Jaynee Ruiz, Gabe Scott, Michelle Segrave-Daly, Nina Sohn, John Taylor, Maria Tenreiro, Dennis Valdivia, and Kym Wesley.

The academic background for this project also received invaluable assistance from a seminar at Mills College held in Spring 2001. Sincere thanks to the inspirational Moira Roth, to Trustee Maryellen Herringer, to Bonnie Bane for literary research, and to the students in that exciting and thoughtful seminar, including:

Sheeka Arbuthnot, Hannah Freed, Kit Friday, Katja Geldhof, Addie Grushkowitz, Jin Hee Kim, Rumeena Muzaffar, Melissa Neal, Sandra Porto, Marcia Randall, Katrina Reichert, Kathy Spaeth, Melinda Sperry, Senta Stewart, Julie Sutherland, Stacy Thompson and MaryAnn White.

Community involvement, especially with the music festival celebrating the opening of the exhibition, represents another very special aspect of this project. We are deeply indebted to Mario Garcia Durham and the staff of the Yerba Buena Gardens Festival, and Eric Weiss and staff of *Mother Jones*. Other important community contributors include Apollonia Morrill, Michael Duty, Melanie Hamburger, and Harry S. Parker III. The visionary work of M. Melanie Beene, Prudence N. Kohler, and Frances Phillips was of the highest importance. Some of the many others who provided scholarly input are Patricia Albers, Karen Bennett, Timothy Burgard, Daniell Cornell, Jeff Gunderson, bell hooks, Elmer Johnson, Paul Karlstrom, Peter Selz, Alison Thoreau, Charles Wollenberg, and Masha Zakheim.

The project benefited tremendously from the excellent staff at the California Historical Society, including Andrew Bigler, Maren Jones, Pamela Young Lee, Jennifer Liss, Marian Ueki, Crissa Van Vleck, and everyone else at this important institution. Similarly, it has been a joy to work with the staff at the California Exhibitions Resource Alliance, including Lisa Erickson and Joan Jasper, which enabled the touring of the exhibition. We thank Jeannine Gendar, Kim Hogeland, David Isaacson, Rebecca LeGates, Lisa K. Manwill, Sarah Neidhardt, Patricia Wakida, interns Liz Ball and Yvonne Yang, and the entire staff of Heyday Books for their creative contributions, as well as designer David Bullen.

It is impossible to recognize fully the artists and their families, friends, colleagues, and collectors who provided so much background information about the artists' careers and works. A partial list with warmest acknowledgements to everyone includes: Juana Alicia, Lucienne Allen, Paule Anglim, Peter Arnautoff, David Avalos, David Bacon, George Blake, Joseph Blum, Judy Branfman, Sheila Braufman, Karin Breuer, Michael Brown, Don Cairns, Freeman Chee, Mrs. Claude Clark, Claude Lockhart Clark, Leslie Correll, Pele deLappe, Sergio de la Torre, Francisco J. Domínguez, Christina Fernández, Jon Fromer, Juan Fuentes, Erin García, Rupert García, Louise Gilbert, Luis "Louie the Foot" González, Christopher Grimes, Ursula Gropper, Ester Hernández, Louis Hock, Jan Holloway, Nancy Hom, Pirkle Jones, Bruce Kaiper, Mike Kelley, Fred Lonidier, Yolanda López, Hung Liu, Robert McChesney, Mary Fuller McChesney, Dan McCleary, Jennifer McFarland, Amalia Mesa-Bains, Malaquías Montoya, Julio Morales, Mary Murray, Evelyn Nadel, Douglas R. Nickel, Judy Nitzberg, Hela Norman, Ernesto Palomino, Dan Perkins, Linda Poe, Jane L. Reed, Ulla Reilly, Maria Rode, Patricia Rodríguez, Nancy Rowe and family, Frederik L. Schodt, Allan Sekula, Charlotte Sherman, Elizabeth Sisco, Mary Clare Stevens, Lee Stone, Larry Sultan, Margaret Takei, Susie Tompkins Buell, Cathryn Thurow, Mario Torero, Elsa Ulloa, Tom Vontersch, Gene Vrana and the staff of the ILWU, Jessica White, Helene Whitson, Criff Williams, Sylvia Wolf, and Suzanne Zada.

To all of these and many more, thank you, in solidarity with the spirit of this project.

Literary Permissions

Karen Brodine, "Woman Sitting at the Machine, Thinking" from *Woman Sitting at the Machine, Thinking: Poems,* by Karen Brodine, Red Letter Press, © 1990. Used with permission.

Carlos Bulosan, *America Is in the Heart: A Personal History* (New York: Harcourt, Brace, and Co., 1946, reprinted by University of Washington Press, 1973).

César Chávez, untitled excerpt from the website of the United Farm Workers, www.ufw.org; TM/© 2003 the César E. Chávez Foundation, www.chavezfoundation.org.

Diana García, "Turning Trays." From *When Living Was a Labor Camp.* © 2000 Diana García. Reprinted by permission of the University of Arizona Press.

Woody Guthrie, *Harry Bridges.* © Copyright 1966 by STORMKING MUSIC, INC. All rights reserved. Used by permission.

Robinson Jeffers. "The Purse-Seine." © 1938 and renewed 1996 by Donnan & Garth Jeffers, from *Selected Poetry of Robinson Jeffers* by Robinson Jeffers. Used by permission of Random House, Inc.

Sarah Menefee, untitled poem, "a woman serves . . ." from *I'm not thousandfurs* (Curbstone Press, 2002) by Sarah Menefee. Reprinted with the permission of Curbstone Press. Distributed by Consortium.

Frank Norris, "The Brute." Originally published in *The Wave,* March 13, 1899 and later in Norris's *Collected Writings* (New York: Doubleday, Doran & Co., Inc., 1928).

Kenneth Rexroth, "The Bad Old Days," by Kenneth Rexroth, from *The Collected Shorter Poems,* copyright © 1940, 1944, 1963 by Kenneth Rexroth. Reprinted by permission of New Directions Publishing Corp.

Malvina Reynolds, "Bury Me in My Overalls" from *Song in My Pocket* by Malvina Reynolds. Copyright © 1954 by Malvina Reynolds. Reprinted by permission of Nancy Schimmel.

Gary Soto, "A Red Palm." From *New and Selected Poems* ©1995 by Gary Soto. Used with permission of Chronicle Books LLC, San Francisco. Visit http://www.chroniclebooks.com.

"What Is a Movement?" From *El Malcriado,* English edition, volume 19, 1965.

Plate 111. Bits Hayden, *No Help Wanted*,

1948, book illustration for *On the Drumhead*, a selection from the writing of Mike Quin